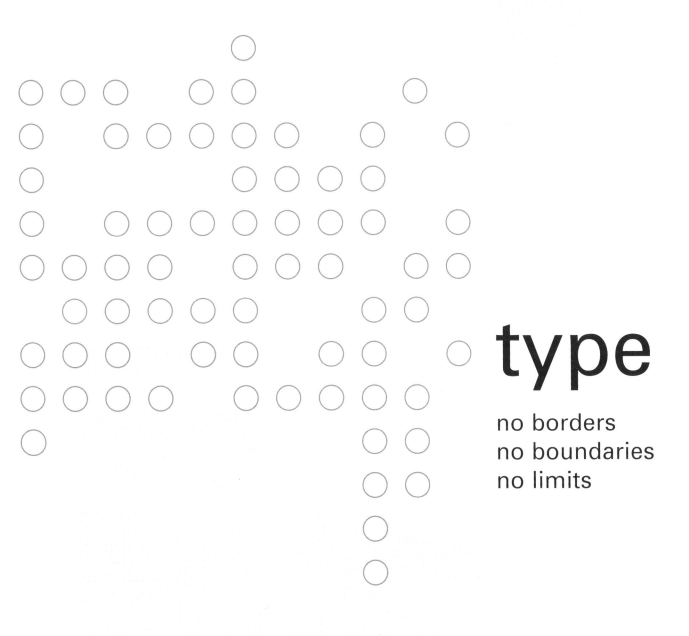

type

no borders
no boundaries
no limits

[type]

no borders
no boundaries
no limits

general editor: roger walton

AustriaArgentinAu
BRAZILCanadaCroat
FINLANDGermanyIrela...
ItalYMexicoNetherlands...
SpainSwedenSwitzerland...

...guin
...nce
...rael
...England

type: no borders, no boundaries, no limits

First published in 2002 by:
HBI, an imprint of HarperCollins Publishers
10 East 53rd Street
New York, NY 10022-5299
United States of America

Distributed to the trade and art markets in the
U.S. by:
North Light Books,
an imprint of F&W Publications, Inc.
1507 Dana Avenue
Cincinnati, OH 45207
Tel: (800) 289-0963

Distributed throughout the rest of the world by:
HarperCollins International
10 East 53rd Street
New York, NY 10022-5299
Fax: (212) 207-7654

ISBN: 0-06-621391-6

First published in Germany in 2002 by:
NIPPAN
Nippon Shuppan Hanbai Deutschland GmbH
Krefelder Str. 85
D–40549 Düsseldorf
Tel: (0211) 504 80 80 / 89
Fax: (0211) 504 93 26
E-Mail: nippan@t-online.de

ISBN: 3-935814-06-2

Conceived, created, and designed by:
Duncan Baird Publishers
6th Floor, Castle House
75–76 Wells Street, London W1T 3QH

Designer: Allan Sommerville
Editor: Marek Walisiewicz at Cobalt id
Project Co-ordinator: Tamsin Wilson

10 9 8 7 6 5 4 3 2 1

Typeset in Univers 55
Color reproduction by Colourscan, Singapore
Manufactured in China by Imago

contents

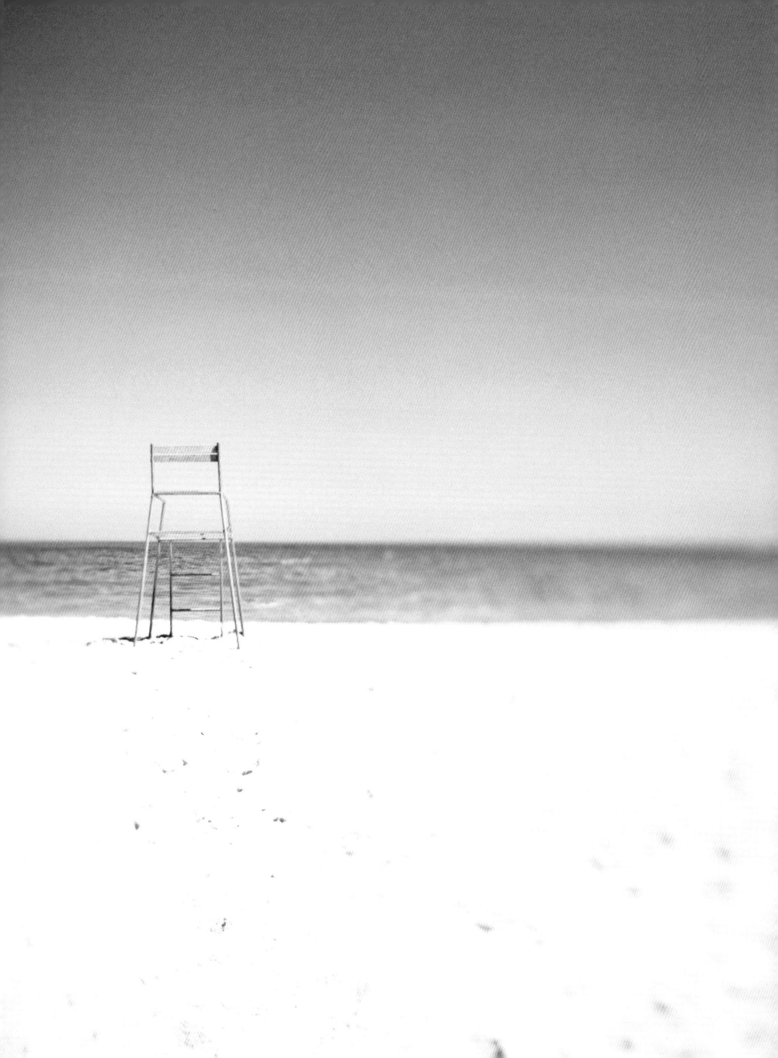

foreword

This book is a widescreen snapshot of state-of-the-art design. When you look through its pages, you'll witness the vigorous cross-cultural influences that are feeding the imaginations of the most innovative graphic designers and studios around the world. As the need for effective communication becomes ever more pressing, design ingenuity pushes beyond existing boundaries to meet the challenges of a changing world.

Type: No Borders, No Boundaries, No Limits brings the wildest, most thought-provoking typographic design into your studio. You don't even have to get out of your chair.

RW

section 1

type and **image**

Designer Tom Sieu

Art directors Tom & John

Design company
Tom & John: a design collaborative

Country of origin USA

Client Bark Magazine

Work description One of a series of
promotional posters for the self-
styled 'modern dog culture zine,'
which presents interesting views
on how dogs affect our lives.

Dimensions 13 ½ x 19 in; 343 x 483 mm

LITERATURE

ART

IDEAS

AIGA

AIGA | LA PRESENTS **SOUNDBLAST**
AT THE PETERSEN AUTOMOTIVE MUSEUM
OCTOBER 26, 2000

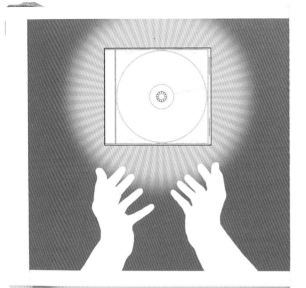

PROTECT THE CD PACKAGE

Designer/art director Stefan G Bucher

Photographer Jason Ware

Design company 344 Design

Country of origin USA

Client AIGA Los Angeles

Work description Poster (left), catalog, and slip case (this page) for a design exhibit entitled 'Worship the CD Package,' which explores CD packaging.

Dimensions Poster: 18 x 24 in; 457 x 610 mm
Catalog: 5 1/2 x 4 1/4 in; 140 x 108 mm

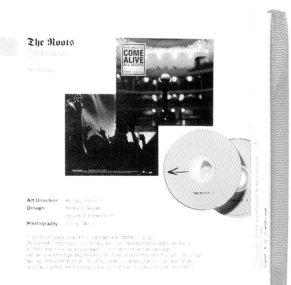

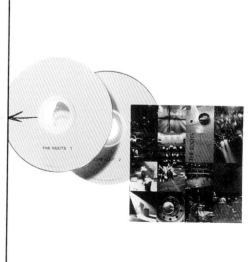

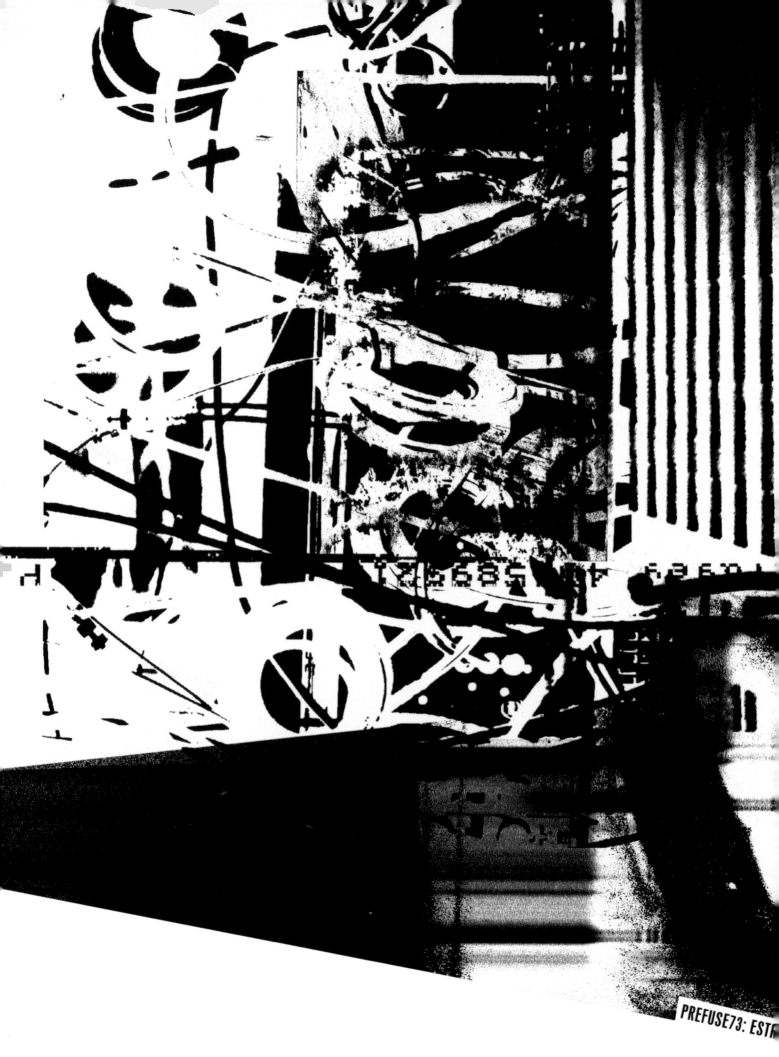

PREFUSE73: ESTR

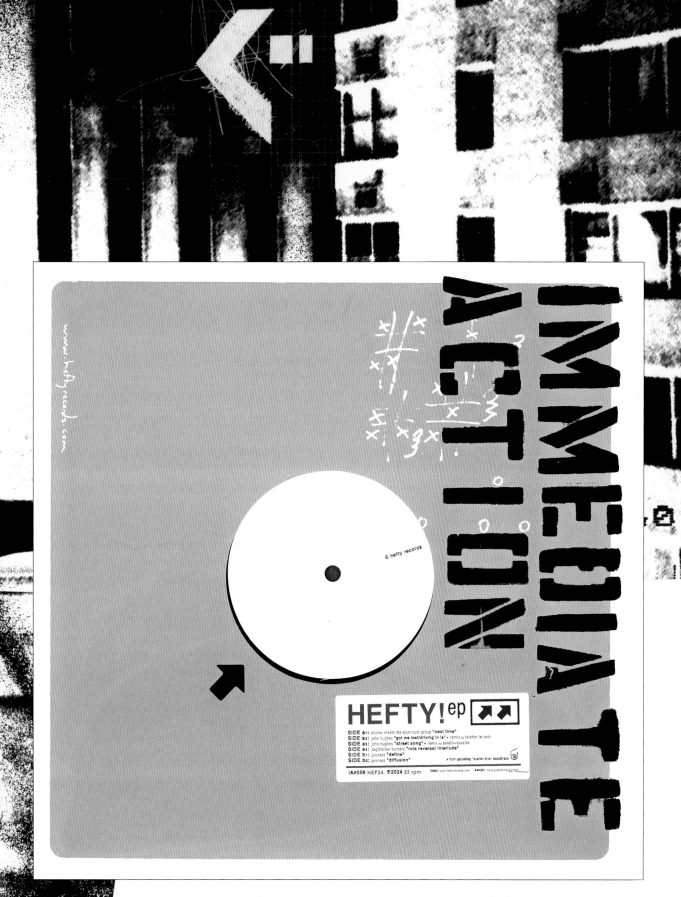

Design company
　Graphic Havoc avisualagency
Photographer Graphic Havoc
Country of origin USA

Client Hefty Records
Work description Sleeve design for the
　Immediate Action series of vinyl releases.
Dimensions 12 1/4 x 12 1/4 in; 311 x 311 mm

07:00 pm Walking to a petshop across the street.

05:17 pm Waiting for 6 o'clock.

11:00 am Sitting at a square near my office.

Designer Anisa Suthayalai

Art director Carlos Segura

Illustrator Anisa Suthayalai

Design company Segura Inc

Country of origin USA

Client The [T-26] Digital Type Foundry

Work description Newspaper produced as part of an ongoing mailing to announce new fonts.

Dimensions 12 x 18 in; 305 x 457 mm

11:00 pm Talking to my friend.

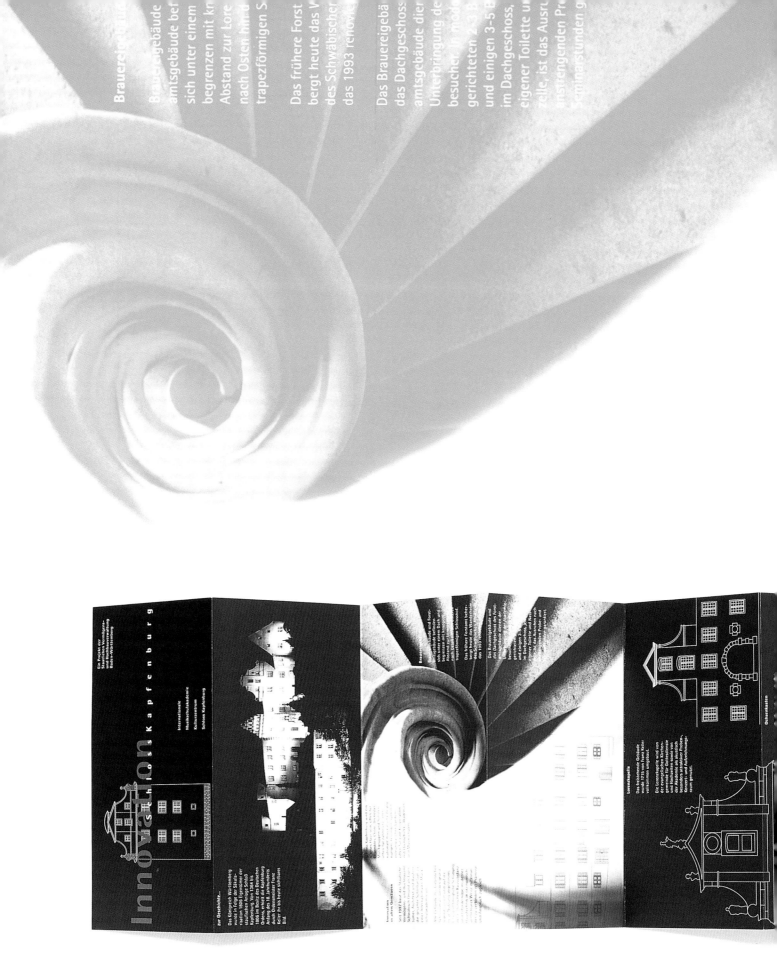

Designers/art directors
Gerd and Barbara Baumann

Design company Baumann & Baumann

Country of origin Germany

Client Schloss Kapfenburd International Academy of Music

Work description Corporate identity and gatefold orientation brochure for a music college and venue housed in a restored castle in Swabia, Germany.

Dimensions
7 x 31 1/2 in; 180 x 800 mm (unfolded)

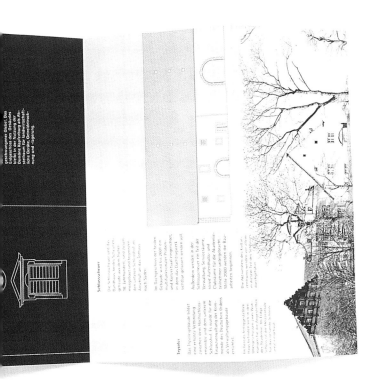

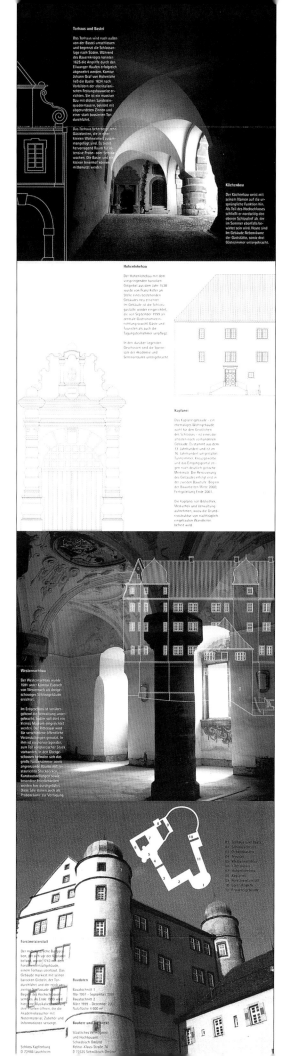

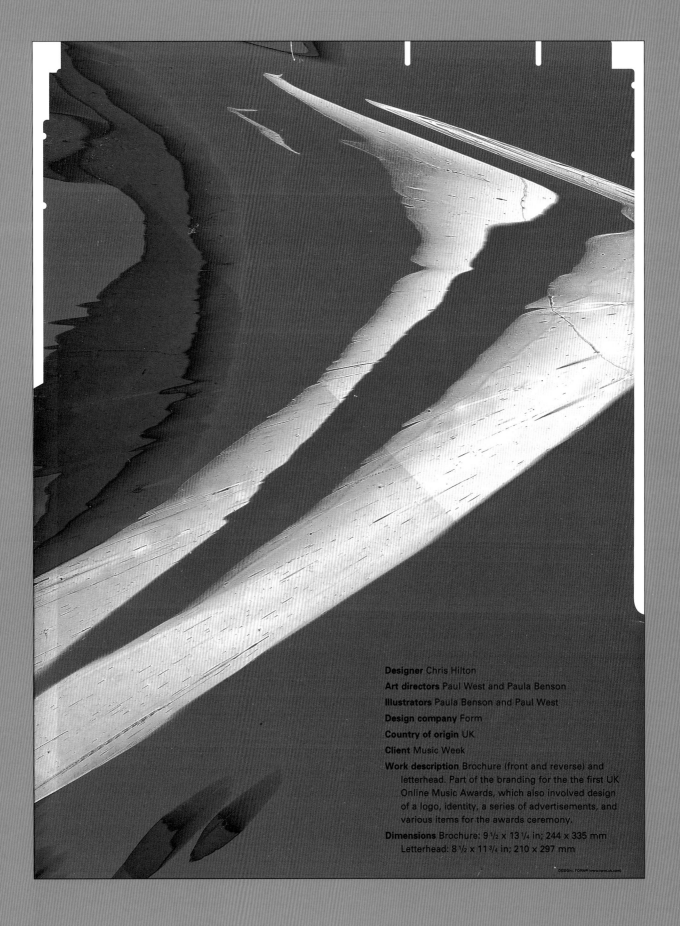

Designer Chris Hilton

Art directors Paul West and Paula Benson

Illustrators Paula Benson and Paul West

Design company Form

Country of origin UK

Client Music Week

Work description Brochure (front and reverse) and
 letterhead. Part of the branding for the the first UK
 Online Music Awards, which also involved design
 of a logo, identity, a series of advertisements, and
 various items for the awards ceremony.

Dimensions Brochure: 9 1/2 x 13 1/4 in; 244 x 335 mm
 Letterhead: 8 1/2 x 11 3/4 in; 210 x 297 mm

DESIGN: FORM® (www.form.uk.com)

UK ONLINE MUSIC AWARDS_00

THE UK ONLINE MUSIC AWARDS_00

■ UBM ENTERTAINMENT GROUP_
UNITED BUSINESS MEDIA LTD
8 MONTAGUE CLOSE, LONDON BRIDGE
LONDON SE1 9UR
□ EMAIL:. INFO@UKONLINEMUSICAWARDS.COM
□ FAX:. 020 7407 7087

□ PRODUCTION TEL:. 020 7940 8592
□ ENTRIES TEL:. 020 7940 8570
□ TICKETS TEL:. 020 7940 8665
WWW.UKONLINEMUSICAWARDS.COM
WWW.UNITEDBUSINESSMEDIA.COM
WWW.MUSICWEEK.COM

PLACE OF REGISTRATION:. ENGLAND & WALES
COMPANY NUMBER:. 4002906
REGISTERED OFFICE:. SOVEREIGN HOUSE
SOVEREIGN WAY, TONBRIDGE, KENT TN9 1RW
un A UNITED NEWS & MEDIA COMPANY

Designer/art director Walter Bohatsch

Design company
Bohatsch Graphic Design GmbH

Country of Origin Austria

Client Massiv

Work descripton Hardback book.
A collection of textual material from
a variety of authors that forms the
basis of a theater production – Massiv.

Dimensions 6 1/4 x 9 1/2 in; 158 x 240 mm

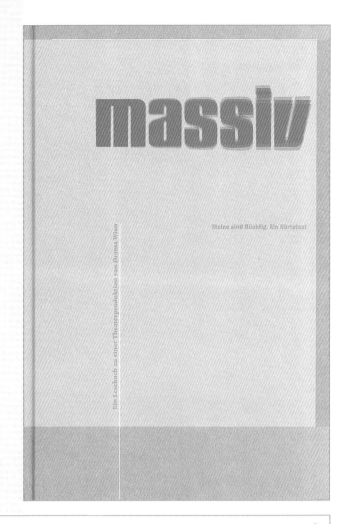

massiv

gesicht stein gesicht stein gesicht stein gesicht stein gesicht stein gesicht stein gesicht
stein gesicht stein gesicht stein gesicht stein gesicht stein gesicht stein gesicht stein
gesicht stein gesicht stein gesicht stein gesicht stein gesicht stein gesicht stein gesicht
stein gesicht stein gesicht stein gesicht stein gesicht stein gesicht stein gesicht stein
gesicht stein gesicht stein gesicht stein gesicht stein gesicht stein gesicht stein gesicht
stein gesicht stein gesicht stein gesicht stein gesicht stein gesicht stein gesicht stein
gesicht stein gesicht stein gesicht stein gesicht stein gesicht stein gesicht stein gesicht
stein gesicht stein gesicht stein gesicht stein gesicht stein gesicht stein gesicht stein
gesicht stein gesicht stein gesicht stein gesicht stein gesicht stein gesicht stein gesicht
stein gesicht stein gesicht stein gesicht stein gesicht stein gesicht stein gesicht stein
gesicht stein gesicht stein gesicht stein gesicht stein gesicht stein gesicht stein gesicht
stein gesicht stein gesicht stein gesicht stein gesicht stein gesicht stein gesicht stein
gesicht stein gesicht stein gesicht stein gesicht stein gesicht stein gesicht stein gesicht
stein gesicht stein gesicht stein gesicht stein gesicht stein gesicht stein gesicht stein
gesicht stein gesicht stein gesicht stein gesicht stein gesicht stein gesicht stein gesicht
stein gesicht stein gesicht stein gesicht stein gesicht stein gesicht stein gesicht stein
gesicht stein gesicht stein gesicht stein gesicht stein gesicht stein gesicht stein gesicht
stein gesicht stein gesicht stein gesicht stein gesicht stein gesicht stein gesicht stein
gesicht stein gesicht stein gesicht stein gesicht stein gesicht stein gesicht stein gesicht
stein gesicht stein gesicht stein gesicht stein gesicht stein gesicht stein gesicht stein
gesicht stein gesicht stein gesicht stein gesicht stein gesicht stein gesicht stein gesicht
stein gesicht stein gesicht stein gesicht stein gesicht stein gesicht stein gesicht stein
gesicht stein gesicht stein gesicht stein gesicht stein gesicht stein gesicht stein gesicht
stein gesicht stein gesicht stein gesicht stein gesicht stein gesicht stein gesicht stein
gesicht stein gesicht stein gesicht stein gesicht stein gesicht stein gesicht stein gesicht
stein gesicht stein gesicht stein gesicht stein gesicht stein gesicht stein gesicht stein
gesicht stein gesicht stein gesicht stein gesicht stein gesicht stein gesicht stein gesicht
stein gesicht stein gesicht stein gesicht stein gesicht stein gesicht stein gesicht stein
gesicht stein gesicht stein gesicht stein gesicht stein gesicht stein gesicht stein gesicht
stein gesicht stein gesicht stein gesicht stein gesicht stein gesicht stein gesicht stein
gesicht stein gesicht stein gesicht stein gesicht stein gesicht stein gesicht stein gesicht
stein gesicht stein gesicht stein gesicht stein gesicht stein gesicht stein gesicht stein
gesicht stein gesicht stein gesicht stein gesicht stein gesicht stein gesicht stein gesicht
stein gesicht stein gesicht stein gesicht stein gesicht stein gesicht stein gesicht stein
gesicht stein gesicht stein gesicht stein gesicht stein gesicht stein gesicht stein gesicht

Jimmie Durham
Der Verführer und der steinerne Gast,
Ausstellung Haus Wittgenstein, Wien, 1996
courtesy Galerie Christine König, Wien

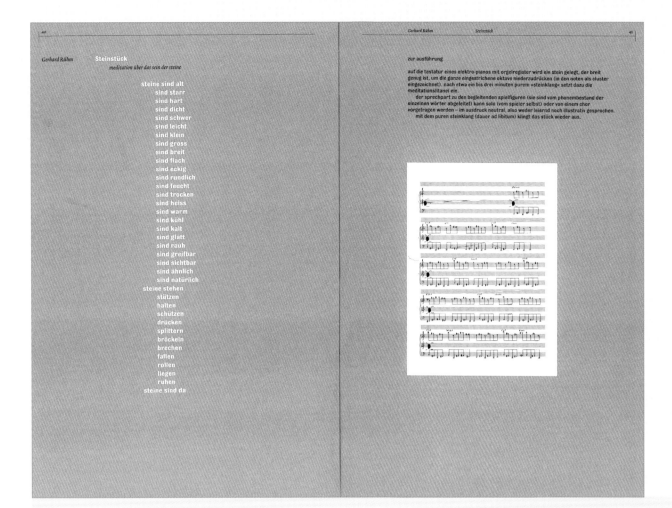

Gerhard Rühm **Steinstück**
meditation über das sein der steine

steine sind alt
sind starr
sind hart
sind dicht
sind schwer
sind leicht
sind klein
sind gross
sind breit
sind flach
sind eckig
sind rundlich
sind feucht
sind trocken
sind heiss
sind warm
sind kühl
sind kalt
sind glatt
sind rauh
sind greifbar
sind sichtbar
sind ähnlich
sind natürlich
steine stehen
stützen
halten
schützen
drücken
splittern
bröckeln
brechen
fallen
rollen
liegen
ruhen
steine sind da

zur ausführung

auf die tastatur eines elektro-pianos mit orgelregister wird ein stein gelegt, der breit genug ist, um die ganze eingestrichene oktave niederzudrücken (in den noten als cluster eingezeichnet). nach etwa ein bis drei minuten purem »steinklang« setzt dazu die meditationslitanei ein.

der sprechpart zu den begleitenden spielfiguren (sie sind vom phonembestand der einzelnen wörter abgeleitet) kann solo (vom spieler selbst) oder von einem chor vorgetragen werden – im ausdruck neutral, also weder leiernd noch illustrativ gesprochen. mit dem puren steinklang (dauer ad libitum) klingt das stück wieder aus.

Aloysia *(beleidigt)*:
Also gut:
Steinkassette, Steindreck, Steinkette, Steinesel, Steinessen,
Steinbesen, Steinstadion, Steinkrawatte, Steinhase, Steinfrage,
Steinbimbo, Steinschmäh!
Steinbäh!
(streckt Margarete die Zunge raus)
Margarete: Tu nur so,
als wäre ich eine Idiotin!
Tu ruhig so!
Tu ruhig so!
Tu es!
Tu es!
Aloysia: Steinkrätze, Steinschmelze, Steinpetze, Steinoktave,
Modehase!
Margarete: Realize you're built to spill ...
It's no big deal ...
Aloysia: Steinwuchs, Steinbart, Steingarten, Harmonie überall,
Steinbrechen, Steinstechen, Steinhaube, Steinlabe, Steingabe,
laber mich nicht voll, Steinwutz, Steinfutz, Steingutz,
Steinschabe, Steindraht, Steinwandlung, Steinvergabe,
Steinwuchs, Steinrambo, Steinrockystatue mitten in
Philadelphia, also weit entfernt, Steinberg, misantropisches
Monodrama Teil vier, Steingehege, Steingelege, Steinrechner,
Wurststein, Apfelmus, Kotai und Mo, minimal, Steinfresse,
Steillage, Steinpizza, Steingemüse, versteinerte Dinosaurier-
scheiße, Asteroideneinschlag, karthesischer Steinstammbaum,
versteinerte Autoren: Friedrich Schiller!
(Es donnert wieder heftig, beide zucken zusammen)
Margarete: Oh Gott!
Not!
Jetzt kommen sie uns holen!
Lass uns sehen,
dass wir hier wegkommen!
Aloysia: Ist gut!
Margarete: Fahren wir nach Mondsee!
Dort ist es ja doch viel schöner!
Aloysia: Ist gut!
*(Beide raffen sich auf, klettern von dem Stein herunter,
verlassen die Bühne)*

Vorhang

Bohatsch: Unsere Arbeitsweise bezieht sich schon auch auf Film, auf die filmische Schnitttechnik, seien es jetzt harte Schnitte, seien es Überblendungen, sei es Ein- oder Ausblenden. So zu denken, als würde man einen Film machen oder als würde man einen Film sehen, und diese Techniken versuchen, am Theater anzuwenden – nur werden sie am Theater ganz etwas Anderes. Das hat für mich mit ästhetischer Aktualität zu tun.

Rubin: Uns interessieren oft die Momente, die üblicherweise wenig beachtet werden. Bei unserer Materialiensammlung zum Thema Stein haben wir auch über Sisyphos gesprochen. Bei Camus zum Beispiel steht, dass eigentlich Sisyphos' Weg bergab wesentlich interessanter ist, als wenn er den Stein hinaufrollt.

Rollig: Genau, denn das Hinaufrollen ist ja determiniert und Zweck, und da muss er nicht denken.

Weber: Wir würden Sisyphos zeigen, wie er seinen Stein wieder und wieder holen geht. Wenn Sisyphos seinen Stein holen geht – da herrscht das Dilemma, weil das der Moment ist von möglichen Entscheidungen. Diese Momente soll man am Theater erleben.

Christian Frank
Figur
1979
Mühldorfer Marmor
50 x 23 x 158 cm

Christian Frank
Figur
1978
Sandstein
44 x 11 x 113 cm

INVITATION

MOONBEAM DREAM

AND NATIONWIDE PAPERS

PRESENTED BY: WAUSAU PAPERS

: ONE ENCHANTED EVENING AT THE PRADO | TICKET →

SO THAT'S WHEN THE PIG PULLED ME OVER TO GIVE ME A TICKET, BUT. WHEN I TRIED TO EXPLAIN TO HIM THAT THE SCHOOLBUS JUST DOES NOT ≡ GO ≡ ANY STRAIGHTER, I COULDN'T QUITE SEEM TO GET MY WORDS AROUND THE BIG MASS OF BUBBLEGUM SWALLOWING MY TONGUE. I KEPT BLOWING THESE GARGANTUAN, WATERMELON BUBBLES THAT STUCK IN MY HAIR. WHEN I WAS FINALLY ABLE TO DISENGAGE MY MOUTH FROM THE GUM, I SPAT MY TEETH OUT WITH IT.

JAMES I ARRIVED AT THE BALL IN FABULOUS GLAMOUR, WEARING MY VERY FINEST LEOPARD PRINT TUTU. SHIMMERY PEOPLE CONVERSED AT EVERY NOOK + CRANNY, I KNEW I'D ARRIVED AT (THE PARTY OF A LIFETIME!!) A REGAL WHITE PONY SAUNTERED UP, AND I CONGRATULATED HIM ON HIS MAGNIFICENT FAUX FUR JUMPSUIT. I SPIED MY X-BOYFRIEND JAMES FROM ACROSS THE ROOM + HE ASKED ME TO DANCE!? HE SEEMED MORE FISH-LIKE THAN I HAD REMEMBERED, AND MUCH SHORTER.

Designers Pam Meierding,
 Karen Winward and Gina Elefante

Art director Don Hollis

Illustrator Tessa Bendeler

Design company Hollis

Country of origin USA

Clients Wausau Paper and
 Chive restaurant

Work description Promotional cards
 for paper manufacturer Wausau
 (above) that announce the launch
 party for a new range of papers.
 Drinks coasters (top right) and an
 envelope (right) show the style
 developed for San Diego
 restaurant, Chive.

Dimensions Various

H
V
3
CH1V3

PR3M1UM | W73M
V
3
H

VODKAsmirnoff
G1Nbombay
RUMbacardi
SCOTCHdewers
CORD1ALSbols
BOURBONwildturkey
BRANDYchristianbrothers
TEQU1LAcuervogold

CH1V3

558**fourth**a**v**e**nue**s**an**di**e**g**o**c**a**9**2101

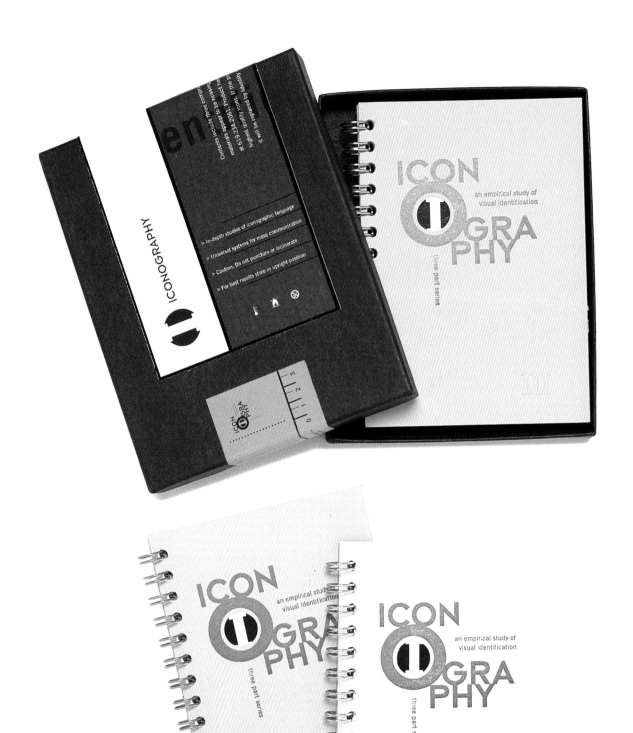

Designer/art director Don Hollis

Design company Hollis

Country of origin USA

Client Self-promotional work

Work description Three self-promotional wire-bound booklets contained within a box sleeve. The books explore the visual power of the single image.

Dimensions 3 ¹/₂ x 5 in; 90 x 127 mm

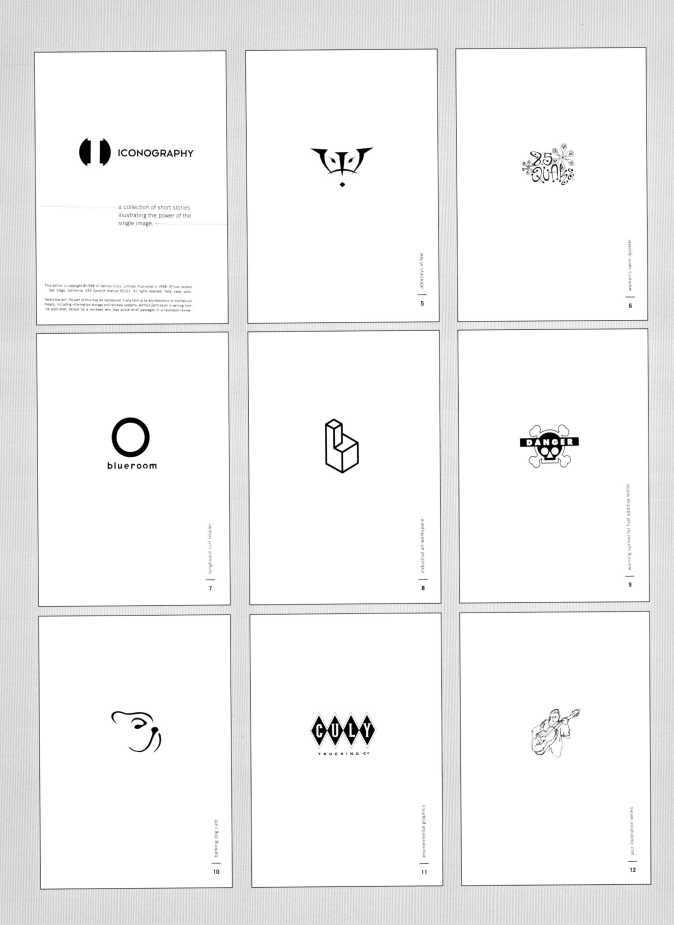

ICONOGRAPHY

a collection of short stories
illustrating the power of the
single image.

attorneys at law

5

women's swim apparel

6

blueroom

longboard surf retailer

7

industrial art workspace

8

DANGER

warning symbol for fuel additive bottle

9

barking dog café

10

GULY
TRUCKING Cº

environmental graphics

11

jazz illustration series

12

Designers Ian Mitchell and
international collaborators

Design collective Beaufonts

Country of origin UK

Client/project Chinese Whispers

Work description Fonts designed as part of
the Chinese Whispers project. This was
an online experiment in collaborative font
design involving more than 180 people
from 23 countries, finally published in
the form of a CD and poster. Completed
fonts can be viewed and downloaded at
www.beaufonts.com/pssst

Dimensions Electronic format

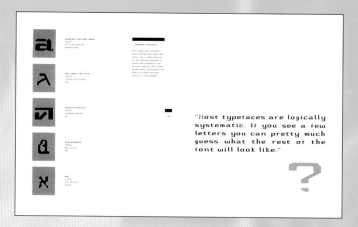

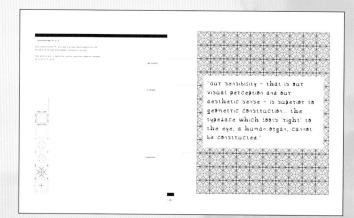

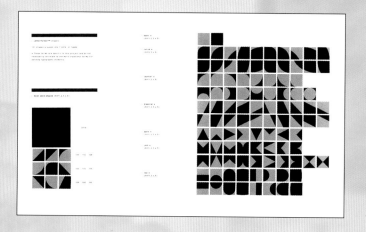

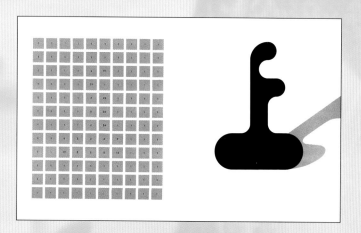

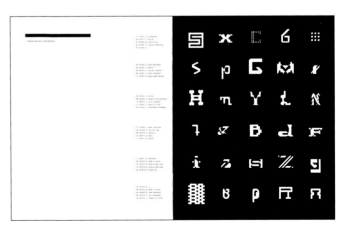

Designer David Hand

Design collective Beaufonts

Country of origin UK

Client/project Weldfonts

Work description Weldfonts is a set of digital fonts
 resulting from experiments with hairspray and
 fax paper (continued on next spread).

Dimensions Electronic format

WEDGE ME!
WEDGE YOU!
WEDGE THE WORLD!
WEDGE FOR THE MASSES!
YOU HAVE BEEN WEDGED!
MORE MORE MORE WEDGE!

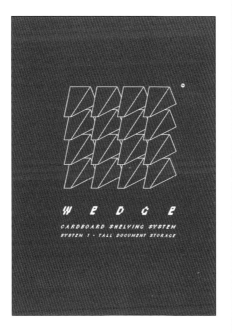

Designer David Hand

Design company Splinter

Country of origin UK

Client Splinter

Work description Promotional poster for a Splinter product – a cardboard shelving system called Wedge.

Dimensions 33 x 23 ½ in; 840 x 595 mm

EDGE

WEIGHT

EASY TO HANDLE

EASY TO CONSTRUCT

36

ABCDEFGH
IJKLMNOPQ
RSTUVWXYZ

cooSnt² ©2001 INSECT

ABCDEFG
HIJKLMNO
PQRSTUVW
XYZ

cooSnt ©2001 INSECT

cooSntions ©2001 INSECT

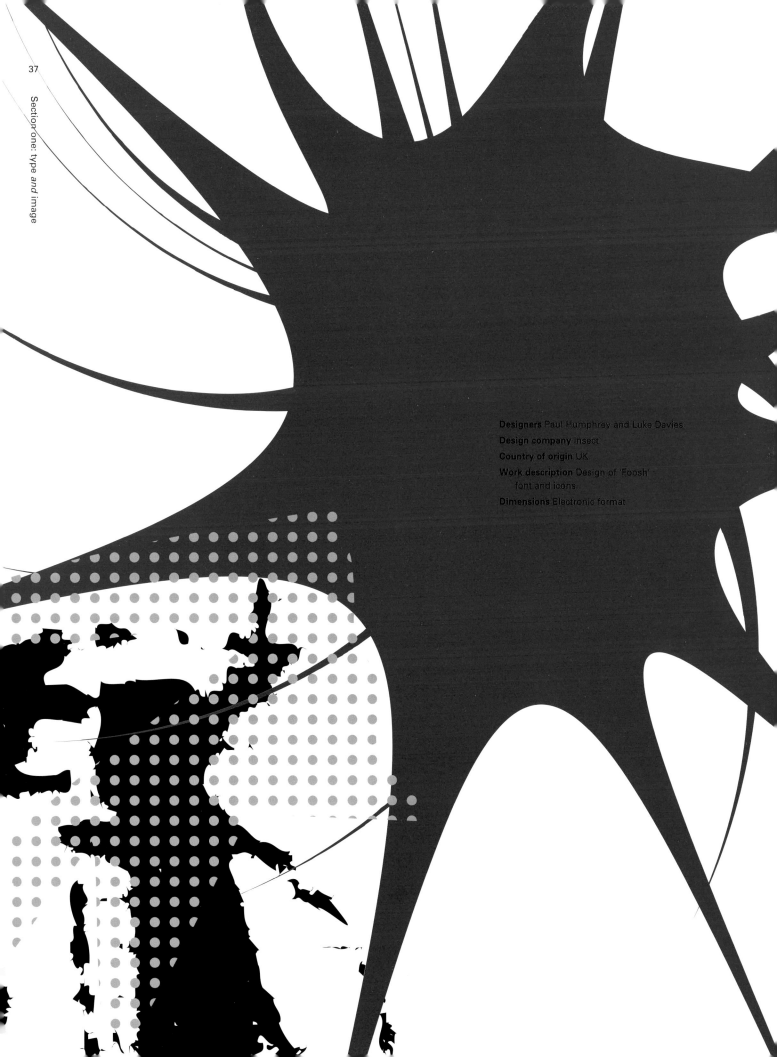

Designers Paul Humphrey and Luke Davies
Design company Insect
Country of origin UK
Work description Design of 'Foosh'
 font and icons.
Dimensions Electronic format

Designer Chris Harrison

Art director Peter Chadwick

Illustrator Thomas Williams

Design company Zip Design

Country of origin UK

Work description Record sleeve printed
in black only on manilla board.

Dimensions 12 1/2 x 12 1/2 in; 320 x 320 mm

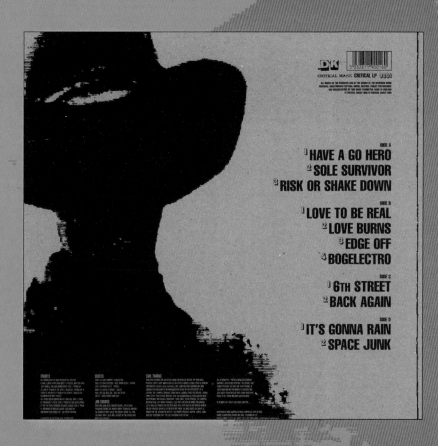

SIDE A
1 HAVE A GO HERO
2 SOLE SURVIVOR
3 RISK OR SHAKE DOWN

SIDE B
1 LOVE TO BE REAL
2 LOVE BURNS
3 EDGE OFF
4 BOGELECTRO

SIDE C
1 6TH STREET
2 BACK AGAIN

SIDE D
1 IT'S GONNA RAIN
2 SPACE JUNK

Urban
DK
HAVE
A GO
HERO

boom roos vis
vuur boog pim
pijl reus
0123 6789
12 + 5 = 17
$8 \div 2 = 4$

BOOM ROOS
VIS VUUR
BOOG PIM
PIJL REUS

Educational

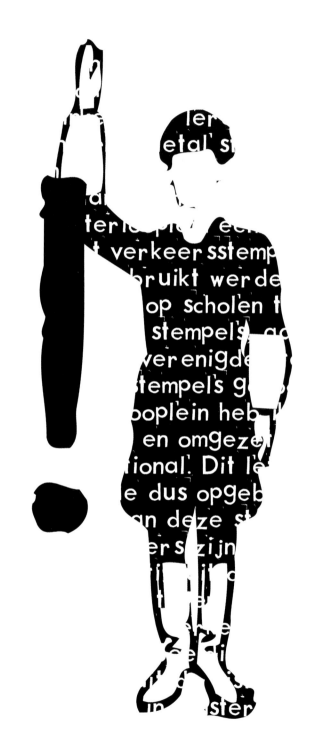

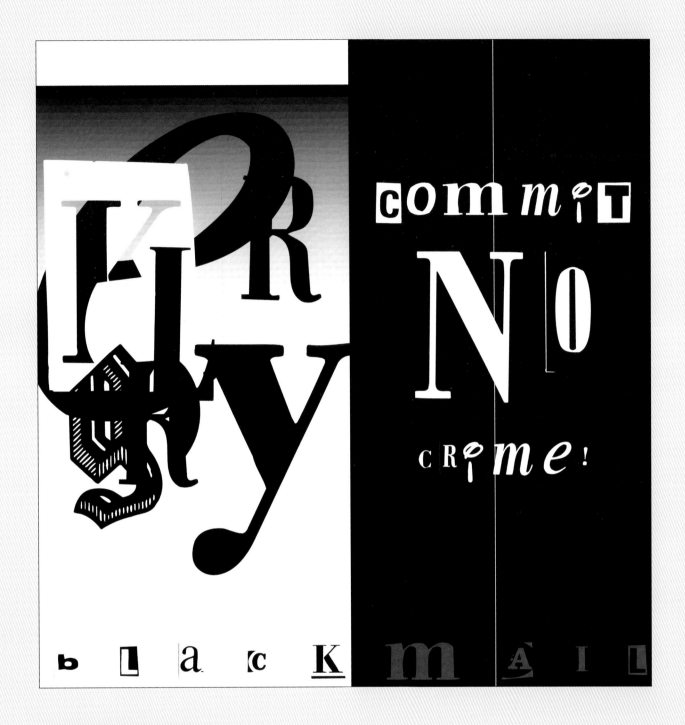

Designer/art director Martijn Oostra

Design company Martijn Oostra
Graphic Design

Country of origin The Netherlands

Work description Font design: Educational
(left) and Blackmail (above).

Dimensions Electronic format

Sequoyah
ᎦᎡᏣᎠᎬᎦᎨᏣᎯᎥᎫᏝᎷᎻᎼᏛᎹᏆᏒᎡᏎᎤᎧᏍᏣᏃᎠᎬᏣᎠᎬᎦᏄᎯᏖᎫᏝᎷᎻᏂᎤᎬᏒᎦᏎᎤᏩᎧᏍᏓᏃᏃᎬᏃᏃᏎᎤᏣᏃᎧ

Designer/art director Sean Fermoyle

Design company simpletype

Country of origin USA

Work description Details from self-promotional
 posters for the simpletype fonts foundry.

Dimensions 11 x 17 in; 280 x 432 mm

digit
FREEPOST
digit - digital experiences ltd
54-55 Hoxton Square
London N1 6BR

Brand Research Project

Handle with care

REF CODE 1009/2001

Brand Research Project

Project outline

In order to create a cross-section of the central identity and essence of the leading consumer brands across the UK and Europe today, you have been selected to be one of the core group of brands to take part in a rather unique research project.

A simple few minutes of your time is required, as the person best qualified to produce a sample of the 'essence' of your brand. The sample we request can take on any form, gaseous, liquid or solid, and should be captured within one of the enclosed specimen jars.

We have included a standard sample capturing kit for you to utilise. We only request one of the jars to be used and returned within the next 14 days using the enclosed pre-paid envelope. The other may be retained by yourself if desired, to keep your own record of the Essence of your Brand.

The results of this extraordinary experiment will be available for you to access on-line at **www.digitlondon.com/brandessence.**

The kit contains:

a. A latex glove.
b. Pipette - for collection of a liquid sample.
c. Forceps - for collection of a solid sample.
d. Two Specimen jars - one to be utilised and returned, one to be retained if desired.
e. Pre-paid envelope - for return of the Brand Essence sample to Digit.

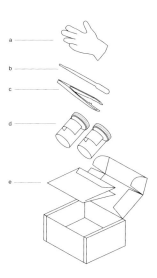

a
b
c
d
e

Instructions

1. Select sample.
2. Capture within one of the specimen jars.
3. Secure lid tightly and fill in the label with the name of your brand, company, and the date. (printed clearly)
4. Place jar within the pre-paid envelope for return to Digit.

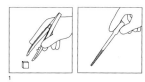

1

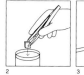

2

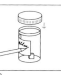

3

4

Digit - Digital Experiences Limited is one of the UK's leading Interactive Design Consultancies, specialising in all forms of digital communications. For more information about Digit or any questions about the project, please check out our website at **www.digitlondon.com** or feel free to phone Rob Cooke or Toby Evetts on **020 7684 6769.**

digit

REF CODE 1009/2001

Designer Nille Halding

Art director Kevin Helas

Design company Digit – Digital
Experiences Limited

Country of origin UK

Work description A sample collection
kit comprising latex gloves, pipettes,
tweezers, and specimen jars. The kit
was sent out to companies, inviting
them to return a 'sample' of their
brand in an inventive twist on the
self-promotional mailing.

Dimensions Various

■□ DIAGNOSIS REFERRAL

We are still awaiting your sample.

Time is running out! You will have received a sample kit in the post, which
enables you to capture a sample of the 'essence' of your brand. Please
return a sample in the next few days, in the pre-paid envelope which you
were provided with, to take part in this unique project.

Current results of our research are available for you to view on-line at
www.digitlondon.com/brandessence.

digit

Digit - Digital Experiences Limited is one of the UK's leading Interactive Design Consultancies, specialising in all forms of digital communications.
For more information about Digit or any questions about the project, please check out our website at **www.digitlondon.com** or feel free to phone
Rob Cooke or Toby Evetts on **020 7684 6769**.

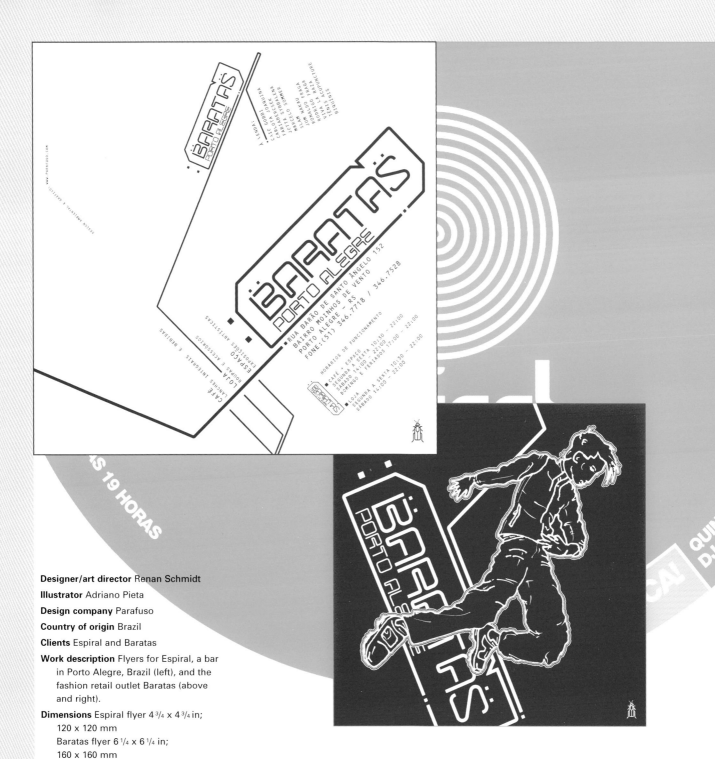

Designer/art director Renan Schmidt

Illustrator Adriano Pieta

Design company Parafuso

Country of origin Brazil

Clients Espiral and Baratas

Work description Flyers for Espiral, a bar in Porto Alegre, Brazil (left), and the fashion retail outlet Baratas (above and right).

Dimensions Espiral flyer 4 3/4 x 4 3/4 in; 120 x 120 mm
Baratas flyer 6 1/4 x 6 1/4 in; 160 x 160 mm

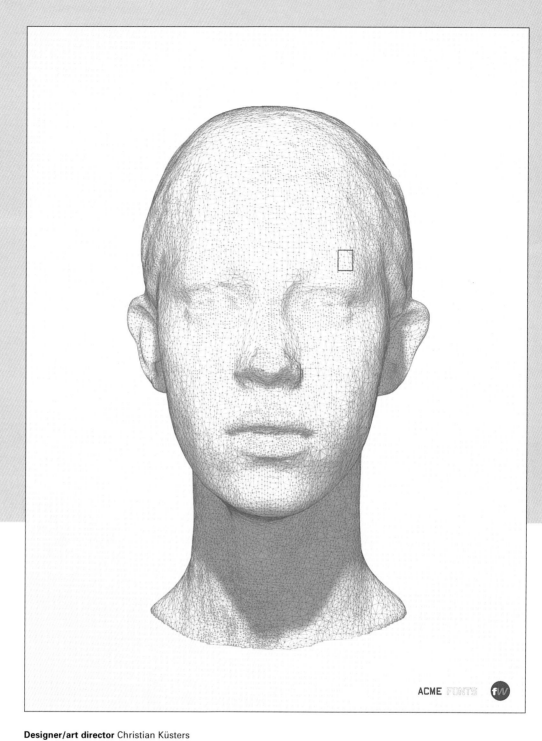

Designer/art director Christian Küsters
Photographer Sølve Sundsbø
Digital retouching Alex Rutherford at Lost in Space
Design company CHK Design
Country of origin UK
Client Fontworks UK
Work description Promotional poster for font foundry.
Dimensions 16 x 21 ½ in; 410 x 550 mm

AF Amateur 69 (Corsten Schwesig)
ABCDEFGHIJKLMNOPQR STUVWXYZ abcdefg hijklmn vwxyz 12345 678910 £$&!

AF Nicoteen 13 (Carsten Schwesig)
ABCDEFGHIJKLMNOPQRSTUVW XYZ abcdefghijklmnopqrstuvwxyz 1234567890 (!?£$&) ŒæfiflŒœ

AF Syrup (Corsten Schwesig)
ABCDEFGHIJKLMNOPQRSTUVWXYZ abcdefghijklm nopqrstuvwxyz 1234567890 !@£$%&

AF SPIN FAMILY (Simon Piehl)
AF Spin Regular
ABCDEFGHIJKLMNOPQRSTUV WXYZ abcdefghijklmnopqrs tuvwxyz 1234567890 !$%&

AF Spin Italic
ABCDEFGHIJKLMNOPQRSTU VWXYZ abcdefghijklmnopqr stuvwxyz 1234567890 !$%&

AF Spin Bold
ABCDEFGHIJKLMNOPQRST UVWXYZ abcdefghijklmno pqrstuvwxyz 1234567890

AF Spin Bold Italic
ABCDEFGHIJKLMNOPQRST UVWXYZ abcdefghijklmn opqrstuvwxyz 1234567890

AF Interface One (Christian Küsters)
ABCDEFGHIJKLMNOPQRS TUVWXYZ abcdefghijklm nopqrstuvwxyz 1234567890 !£$%&

AF Interface Two (Christian Küsters)
ABCDEFGHIJKLMNOP QRSTUVWXZ abcdef ghijklmnopqrstuvwx yz 1234567890 @£$&

ABCDEFGHIJKLMNOPQRSTUV WXYZ abcdefghijklmnop vxyz 1234567890 !@£$%&

ABCDEFGHIJKLMNOPQRS TUVWXYZ abcdefghijklmn opqrstuvwxyz 12345678 90 !@£$%&

AF Hadrian (Christian Küsters)
ABCDEFGHIJKLM NOPQRSTuvwxyz abcdefghijklmnopqrs tuvwxyz 1234567890 (£$%&)
THE END McQUEEN

AF RETROSPECTA FAMILY (Christian Küsters)
AF Retrospecta Roman
ABCDEFGHIJKLMNOPQRSTUVWXYZ abcdef hijklmnopqrstuvwxyz 1234567890 £@$&fiflŒœÆæ

AF Retrospecta Italic
ABCDEFGHIJKLMNOPQRSTUVWX abcdefghijklmnopqrstuvwxyz 1234567890 £@$&fiflŒœÆæ

AF Retrospecta Bold
ABCDEFGHIJKLMNOP QRSTUVWXYZ abcdefghijklmnopqrstuvwxyz 1234567890 £@$&fiflŒœÆæ

AF Retrospecta Bold Italic
ABCDEFGHIJKLMNOPQRSTUVWXYZ abcdefghijklmnopqrstuvwxyz 1234567890 £@$&fiflŒœÆæ

AF Screen (Paul Wilson)
ABCDEFGHIJ KLMNOPQRS TUVWXYZ abcdefghijk lmnopqrs tuvwxyz 123456 7890

AF Track One (Christian Küsters)

AF Track Two (Christian Küsters)
ABCDEFGH IJ LMNOPQRSTUV WXYZ abc Kdefghijklmnopqrs tuvwxyz 1234567890 @£$

AF Cashier 1 (Christian Küsters)
AB DEFGH CIJKL MNOPQRSTUVWXYZ abcdefghijklmn opqrstuvwxyz12 34567890 £$£?

AF Wendingen (H. T. Wijdeveld)
ABCDEFGHIJKL MNOPQRSTUVWXYZ ABCDEFGHIJKLMNOPQ RSTUVWXYZ 1234567890

AF Champ Fleury (Christian Küsters)
ABCDEFGH IJKLMNOP QRSTV WXYZ

AF Video Wall (Anthony Burrill)
ABCD EFGH IJKLMNOP QRSTUVW YZ 1234 567 890 . +%? □

AF Tosience (Paul Farrington Letters SONIC)

AF BATTERSEA FAMILY (Henrik Kubel)
AF Battersea Regular
ABCDEFGHIJKLMNOPQRSTUVWXYZ abcdefghijklmnopqrstuvwxyz 1234567890 [!?@£$&] © ÆæŒœfifl

AF Battersea Medium
ABCDEFGHIJKLMNOPQRSTUVWXYZ abcdefghijklmnopqrstuvwxyz 1234567890 [!?@£$&] © ÆæŒœfifl

AF Battersea Bold
ABCDEFGHIJKLMNOPQRSTUVWXYZ abcdefghijklmnopqrstuvwxyz 1234567890 (!?@£$&) ÆæŒœfifl

AF KLAMPENBORG FAMILY (Henrik Kubel)
AF Klampenborg Regular
ABCDEFGHIJKLMNOPQRSTUVWXYZ abcdefghijklmnopqrstuvwxyz 1234567890 [!?@£$&] ÆæŒœfifl

AF Klampenborg Medium
ABCDEFGHIJKLMNOPQRSTU VWXYZ abcdefghijklmnop qrstuvwxyz 1234567890 (!?@£$&) ÆæŒœfifl

AF Klampenborg Bold
ABCDEFGHIJKLMNOP QRSTUVWXYZ abcde fghijklmnopqrstuv wxyz 1234567890 (!?@£$&) Æœ Œœfifl

AF Carplates Regular (Sandy Suffield/Ch. Küsters)
ABCDEFGHIJKLM NOPQRSTUVWXYZ abcdefghijklmnopqrstu vwxyz 1234567890 @£$%&

AF Carplates Bold (Sandy Suffield: Concept & UC letters/Christian Küsters: LC letters)
ABCDEFGHIJKLMNOPQRS TUVWXYZabcdefghijklmnopq opqrstuvwxyz 1234567890 £$&

AF Oneline (Anne wiebebrink)
ABCDEFGHIJKLMNOPQRSTUVWXYZ abcdefghijklmnopqrstuvwxyz 1234567890 (?!@£$&)

AF Allen (Alex Rich)
ABCDE FGHIJ LMNOPQR STUVW YZ 123 4567890

AF Constants (Andy Long) Letter A
TWO LINES EXTENDING FROM THE BASELINE AT AN ANGLE OF 69° TO IT, JOINING AND TERMINATING AT A POINT ON THE HEADLINE DIRECTLY ABOVE A POINT HALFWAY BETWEEN THEIR BASE POINTS. LINE EXTENDING FROM A POINT ON THE RIGHT OF THE LEFT LINE A THIRD OF ITS LENGTH FROM THE BASE, RUNNING PARALLEL TO THE BASELINE AND TERMINATING AT THE RIGHT LINE.

ABC DEFGHI JKLMNOPQ RSTUV XYZ

AF P.A.N. Regular (Robert Green)
ABCDEFGH IJKLMNOPQR STUVWXYZ 1234 1234567890 @&$%

AF P.A.N. Bold (Robert Green)
ABCDEFGHIJKLMNOPQRS TUVWXYZ 1234567890 @&$

AF Satellite (Christian Küsters)

AF Angel (Christian Küsters)
ABCDEFGH KLMNOPQ STUVWX YZ 1234567 890 £$&

ABCDEFG HIJKLMNOPQRST UVWXYZ abcdefghijklmn nopqrstuvwxyz 1234567890 £?&
AF Camberwell (Christian Küsters)

Design: Christian Küsters
Cover Photograph: Salve Sundsbø (T +44 207 253 5990)
Digital retouching: Lost in Space
Printed on Hispeed Virtual Pearl 120gsm
Paper kindly donated by Arjo Wiggins Fine Papers
Please phone 0800 993300 for samples and a swatch
Hispeed Colours is a trademark of Arjo Wiggins

To submit new Fonts
ACME FONTS
4 Regent House
109–111 Britannia Wolk
London N1 7ND
T +44 (0)207 490 7877
F +44 (0)207 490 8442
E acmefonts@chkdesign.demon.co.uk
http://www.acmefonts.net

To order ACME FONTS
Fontworks UK Ltd.
T +44 (0)207 490 5390
T +44 (0)207 490 2002
F +44 (0)207 490 5391
E sales@type.co.uk
http://www.type.co.uk

ACME FONTS

newut

ist ein neues schriftsystem, in welchem alle versalien die gleiche höhe wie die x-höhe der minuskeln aufweisen • ausgangspunkt waren unter anderem gedanken, welche ab den zwanziger jahren TSCHICHOLD, BAYER, CASSANDRE, BILL, THOMPSON und FRUTIGER zu ihren sogennanten singel- oder UNIVERSALalphabeten führten. ihre schriften bestanden in der regel aus einem set des lateinischen alphabets, in dem sie für diese gruppe von 26 buchstaben einen mix von versalien und minuskeln verwendeten • mit newut präsentiere ich eine lösung, welche durch das vollständige set aller versalien und minuskeln ein grösseres anwendungspotential bietet als ein reines SINGELalphabet • die einzelnen newut familien haben ein interessantes schriftbild mit einer sehr gleichmässigen grauwirkung. mit dieser schrift kann orthographisch korrekt gearbeitet werden, sie soll aber vor allem zum experimentieren anregen und dazu einladen, mit der deutschen sprache, ihrer gross- und kleinschreibung und der sprache im allgemeinen lustvoll neu umzugehen.

die familien classic, plain und tip

neben der notwendigkeit die auf x-höhe gezeichneten versalien breiter zu halten um gleiche weissraumproportionen wie bei den minuskeln zu haben, stellte sich auch das problem von versalien welche die gleiche, oder eine ähnliche form wie diese aufweisen. je nach präferenz und einsatz ergibt sich die wahl aus einer der drei familien:

newut classic-medium

Aa Bb Cc Dd Ee
Ff Gg Hh Ii Jj
Kk Ll Mm Nn
Oo Pp Qq Rr Ss
Tt Uu Vv Ww
Xx Yy Zz ŒŒ
ÆÆ &et 12345

newut plain-medium

Aa Bb Cc Dd Ee
Ff Gg Hh Ii Jj
Kk Ll Mm Nn
Oo Pp Qq Rr Ss
Tt Uu Vv Ww
Xx Yy Zz ŒŒ
ÆÆ &et 12345

newut tip-medium

Aa Bb Cc Dd Ee
Ff Gg Hh Ii Jj
Kk Ll Mm Nn
Oo Pp Qq Rr Ss
Tt Uu Vv Ww
Xx Yy Zz ŒŒ
ÆÆ &et 12345

die schnitte Light-Medium-Heavy

jede familie liegt in den drei schnitten Light-Medium-Heavy vor. der schriftstärkenunterschied zwischen Light-Medium und Medium-Heavy ist so angelegt, dass man auch zwischen diesen paarkombinationen auszeichnungsmässig arbeiten kann.

newut classic-Light

als man ray 1921 nach paris kam, war er folgedessen kein grünschnabel. er geriet in die herde der revolutionäre, zu den dadaisten. «ich zeigte ihnen einige meiner arbeiten und sie fanden, diese seien genau von der art, fur die sie kämpften.» in seinem gepäck muss sich die photographie von auf einem tisch geleerten aschenbecher abfall befunden haben; jedenfalls montierte er nun diese noch in new york entstandenen inkunabel dadaistischer zufallsaesthetik mit einem ausschnitt des stadtplans von paris, mit dem er sich in den ersten wochen orientierte. beide teile auf ein gezeichnetes schachbrett geklebt und so die erinnerung an buchamp wachhaltend, verknupfte er sie mit dem wort «TRANSATLANTIQUE» (1920/21). ein symbol seiner lebenssituation, ein paradigmatisches werk aber auch fur seinen undogmatischen spielerischen umgang mit medien wie die transformation biographischer elemente in die damalige kunstwelt.

newut classic-medium

als man ray 1921 nach paris kam, war er folgedessen kein grünschnabel. er geriet in die herde der revolutionäre, zu den dadaisten. «ich zeigte ihnen einige meiner arbeiten und sie fanden, diese seien genau von der art, für die sie kämpften.» in seinem gepäck muss sich die photographie von auf einem tisch geleerten aschenbecher abfall befunden haben; jedenfalls montierte er nun diese noch in new york entstandenen inkunabel dadaistischer zufallsaesthetik mit einem ausschnitt des stadtplans von paris, mit dem er sich in den ersten wochen orientierte. beide teile auf ein gezeichnetes schachbrett geklebt und so die erinnerung an buchamp wachhaltend, verknüpfte er sie mit dem wort «TRANSATLANTIQUE» (1920/21). ein symbol seiner lebenssituation, ein paradigmatisches werk aber auch für seinen undogmatischen spielerischen umgang mit medien wie die transformation biographischer elemente in die damalige kunstwelt.

newut classic-Heavy

als man ray 1921 nach paris kam, war er folgedessen kein grünschnabel. er geriet in die herde der revolutionäre, zu den dadaisten. «ich zeigte ihnen einige meiner arbeiten und sie fanden, diese seien genau von der art, für die sie kämpften.» in seinem gepäck muss sich die photographie von auf einem tisch geleerten aschenbecher abfall befunden haben; jedenfalls montierte er nun diese noch in new york entstandenen inkunabel dadaistischer zufallsaesthetik mit einem ausschnitt des stadtplans von paris, mit dem er sich in den ersten wochen orientierte. beide teile auf ein gezeichnetes schachbrett geklebt und so die erinnerung an buchamp wachhaltend, verknüpfte er sie mit dem wort «TRANSATLANTIQUE» (1920/21). ein symbol seiner lebenssituation, ein paradigmatisches werk aber auch für seinen undogmatischen spielerischen umgang mit medien wie die transformation biographischer elemente in die damalige kunstwelt.

das zeichenset

der newut entspricht in allen varianten und schnitten dem vollständigen postscript standardset, sowie einigen ihr eigenen spezialzeichen.

abcdefghijklmnopqrstuvwxyzABCDEFGHIJKLMNOPQRSTUVWXYZ
1234567890 ¼ ⅓ ⅔ ¾ % ‰ /.,:;-–—.'' ,"" „<>«»*/?!¿¡()[]{}†‡§¶¥€¥£ƒ¢$
flfißæÆœŒøØ&et&áâàäãåçéêèëíîìïñóôòöõúûùüÿÁÂÀÄÃÅÇÉÊÈËÍÎÌÏ
ÑÓÔÒÖÕÚÛÙÜŸ©®™@•…#ªº+–=≠±µ|❶↖↗↙↘←→

Designer/art director André Baldinger
Design company amb+ Conception Visuelle
Country of origin Switzerland
Work description Printed sample sheet of the Newut typeface (above) and promotional poster for the font (right), silkscreened in yellow and black.
Dimensions
Sample sheet 11 x 16 ½ in; 280 x 420 mm
Poster 35 ½ x 50 ½ in; 900 x 1280 mm

New

universal

Typeface

A typeface to experiment and explore written language in a new sexy way

Newut is a new grotesque which has all capitals designed to be the same height as the lowercase.

It comes in three weights, *Light*, Medium, **Heavy** and you can choose from three variationes classic, Plain or Tip.

Newut is available directly from **amb+**™. For more information contact us at info@ambplus.com or visit www.ambplus.com

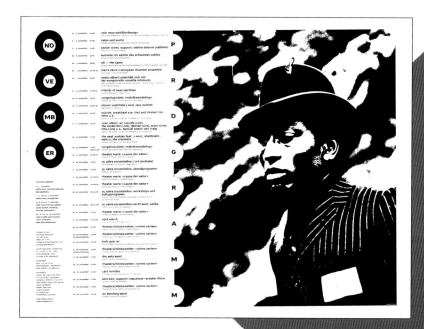

Designer/art director André Baldinger

Design company amb+ Conception Visuelle

Country of origin Switzerland

Client Rote Fabrik ('Red Factory')
Cultural Center

Work description Monthly program
and newsletter for cultural center.

Dimensions 12 ½ x 19 in; 320 x 480 mm

T
L
R
O

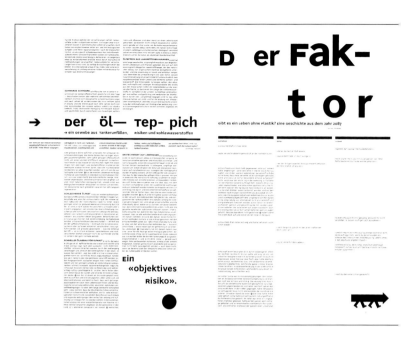

D er **Fak-
t o r**

gibt es ein Leben ohne Plastik? eine geschichte aus dem jahr 2087

→ **Der öl— tep- pich**
→ ein gewebe aus tankerunfällen, risiken und kohlewasserstoffen

ein
«objektives
risiko».

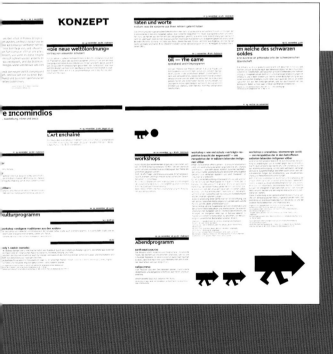

KONZEPT

«die neue weltolordnung»
vortrag von alexander schubert

e incomindios
– ausstellung, küche und disco

L'art enchainé

kulturprogramm

workshops

taten und worte
nichum was bei sorgenne aus ihren reihen gelernt haben

oil — the game
spielabend und mitspragramm

im Reiche des schwarzen
goldes
– ein eurakeise an orthonale orte der schweizerischen
glanschaft

workshops

Abendprogramm

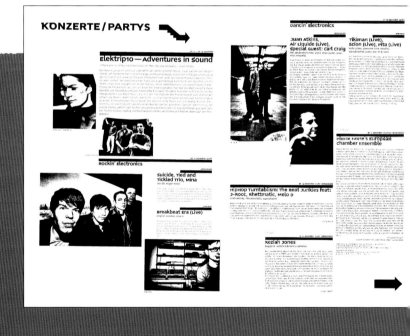

KONZERTE / PARTYS

elektrip10 — Adventures in sound

rockin' electronics

dancin' electronics

Juan Atkins,
Air Liquide (Live),
Special Guest: Carl Craig

Tikiman (Live),
Scion (Live), Pita (Live)

suicide, Tied and
Tickled Trio, Mina

breakbeat Era (Live)

Keziah Jones

HipHop Turntablism: the beat Junkies feat:
J-Rocc, Rhettmatic, Melo D

chamber ensemble

(NO.)

1

SETH AFFOUMADO
PHOTOGRAPHER

T. 415 . 731 . 7300

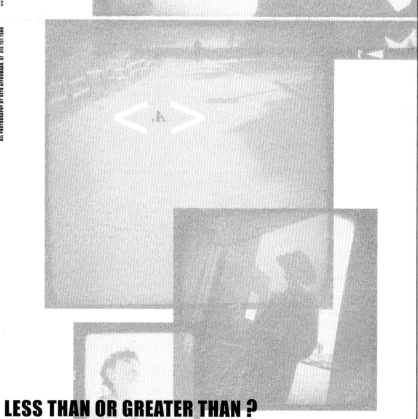

< *A.* >

< *A.* >

LESS THAN OR GREATER THAN ?

The value of any given moment is the synthesis of one's thoughts and images.
This process is unconscious. By compiling stills of information, no matter how
great or small, your very own history is defined.

The value of any given moment is the synthesis of one's thoughts and images.
This process is unconscious. By compiling stills of information, no matter how
great or small, your very own history is defined.

STILLS :

SETH AFFOUMADO
PHOTOGRAPHER

T. 415. 731. 7300

POINTS OF REFERENCE.

Lines drawn between one point and another are significant in themselves. These lines become suggestions for the senses to experience. Segments of these lines may represent a (still) moment of that personal experience.

www.planetpoint.com/seth_affoumado

DESIGN: TOM SIEU, 6° DESIGN, SF. 415 621 0444

Designer Tom Sieu

Art directors Tom & John

Design company Tom & John:
a design collaborative

Country of origin USA

Client Carson Vasquez

Work description Cards for photographic
studio printed on translucent stock
(two variants). Shown unfolded (left)
and folded (above).

Dimensions 8 x 19 in; 200 x 482 mm

$$\text{C P M} \quad *$$

Das Vermögen

Designer/art director Guido Schneider

Illustrator Guido Schneider

Copywriter Christian Schlosser

Design company godz

Country of origin Germany

Client CPM

Work description Corporate brochure
for financial planning company.

Dimensions 8 x 10 in; 200 x 250 mm

Das

Die Er

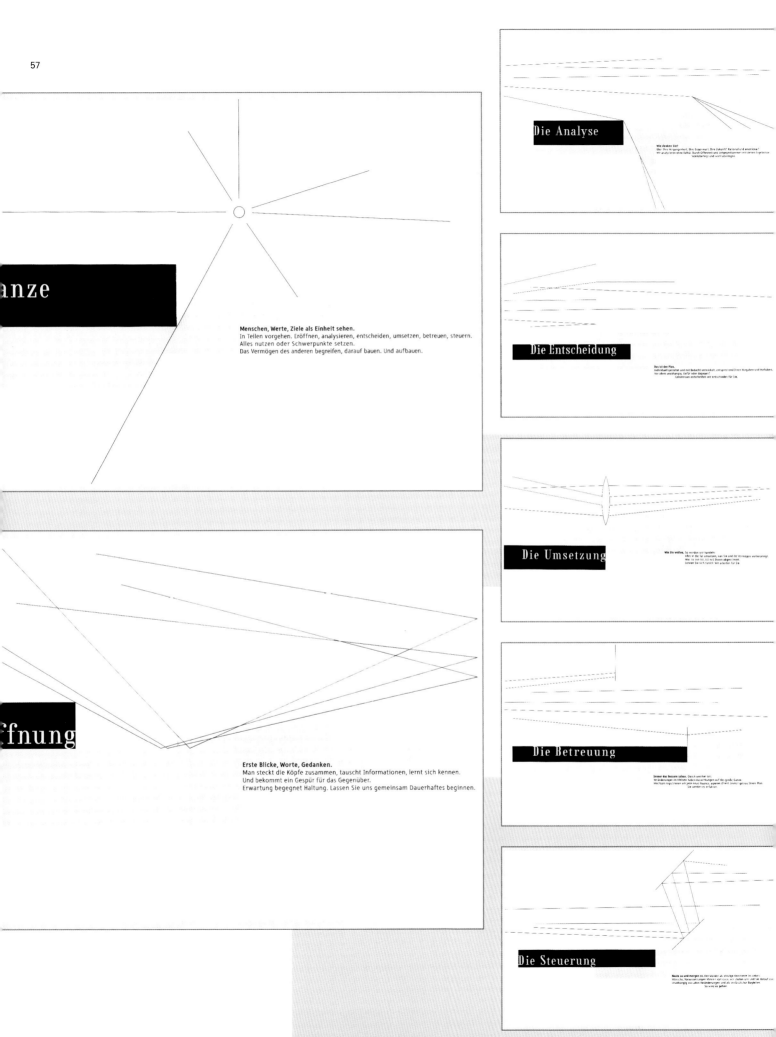

anze

Menschen, Werte, Ziele als Einheit sehen.
In Teilen vorgehen. Eröffnen, analysieren, entscheiden, umsetzen, betreuen, steuern.
Alles nutzen oder Schwerpunkte setzen.
Das Vermögen des anderen begreifen, darauf bauen. Und aufbauen.

fnung

Erste Blicke, Worte, Gedanken.
Man steckt die Köpfe zusammen, tauscht Informationen, lernt sich kennen.
Und bekommt ein Gespür für das Gegenüber.
Erwartung begegnet Haltung. Lassen Sie uns gemeinsam Dauerhaftes beginnen.

Die Analyse

Die Entscheidung

Die Umsetzung

Die Betreuung

Die Steuerung

Face: AK
Design: Form®

éĉіĉıĉAK

ABCDEFGHIJKLM
NOPQRSTUUWXYZ
0123456789!ŒŒ$
&*[]_-=:;""""<>?/\

Designers Paul West, Paula Benson, and John Siddle

Design company Form

Country of origin UK

Work description Typeface design of two fonts – AK (above)
and Peg (right). The latter was made by greatly enlarging
a tiff image of 6 point type.

Dimensions Electronic format

Face: PEG
Design: Form®

i cant read this typeface

ABCDEFGHIJKLMNOPQRSTUVWXYZ
abcdefghijklmnopqrstuvwxyz
0123456789()_-;""&?/.

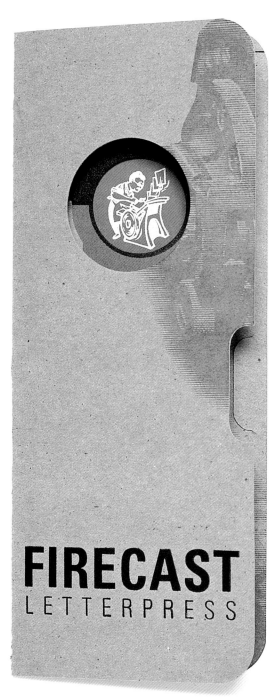

FIRECAST
L E T T E R P R E S S

version.1
graphic series

(rhythm)

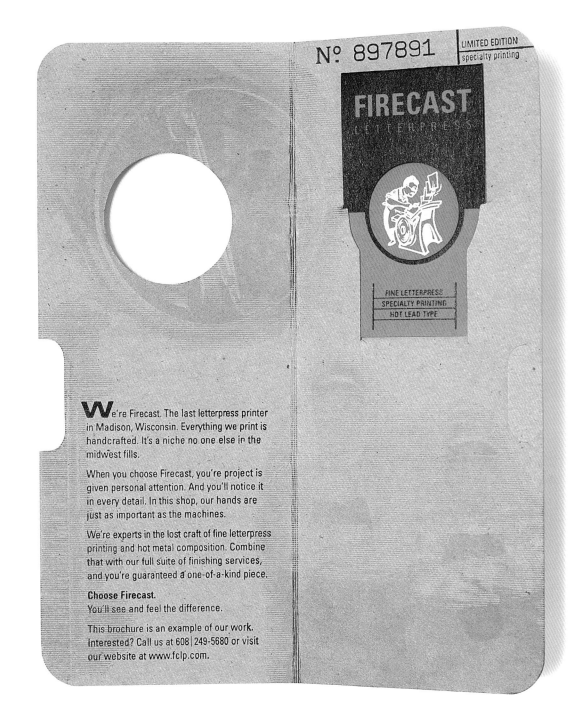

Nº 897891

LIMITED EDITION
specialty printing

FIRECAST
LETTERPRESS

FINE LETTERPRESS
SPECIALTY PRINTING
HOT LEAD TYPE

We're Firecast. The last letterpress printer in Madison, Wisconsin. Everything we print is handcrafted. It's a niche no one else in the midwest fills.

When you choose Firecast, you're project is given personal attention. And you'll notice it in every detail. In this shop, our hands are just as important as the machines.

We're experts in the lost craft of fine letterpress printing and hot metal composition. Combine that with our full suite of finishing services, and you're guaranteed a one-of-a-kind piece.

Choose Firecast.
You'll see and feel the difference.

This brochure is an example of our work. Interested? Call us at 608 | 249-5680 or visit our website at www.fclp.com.

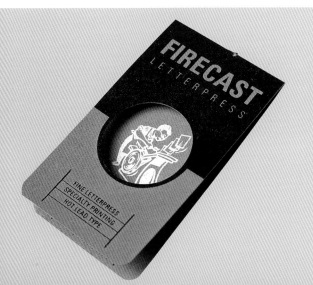

Designer/art director Corey Szopinski

Illustrator Dave Brickert

Photographer Eric Tadsen

Design company Carbon Design

Country of origin USA

Work description Brochure and card promoting the print works Firecast Letterpress. Through the use of scoring, die cutting, numbering, and crash printing, the items highlight the versatility of the letterpress process and demonstrate the tactile qualities that distinguish letterpress from offset print.

Dimensions Brochure (folded): 3 ½ x 8 ½ in; 88 x 217 mm
Card 4 x 6 in; 102 x 153 mm

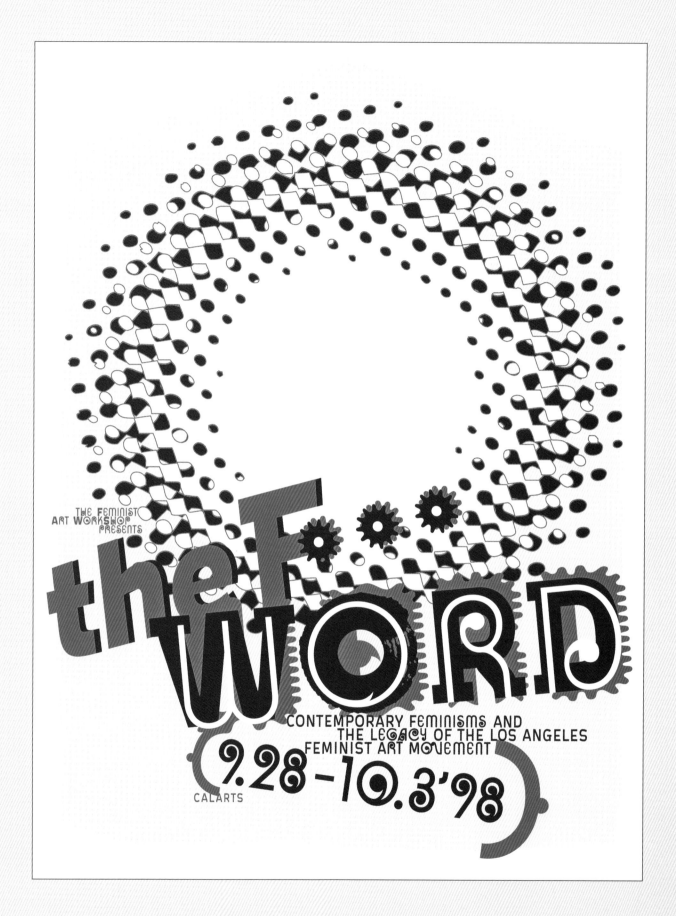

Section one: type and image

THE FEMINIST ART WORKSHOP (FAWS)
CalArts - Critical Studies
24700 McBean Parkway
Valencia, California, 91355
http://www.calarts.edu/~thefword
Phone: (805) 255.1060

SCHEDULE OF EVENTS

September 28 – October 3rd:
READING ROOM & EXHIBITION
9 am – 6 pm (All Galleries)
Thursday, October 1st:
VIDEO SCREENINGS
7 pm – 9 pm (Room F200)
Exhibition RECEPTION & Readings
9 pm – 11 pm (All Galleries)
Friday, October 2nd:
RECEPTION and DINNER
6 pm (Cafe)
Saturday, October 3rd:
WORKING SYMPOSIUM
9 am – 6 pm (CalArts)

THE F WORD

CalArts' groundbreaking feminist art programs of the early 1970s are at the center of the dynamic history of feminist art education.

A group of CalArts students, alumni and faculty have come together as the Feminist Art WorkShop (FAWS) which has grown to include participants from other Southern California arts institutions.

FAWS has engaged in a series of discussions and workshops regarding the feminist programs that took place at CalArts in the Seventies.

To better establish their legacy and to foster understanding of contemporary feminisms, FAWS seeks to create a dialogue between the different generations associated with feminist practice.

The F-WORD: Contemporary Feminisms and the Legacy of the Los Angeles Feminist Art Movement is a week of events culminating with a working symposium on Saturday, October 3rd.

The symposium includes original participants of WOMANHOUSE, the CalArts Feminist Art Program and the Women's Design Program, along with Los Angeles artists, writers and curators.

READING ROOM

Feminist texts, feminist-influenced texts, artists books, original texts from the CalArts Feminist Art Program. FAWS is creating a bibliography based on recommendations and reviews of specific sources which have individually influenced our understanding of feminism.
Daily video screenings.

EXHIBITION

The F WORD – An exhibition of California-based artists influenced by feminism. Artists are: Danielle Abrams; Theresa Brown; Patty Davidson; Verónica Duarte; Meghan Guthrie; Liz Harvey; Micol Hebron; Ruth Katz; Lori Kaufman; Lun*nah Menoh; Maggie Miller; Ivan Montefiore; Sandeep Mukherjee; L. Jane Tsong.

VIDEO SCREENINGS

Videos from the Woman's Building Performance and documentary works from the 1970s, produced by the Feminist Art Program and the Woman's Building. Curated by Nancy Buchanan.
Guest Speaker: Annette Hunt.

RECEPTION & DINNER

For symposium speakers, members of the Feminist Art Program and the Women's Design Program, and the Feminist Art WorkShop.
Opening Remarks by Janet Sternburg.

The F-WORD: Contemporary Feminisms and the Legacy of the Los Angeles Feminist Art Movement.

Taking the Feminist Art Program and the Women's Design Program as a starting point, this Working Symposium will address feminist art legacies and strategies for the future. Reception to follow.
PARTICIPANTS: Fran Bennett; Kaucyila Brooke; Nancy Buchanan; Theresa Chavez; Leslie Dick; Cheri Gaulke; Amelia Jones; Suzanne Lacey; Simon Leung; Sue Maberry; Beverly O'Neill; Alison Saar; Mira Schor; Mady Schutzman; Faith Wilding.

Music performances by artists from XX 1998: CalArte Women's CD, the first-ever compilation of original works by women student performers produced by students Hillary Maroon and Sandra Valasquez.

WORKING SYMPOSIUM

The PINK BOX, a private self-service video station, will be available to document your responses.

The F-WORD: Contemporary Feminisms and the Legacy of the Los Angeles Feminist Art Movement is funded by the California Institute of the Arts.
Special thanks to Foundation Press, Santa Monica.
Design: Andrea Tinnes.

PARTICIPANTS

FRAN BENNETT: Director of Performance, School of Theater; is an actor and teacher of voice and movement, and has led voice production workshops throughout the USA and in England. She is also a member of Antaeus and the Los Angeles Women's Shakespeare Company.

KAUCYILA BROOKE: Faculty, Photography, School of Art is an artist who produces photo & text narratives for installation and publication. She has exhibited at Camerawork & Eye Gallery (San Francisco), the Museum of Contemporary Photography (Chicago), LACE and LACPS (LA).

NANCY BUCHANAN: Faculty, Live Action, School of Film/Video; began using video as a natural extension to performance and installation. Her artworks have been exhibited and screened worldwide, including MOMA (NY), the New Museum (NY), & Ars Electronica (Austria). She has participated in various artist-run organizations such as LACE, LACPS, and the Woman's Building.

THERESA CHAVEZ: Faculty, Interdisciplinary Projects, School of Music; has written & directed various interdisciplinary and collaborative theater works. She is a founding member & artistic co-director of About Productions, a nonprofit arts organization that produces programs which challenge traditional assumptions about history, cultural identity & gender.

LESLIE DICK: Faculty, School of Art is a writer whose novels include Without Falling (1987) and Kicking (1992). Her work has also appeared in various publications including Semiotext(e) and Interview.

CHERI GAULKE: is an artist who was involved with the Woman's Building for 16 years as student, teacher, building manager, artist in residence, performance curator and board member.

AMELIA JONES: is a writer and curator who is an Associate Professor of Art History at UC Riverside. She organized the exhibition Sexual Politics (Los Angeles), wrote Body Art in Feminist Art History at the Armand Hammer Museum, as well as the related symposium Reconsidering Identity and Representation.

SUZANNE LACEY: is an artist who was part of the original Women's Design Program and developed a performance program at the Woman's Building. Her own work involves large scale public performances with groups of women. Most recently, she was the Dean of Art at the California College of Arts and Crafts.

ANNETTE HUNT: is a writer who directed the Women's Video Center at the Woman's Building and personally archived its video-tape collection for many years.

SIMON LEUNG: is an artist and writer who has produced recent work about the residual space of the Vietnam war, as well as a meditation on Marcel Duchamp. He participated in a 1995 issue of October Magazine devoted to re-evaluating feminist practice.

SUE MABERRY: is the Director of the Library at Otis College of Art and Design, where the Women's Building slide archives are housed. She has been involved with Woman's Building for many years.

BEVERLY O'NEILL: Provost, CalArts; has been Provost since 1986. Trained as an art historian, her fields of interest are contemporary art, film and media studies, & feminist history.

ALISON SAAR: is an artist who has exhibited extensively in the U.S. Her work has been shown in the Whitney Museum (NY), the Museum of Contemporary Art (Chicago), and the Armand Hammer Museum (LA) where she exhibited work alongside her mother, Betye.

MIRA SCHOR: is a painter and writer who was a member of the Feminist Art Program and WOMANHOUSE. Until 1996 she was a co-publisher of M/E/A/N/I/N/G; she is also the author of Wet: On Painting, Feminism and Art Culture. She currently on faculty at the Parsons School of Design.

MADY SCHUTZMAN: Assistant Dean, School of Critical Studies; is a poet, scholar and theater artist. She is the co-editor of Play Boal: Theater, Therapy, Activism, and has published work in The Drama Review, Oxalis, Women and Performance, and Errant Bodies.

JANET STERNBURG: Faculty, Writing, School of Critical Studies; creates work in literature and film/video. She has produced, directed and written award-winning films and television series including Through Her Eyes, a series of women's film art.

FAITH WILDING: is an artist and professor who was a member of the Feminist Art Program and WOMANHOUSE. Most recently she taught at Carnegie-Mellon University in Pittsburgh. She is central to a current cyberfeminist project examining women's use of technology.

DIRECTIONS

California Institute of the Arts
24700 McBean Parkway
Valencia, California, 91355
Take the 5 Freeway. Exit at McBean Parkway.
Head east on McBean.
CalArts is the first driveway on the right.

Designer/art director Andrea Tinnes

Country of origin Germany

Work description Cover and double page spreads
from a self-promotional book.

Dimensions 7 ½ x 10 ½ in; 190 x 270 mm

Previous spread

Designer/art director Andrea Tinnes

Country of origin Germany

Work description Poster announcing a series of
events that explore contemporary feminism,
specifically the legacy of the Los Angeles feminist
art movement.

Dimensions 17 x 22 in; 432 x 559 mm

Modern ornament has no forebears and no descendents, no past and no future. It is joyfully welcomed by uncultivated people to whom the true greatness of our time is a closed book and after a short time is rejected.

Das Kind ist amoralisch. Der papua ist es für uns auch. Der papua schlachtet seine feinde ab und verzehrt sie. Er ist kein verbrecher. Wenn aber der moderne mensch jemanden abschlachtet und verzehrt, so ist er ein verbrecher oder ein degenerierter. Der papua tätowiert seine haut, sein boot, seine ruder, kurz alles, was ihm erreichbar ist. Er ist kein verbrecher. Der moderne mensch, der sich tätowiert, ist ein verbrecher oder ein degenerierter. Es gibt gefängnisse, in denen achtzig prozent der häftlinge tätowierungen aufweisen. Die tätowierten, die nicht in haft sind, sind latente verbrecher oder degenerierte aristokraten. Wenn ein tätowierter in freiheit stirbt, so ist er eben einige jahre, bevor er einen mord verübt hat, gestorben.

DASDECK REGULAR
audio interface design

ABC DASDECK

ABCDEFGHIJKLMNOPQRSTUVWXYZ
abcdefghijklmnopqrstuvwxyz 1234567890
äöüÄÖÜ.,;:=+<·> {([&@®©?!/%#€$£¶§*""«‹›»)]}
»WIR BEFINDEN UNS AUF DEM DECK
und orientieren uns nach den Sternen, den Längen- und Breitengraden, den Windrichtungen und Strömen
der schönen neuen Welt der zeitgenössischen elektronischen Kultur.«

DAS DECK
regular
2000/2001

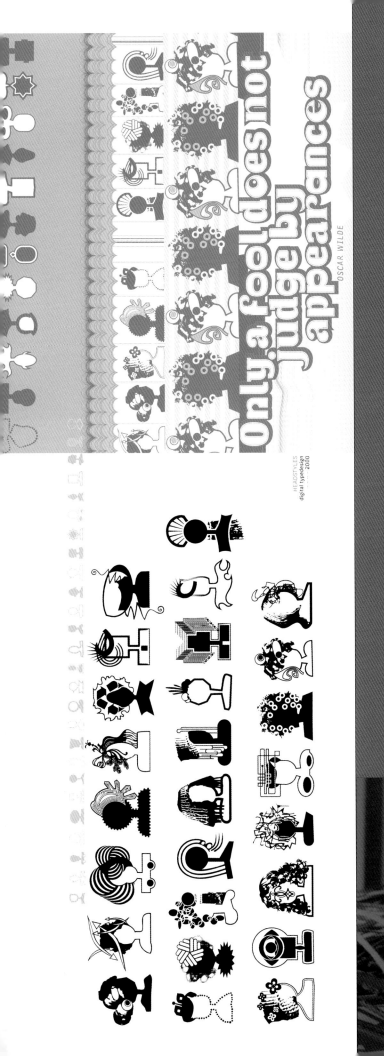

Only a fool does not judge by appearances

OSCAR WILDE

HEADSTYLES
digital typedesign
2000

WORD IMAGERY
exhibition project in the MFA program at CalArts 1997

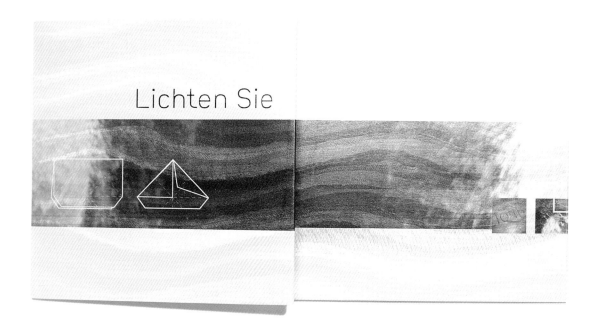

Lichten Sie

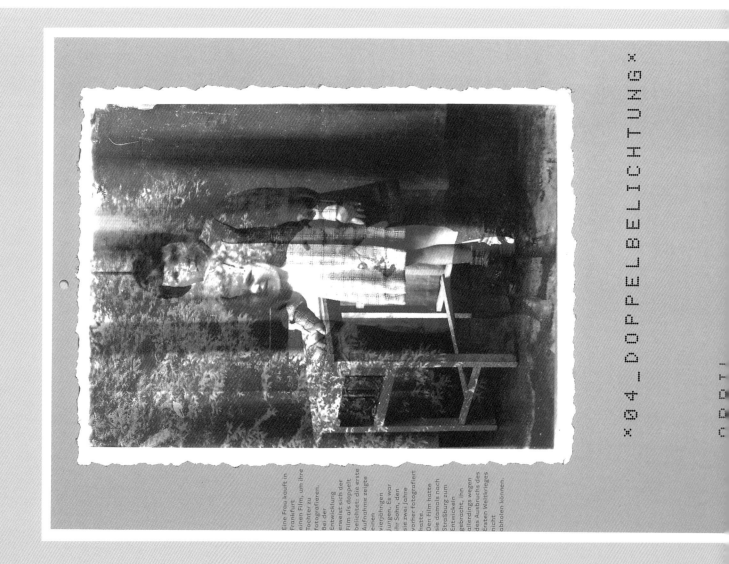

×04_DOPPELBELICHTUNG×

Eine Frau kauft in
Frankfurt
einen Film, um ihre
Tochter zu
fotografieren.
Bei der
Entwicklung
erweist sich der
Film als doppelt
belichtet: die erste
Aufnahme zeigte
einen
vierjährigen
Jungen. Es war
ihr Sohn, den
sie zwei Jahre
vorher fotografiert
hatte.
Den Film hatte
sie damals nach
Straßburg zum
Entwickeln
gebracht, ihn
allerdings wegen
des Ausbruchs des
Ersten Weltkrieges
nicht
abholen können.

Designer/art director Ilja Sallacz

Photographer Bernd Hohlen

Design company Agentur Liquid

Country of origin Germany

Work description Calendar issue of the
quarterly art magazine, Artür (below),
and invitation to the launch of the Liquid
design agency (left and right).

Dimensions Calendar: 8 ¼ x 11 ½ in;
210 x 290 mm
Invitation: 4 x 8 ¼ in; 105 x 210 mm

DIA KOMM

WIR WOLLEN DIESEN RAUM NICHT ALLEIN EINZELNEN FOTOGRAFEN/KÜNSTLERN
VORBEHALTEN, SONDERN AUCH ÜBER DAS WEITE FELD DES FOTOMARKTES INFORMIEREN
UND BERICHTEN. IN DIESER AUSGABE PRÄSENTIEREN WIR STELLVERTRETEND FÜR DIE NEUE
ART DES BILDANGEBOTES DIE INTERNET-AGENTUR „VIVIDIA".
ARTUR HÄLT DIESE ART UND WEISE DER EINBINDUNG DES FOTOGRAFEN FÜR DEN REIN
KOMMERZIELLEN BEREICH DER FOTOGRAFIE FÜR ERWÄHNENSWERT, UM DEN KLEINEN
KREIS VON INSIDERN, DIE MIT FOTOGRAFIE IHR GELD VERDIENEN,
EIN WENIG ZU ERWEITERN.

TEXT: BERND HOHLEN ; FOTOS: VIVIDIA

Zwei wohlbekannte Namen, deren Image nicht unbedingt mit Bildern in Verbindung gebracht wird, haben es, mit erheblichem finanziellem Aufwand, in nur wenigen Jahren geschafft, ein gigantisches Bildarchiv anzuhäufen: Die Firmen CORBIS (Besitzer ist Microsoft-Gründer Bill Gates) und GETTY IMAGES, geführt von Mark Getty, dem Enkel des legendären Ölmilliardärs Paul Getty.

Zusammen stapeln sich mittlerweile 140 Millionen Bilder in ihren Archiven, von denen zur Zeit lediglich 5 Millionen online angeboten werden. Zu den Aufkäufen gehörten nicht nur die Archive bekannter Agenturen wie TEMPSPORT (größtes Sportarchiv der Welt), SYGMA, IMAGE BANK oder PHOTODISC, sondern auch hochkarätiges, wie die Bildrechte an der Londoner Nationalgalerie, der Peters-

burger Heremitage oder das Kunstmuseum Philadelphia, ferner bekannte Bilder wie Einstein mit herausgestreckter Zunge, die Explosion der Challenger Rakete oder Da Vincis Körperskizzen, um nur einige zu nennen. Es ist nur eine Frage der Zeit, bis diese Bilderflut Online angeboten wird. Der Haken an der Sache: es gibt (noch) weder ein anwenderfreundliches Navigationssystem noch einen übersichtlichen

Katalog, ohne den der Online-Kunde in diesem unglaublich großem visuellen Ozean untergehen würde wie die Titanic auf ihrer Jungfernfahrt. Diese starke Monopolisierung dürfte ohnehin zu einem drastischen Preisdiktat führen und so manchen Anbieter in Deutschland das Fürchten lehren. So erschreckend diese auch anmutet, so hat sie den bisher so trägen kommerziellen Bildermarkt doch mächtig

Designer/art director Ilja Sallacz

Photographers Bernd Hohlen and Daniel Fuchs

Design company Agentur Liquid

Country of origin Germany

Work description Quarterly art magazine, Artür.

Dimensions 8 1/4 x 11 1/2 in; 210 x 290 mm

In a similar way, the old noises provided a point and produced the level of design the Attik wanted to communicate at that moment in time - NOISE 4 is approached in the same way. Containing our values, process, business models, ideas, direction content and visual messaging that explains the Attik's unique brand through research and development, integration, convergence and repositioning of a visual and global expression.

NOISE 4 is a hybrid blend and global collaboration of strategic thinkers, consultants, visionaries artists, business, education, facilitators, troubleshooters, graphic and non-graphic designers advertising executives, media planners, PR gurus?-the whole shooting match-from every corner of the world! It is a collation of ideas and concepts that have never been expressed before within an intellectual property. The green light mentality that is required in NOISE 4 focuses on how five words will inter- cross in everyone's life throughout the world in the future......

MANI. [FESTO]
OF
INTENT

Communication
Commerce
Technology
People
Transport

Developing a creative vision of our world then implemented in whatever production or media form it takes...a book...a DVD ...a film...or all the above? These subjects would be the seed to explore the potential interaction connection and relevance of how these topics thread together. They would be tackled as if they are true business ideas.

How does air travel develop from this point? What would be the situation if we could bring Boeing, British Airways, AT&T and Apple together? Unfettered by today's conventions or held back by industrial stereotype we can tackle the ideas with an un- restricted approach. Within each topic, ideas and specific subsections would be investigated.

How does technology affect commerce? How are lifestyles affected by converging media? Who cares? What is the alternative to currency? What products? Human- ware versus hardware. Religion, fashion, passion etc. In the years to come all these subjects will overlap and influence each other forming a complete picture of future events whether we like it or not. Noise 4 is here to visualise this convergence before and whilst it is happening. The picture is complete.

with
bu
be
sa
un
int
co
sp
Hi
no
codes are indecipherable to un-educated receivers, but allow a computer language to exist, using only minimal letter combinations, acronyms and abbreviations. This is creating an increasingly virtual world, where our everyday realities are dependent upon these indecipherable codes + abbreviated messages

1.COMMU_

(NICATION

TE^OI(AD. B) S+W_1

KEY

(TE^O)	THE EXCHANGE OF	(^T)	TECHN
(I)	INFORMATION	(RT)	REMOV
(AD.B)	AS DEFINED BY	(ENO)	EXPRES
S+W)	SHANNON+WEAVER	(HL)	HUMAN
(IP/B)	IS PERFORMED BY	(S)	SENTE
(VV)	VISUAL OR VERBAL	(CO)	CONSI
(N-B)	NOISE BETWEEN	(NP)	NOUN
(T+R)	TRANSMITTER+RECEIVER	(N)	NOUNS
(BT)	BUT THESE	(V)	VERBS
(SC★)	SIGNAL CHARACTERISTICS	(ABD)	ARE B
(AB)	ARE BEING	(NR)	NECCE
(IB)	IMPEDED BY	RB)	REPLA
		(IP)	IRRELE
		(C)	AND C

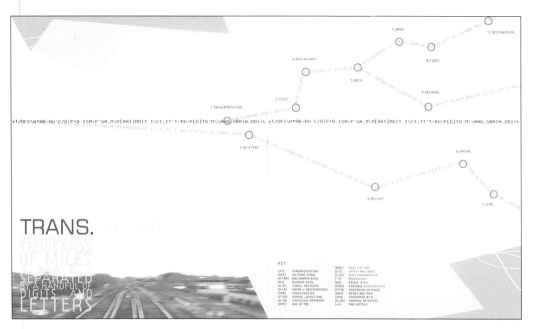

Designer Richard Tucker

Art director Mike Ryan

Design college
Surrey Institute of Art

Country of origin UK

Client Noise 4

Work description Double page
spreads for inclusion in the
'Noise 4' publication. The
work illustrates the future
interaction of five concepts:
communication, people,
transport, technology.
and commerce.

Dimensions 7 x 12 1/4 in;
180 x 310 mm

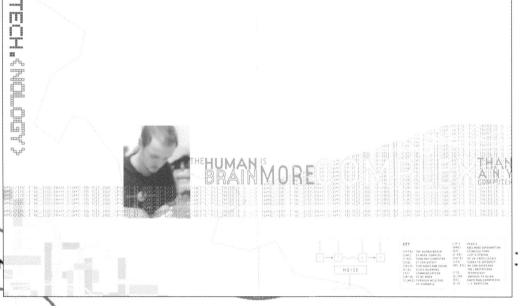

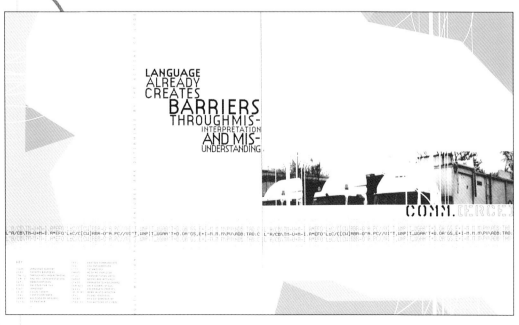

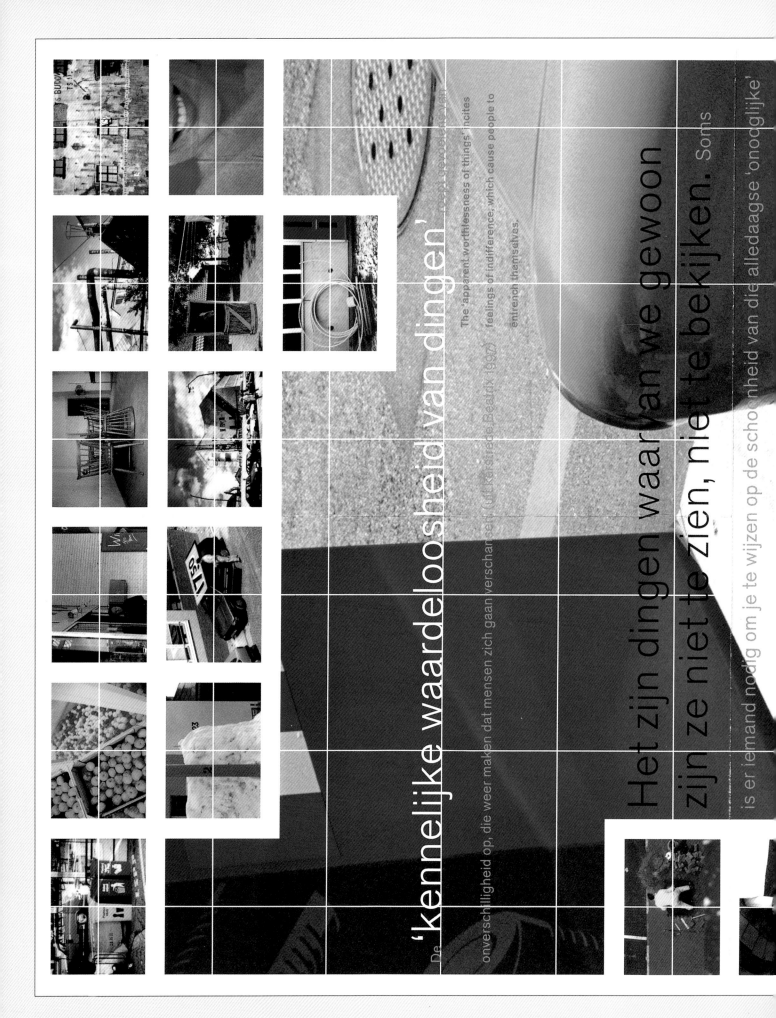

'kennelijke waardeloosheid van dingen'

De … onverschilligheid op, die weer maken dat mensen zich gaan verschansen (uit Kersttoespraak Beatrix 1997)

The 'apparent worthlessness of things' incites feelings of indifference, which cause people to entrench themselves.

Het zijn dingen waarvan we gewoon zijn ze niet te zien, niet te bekijken. Soms is er iemand nodig om je te wijzen op de schoonheid van die alledaagse 'onoogilijke'

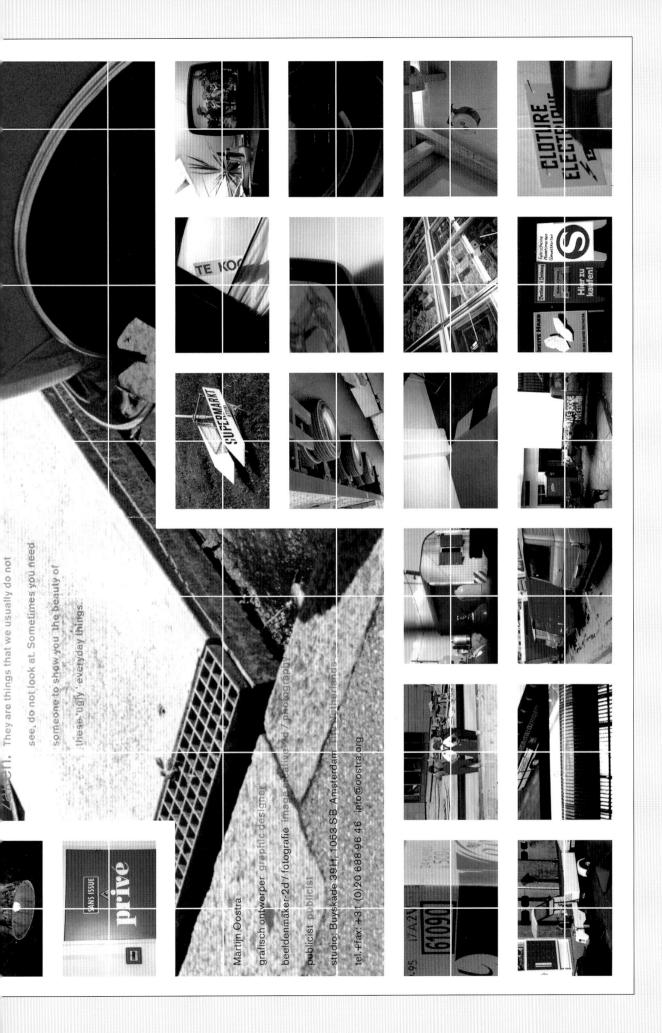

zien. They are things that we usually do not
see, do not look at. Sometimes you need
someone to show you the beauty of
these 'ugly' everyday things.

Martijn Oostra

grafisch ontwerper graphic designer

beeldenmaker 2d / fotografie image creative ad / photography

publicist publicist

studio: Buyskade 39H 1053 SB Amsterdam the netherlands

tel. +fax: +31 (0) 20 688 96 46 info@oostra.org

Previous spread

Designer/art director Martijn Oostra

Photographer Martijn Oostra

Design company Martijn Oostra

Country of origin The Netherlands

Client Self-promotion

Work description Poster/flyer for Martijn Oostra design and photography.

Dimensions 11 ¹/₄ x 16 ³/₄ in; 285 x 426 mm

Designer Rik Bas Backer and Martijn Oostra

Design company Martijn Oostra

Country of origin The Netherlands

Work description Design of retail outlet in Biarritz, France. Font adapted
from EricsSome by Martijn Oostra.

Dimensions Shop frontage

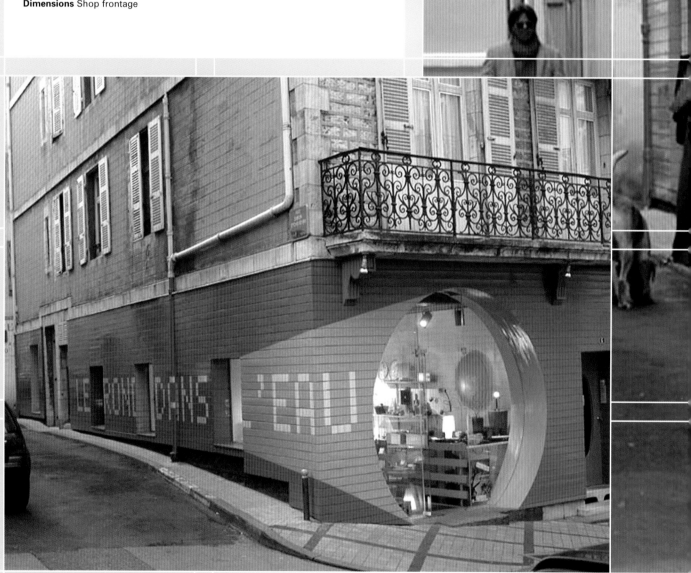

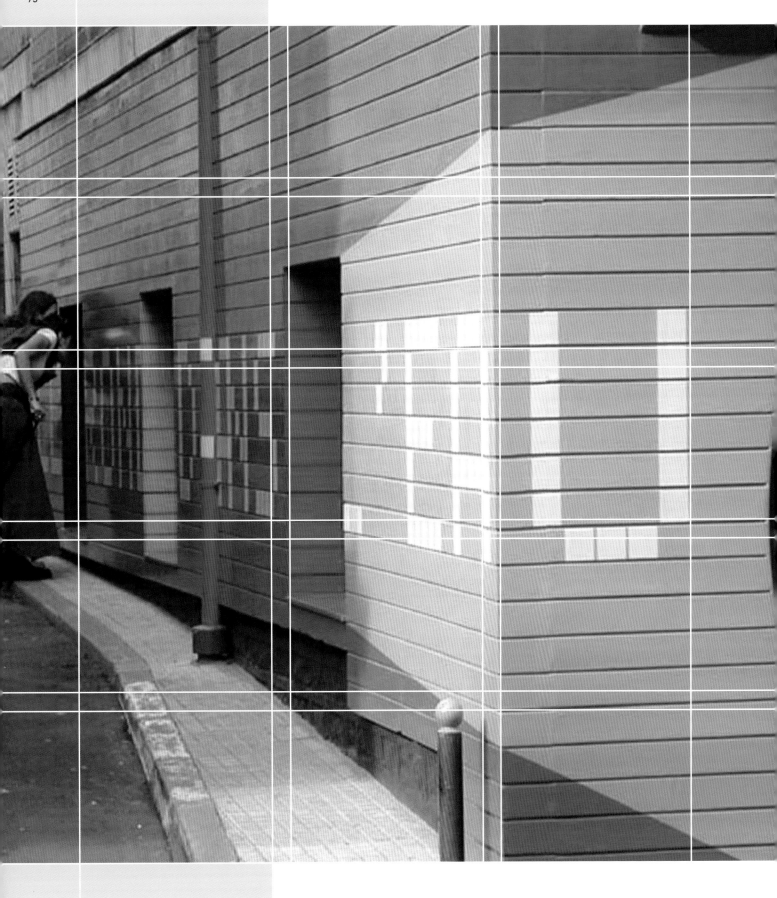

AaÁÀÂÃÄÅaaaaBBBBBB
CÇCCDDDDEEEÉÉEEEE
FFFFFFFFGGGGGG
HHHHHHHHÍÍÎÍÍjiIJJJjjjj
KKKKKKKKLLLLŁLLLL
MMMMMMMMMMmmm
NNÑNnOOOØÖooooo
PPPPPpPQQQQQQ
RRRRRRRRŚßßŠŠSSS
TTTTtttttUUUÜŮU
VVWWWwwXXXx
YYYYŸYYyyZŽŽZz
1234556788900
1231⁄21⁄43⁄4

ÆÆÆŒŒŒ
FJFJFLFLFFLELLLLLbb
ThThTTThTTctctapĐ
£ƒ£$$¢¢¥ƒ ₣@™®©-{}[[
¶¶¶¡!?‡‡§*%÷=+/|;:.,...◊◊

"CONCEIVE
D WITH PASSION BY UN
KNOWN ARTISTS, & CO
NSUMED· IN IMAGE IF
NOT IN USAGE BY A W
HOLE POPULATION WH
ICH APPROPRIATE
S THEM AS A PUR
ELY MAGICAL OBJECT."

*some key strokes contain
pre-designed ligatures.*

*diamond finials can be attached
to either side of a character*

*the monastic scribes twisted and
stretched their illuminated letters into
graphic forms of almost infinite variety*

*superior letters
are contained in
Alchemy Silver High*

*a linking bar joins characters
and continues the line of the
diamond finials.*

*inferior letters
are contained in
Alchemy Silver Low*

*many bizarre symbol alphabets were
developed during the Middle Ages*

*Plug-in characters allow for the
creation of a multitude of ligatures*

The Populist interpretation of the Middle Ages is one of magic and mystery. Many bizarre symbol alphabets were developed during this period; from the simplicity of Runes to the very strange Celestial, Alchemical and Slavic alphabets. Elements from these forms have been recreated with those from the Manuscripts resulting in the graphic forms of Alchemy.

The Manuscripts of the Middle Ages contain a rich diversity and ingenious use of capital lettering. During this period the monastic scribes twisted and stretched their illuminated letters into graphic forms of almost infinite variety. Many of the letter forms of the Alchemy typeface have been derived from the decorated pages of the Lindisfarne Gospels [around 689ᴀᴅ], which contain Anglo-Saxon capitals that have several alternative forms and appear freely mixed-together to enhance a word's shape.

Alchemy™ is an extended alphabet that consists of four typefaces which include all the standard ISO/Adobe characters. The range of alternative characters available depends on the software and hardware platform being used. The types are available for the Macintosh computer and include the new Euro Currency Symbol €.

Jeremy Tankard | Typography
www.typography.net

A menagerie of letters and
ligatures to create detailed
and varied word shapes in
a modern gothic style

after Roland Barthes, Mythologies [1957] 'Le Nouvelle Citroën'

The four faces of Alchemy

ALCHEMY GOLD 24
ALCHEMY GOLD 18
SILVER HIGH
SILVER LOW

Alchemy is defined as 'seeking to turn base metals into gold or silver'. This idea has been retained in the naming of the Alchemy types with Gold 24 and Gold 18 containing the main letter forms and Silver High and Silver Low containing superior and inferior letter positions. All key strokes contain a character, some of which are pre-designed ligatures, others have the ability to 'plug-in' to other characters to create new ligatures. There is also a linking bar and diamond finials that can be attached to either side of a letter form.

ALCHEMY

WITH COMPLIMENTS

Jeremy Tankard | Typography
122 Canalot Studios
222 Kensal Road
London W10 5BN

T +44 (0)20 8964 0985
F +44 (0)20 8969 2420

E jtankard@typography.net
www.typography.net

Date 21 February 2001

Order 18962

Job

To Accounts
 AB & Co.
 123 Abe Street
 London
 W1V 3GT

Jeremy Tankard | Typography
122 Canalot Studios
222 Kensal Road
London W10 5BN

T +44 (0)20 8964 0985
F +44 (0)20 8969 2420

E jtankard@typography.net
www.typography.net

invoice

INVOICE FOR FONTS

Invoice number **01/956**

FONTS		LICENCE
Bliss Light	Mac PS1	1-5 CPUs
Bliss Light Italic	Mac PS1	
Bliss Bold	Mac PS1	
Bliss Bold Italic	Mac PS1	

TOTAL COST

For the fonts listed with licence

Cost	£100.00
VAT at 17.5%	£17.50
Total	**£117.50**

Paid by Visa

VAT number GB 762 561 436

122 Canalot Studios · 222 Kensal Road · LONDON W10 5BN
Telephone +44 (0)181 964 0985
Mobile +44 (0)411 589 083
Facsimile +44 (0)181 969 2420
jtankard@typography.demon.co.uk
www.typography.net

Jeremy Tankard | Typography

...anything type related

Jeremy Tankard | Typography

Telephone +44 (0)181 964 0985
Mobile +44 (0)411 589 083
Facsimile +44 (0)181 969 2420
jtankard@typography.demon.co.uk & www.typography.net
122 Canalot Studios · 222 Kensal Road · LONDON W10 5BN

...anything type related

Jeremy Tankard | Typography

Telephone +44 (0)181 964 0985
Mobile +44 (0)411 589 083
Facsimile +44 (0)181 969 2420
jtankard@typography.demon.co.uk & www.typography.net
122 Canalot Studios · 222 Kensal Road · LONDON W10 5BN

...anything type related

122 Canalot Studios · 222 Kensal Road · LONDON W10 5BN
Telephone +44 (0)181 964 0985
Mobile +44 (0)411 589 083
Facsimile +44 (0)181 969 2420
jtankard@typography.demon.co.uk
www.typography.net

Jeremy Tankard | Typography

...anything type related

Jeremy Tankard | Typography

122 Canalot Studios · 222 Kensal Road · LONDON W10 5BN
Telephone +44 (0)181 964 0985
Mobile +44 (0)411 589 083
Facsimile +44 (0)181 969 2420
jtankard@typography.demon.co.uk
www.typography.net

la ngu age i savi rus

...anything type related

¶ THE LETTER FORMS OF THE SHIRES CHANGE STYLE AS YOU MOVE AROUND THEM AND, LIKE PEOPLE, ARE NOT tied TO ANY ONE PLACE BUT CAN TRAVEL freely FROM SHiRE TO SHiRE AND mix WITH THEIR neighbours.

As the Industrial Revolution gained momentum in the nineteenth century, a need for a strong, brash and aggressive letter form was created. The letter had to shout its presence above that of the well spoken Roman. The resulting letter was not crude and ugly, as often claimed, but exerted new beauty through its proportions and austere authority.

Köln
VRÅ
øster
TRéS
æsthetic
œdipus

There are no ascenders or descenders in The Shire Types, accented characters shrink to fit the general character height and capital letters mix happily with their less stately comrades; it is a classless and caseless system. The resulting word shapes from this linguistic interaction can be very interesting and acceptable, all being hybrids of a familiar face.

AAAaaaa

Derbyshire | Staffordshire | Cheshire | Shropshire | Warwickshire | Worcestershire

Inspiration for the basic shapes came from the Grotesque and Egyptian lettering styles of the Industrial Revolution. The intent was not to pastiche but to revitalise these forms, which in turn have been blended with a variety of interpretations of the shires; including position, industry, dialect, history and countryside.

¶ the shires ARE THE MIDLAND COUNTIES OF ENGLAND.

DERBYSHIRE
STAFFORDSHIRE
CHESHIRE
SHROPSHIRE
warwickshire
worcestershire

The typefaces take their names from six of the shires that are grouped together around the Black Country and the neighbouring rural areas.

as the industrial revolution gained momentum in the nineteenth century, a need for a strong, brash and aggressive letter form was created. the letter had to shout its presence above that of the well spoken roman. the resulting letter was not crude and ugly, as often claimed, but exerted a new beauty through its proportions and austere authority.

¶ABCDDÐEFGHIJKLŁM NOPQRSTUVWXYZÞ FIFL1234567890 ½ ¼ ¾ & ÅÄÇÉÍÑÕØÙÝŸÆŒ A O ™ # % § ! ? ¤ £ € $ ¢ ¥ ƒ ® © @ ", . ¶ABCDEFG HIJKLŁMNOPQRSTU VWXYZÞFIFL123456 7890 ¾ ¼ ÅÅÉÍÑÙ Æ Œ A ™ ", . ¶abcdefghi jklłmnopqrstuvw xyzfiflßß12345678 90 & áäåéíñúÿ æ œ a™ @ ", . ¶ABCDEFGHIJK LŁMNOPQRSTUVWX YZFiFl1234567890 ½ áäåéíñúÿ æ œ a™£ ", . ¶abcdefghijkłł mnopqrstuvwxyz fifißß1234567890 ½ ¼ ¾ & áäåéíñúÿ æ œ a tm!?£@", . ¶ABCDEFG HIJKLŁMNOPQRSTU VWXYZFiFlß1234S6 7890½¼áäåéíñúÿœ œa™?£",.—+)]]¹²³•

Derbyshire | Staffordshire | Cheshire | Shropshire | Warwickshire | Worcestershire

The Shire Types™ consist of six typefaces that include all the standard ISO/Adobe characters. The range of characters available depends on the software and hardware platform being used. The types are available for Mac and PC and include the new Euro Currency Symbol €.

Jeremy Tankard | Typography
www.typography.net

Six typefaces designed to create a dense textural mass of lettering

fontworks

THE SHire TYPES

0171 490 5390

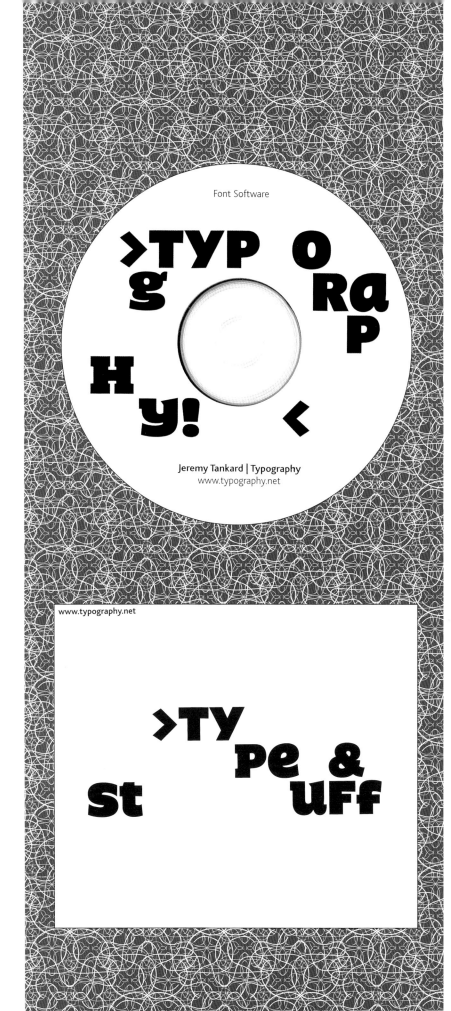

Previous spread

Designer/art director Jeremy Tankard

Design company Jeremy Tankard Typography

Country of origin UK

Client Fontworks (left) and self (right)

Work description One of a series of posters displaying fonts available from the foundry (left). Stationery items, including business cards, letterhead, and compliments slip (right).

Dimensions Poster: 16 x 21 ¼ in; 410 mm x 540 mm Stationery: various

This spread

Designer/art director Jeremy Tankard

Design company Jeremy Tankard Typography

Country of origin UK

Client Fontworks (left) and self (right)

Work description One of a series of posters displaying fonts available from the foundry (left). CD Rom holding font software and licences sent to clients (right).

Dimensions Poster: 16 x 21 ¼ in; 410 mm x 540 mm CD Rom case: 5 x 5 ½ in; 124 x 140 mm

EINLADUNG / INVITATION

"abc"
trade event
DONNERSTAG, 19. OKTOBER 2000
JEUDI 19 OCTOBRE 2000
X-TRA LIMMATHAUS ZÜRICH

Fussball
ist unser leben

im haberhuus köniz
bus nr. 10 schliern, haltestelle schloss

freitag, 23. J
20h30

erzählte welt/ thomas perler / nicolai bernard / daniel imboden skurriles, philosophisches und sehenswertes

STAMP ■ ■

SEND TO ■ ■

"THE GRID"
POSTFACH 3052
8201 SCHAFFHAUSEN

Designers Walter Stähli, Ibrahim Zbat,
and Marco Simonetti
Design company Walhalla Artforce
Country of origin Switzerland
Client Sony Playstation
Work description Sleeve holding invitation
to a trade event for Sony dealers and
software companies (left). The inspiration
was the simplicity of the ps2 box design.
Also, poster for lecture about soccer
short stories (below).
Dimensions Invitation/sleeve:
5 ½ x 5 ½ in; 140 x 140 mm
Poster: 11 ¾ x 16 ½ in; 297 x 420 mm

UNI

WALHALLA, BERN

california college of arts and crafts

ccAc

special events,
exhibitions,
lectures,
performances,
and symposia

fall 2000

public

programs

November 6
Architecture Lecture Series:
Theory and Practice
Laura Cavalcanti and Malu Fatorelli
"Contemporary Art and Architecture
in Rio de Janeiro"
7 pm, Timken Lecture Hall, Montgomery campus (SF)
Info: 415.703.9562

Architect Lauro Cavalcanti and artist Malu
Fatorelli will give a joint presentation on con-
temporary art and architecture in Brazil.

November 8
Los Angeles Admissions Night
7–9 pm, location to be announced
Info: 415.703.9523

An opportunity for prospective students who
live in the Los Angeles area to meet with a visit-
ing CCAC admissions staff member to learn
more about CCAC's programs, have their portfo-
lios reviewed, and (for applicants) complete
their admission interview.

November 10
Small Press Traffic at CCAC presents
Literary Readings Series:
Lyn Hejinian and Pattie McCarthy
7:30 pm, Timken Lecture Hall,
Montgomery campus (SF)
Info: 415.703.9500 or 415.437.3454
Cost: $5 (free to CCAC students)

Lyn Hejinian is a poet, essayist, and translator.
Published collections of her writing include
Writing Is an Aid to Memory, *My Life*, *The Cell*,
and *The Cold of Poetry*. She is the co-director of
Atelos, a literary project commissioning and pub-
lishing cross-genre works by poets. Selections of
Pattie McCarthy's project, *bk of (h)rs* may be
read online at www.poetryproject.com.

November 11–December 15
CCAC Institute presents
Exhibition: Scanner
Oliver Art Center, Oakland campus
Opening reception: Friday, November 10, 7–9 pm
Info: 415.551.9210

Organized by former CCAC Institute Director
Lawrence Rinder, *Scanner* presents a selection
of the most compelling contemporary gallery-
based artwork that incorporates or responds to
digital media. Defying traditional categories to
emerge as new hybrid forms, these works are
complex emotional, psychological, and aesthetic
expressions. Artists include Jeremy Blake,
Clifford LeCuyer, Wendy McMurdo, and Paul
Pfeiffer.

November 13
Architecture Lecture Series:
Theory and Practice
Florence Lipsky
"The Architecture, the Body, and
the Gesture"
7 pm, Timken Lecture Hall, Montgomery campus (SF)
Info: 415.703.9562

Paris-based architect Florence Lipsky of Lipsky-
Rollet Architectes will lecture on the firm's work
in both San Francisco and Paris. This lecture is
offered in conjunction with an exhibition featur-
ing her recent book about San Francisco, *The
Grid Meets the Hills*, at The 3A Garage, 27 South
Park, San Francisco. Exhibition dates: November
2–30, 2000. For gallery information, call
415.543.3347.

November 15
Textile Lecture Series
"Gugger Petter: Woven and
Constructed Forms in Paper"
7 pm, CCAC Textile Arts Department, Room L3,
5301 Broadway (above The Art Store), Oakland
Info: 510.587.3703

Bay Area textile artist Gugger Petter recently
exhibited her weavings at the Museum of Craft
and Folk Art in San Francisco and has a featured
article about her work in the September/
October 2000 issue of *Fiberarts* Magazine.

November 17
Small Press Traffic at CCAC presents
Literary Readings Series:
Rob Fitterman and Sianne Ngai
7:30 pm, Timken Lecture Hall,
Montgomery campus (SF)
Info: 415.703.9500 or 415.437.3454
Cost: $5 (free to CCAC students)

Rob Fitterman is the author of *Metropolis*, an
ongoing writing project, and five other books,
including several collaborations with visual and
music artists. He is the editor-publisher of
OBJECT Journal and *POETSCOOP*. Sianne
Ngai is the author of *Criteria* and, with Brian
Kim Stefans, *The Cosmopolitan*.

November 18–December 16
CCAC Institute presents
**Exhibition: John Maeda: Capp Street
Project Artist-in-Residence**
Logan Galleries, Montgomery campus (SF)
Opening reception: Friday, November 17, 7–9 pm
Info: 415.551.9210

MIT Professor of Graphic Design John Maeda's
powerful work challenges common assumptions
about designing on the computer. This exhibi-
tion will feature new work Maeda will develop as
a Capp Street Project artist-in-residence at
CCAC this fall.

November 29
Graduate Information Night
Montgomery campus (SF), 7–9 pm
Info: 415.703.9523
(see listing, September 13)

November 30
Undergraduate Information Night
Painting/Drawing:
Oakland campus, 7–9 pm
Architecture/interior Architecture:
Montgomery campus (SF), 7–9 pm
Industrial Design:
Montgomery campus (SF), 7–9 pm
Info: 415.703.9523
(see Graduate Information Night listing,
September 13)

December 1
Small Press Traffic at CCAC presents
Literary Readings Series:
Edward Byrne and Kathleen Fraser
7:30 pm, Timken Lecture Hall,
Montgomery campus (SF)
Info: 415.703.9500 or 415.437.3454
Cost: $5 (free to CCAC students)

Edward Byrne is a member of the Kootenay
School of Writing working collective in
Vancouver, British Columbia. His books include
Aporia and *Beautiful Lies*. Kathleen Fraser's
books include a collection of essays, *Translating
the Unspeakable: Poetry and the Innovative
Necessity (Modern and Contemporary Poetics)*,
and *Il Cuore: The Heart*, selected poems.

December 8
Small Press Traffic at CCAC presents
Literary Readings Series:
Barbara Guest
7:30 pm, Timken Lecture Hall,
Montgomery campus (SF)
Info: 415.703.9500 or 415.437.3454
Cost: $5 (free to CCAC students)

The legendary poet and author Barbara Guest
will produce several dramatic pieces.

Unless otherwise noted,
all events are free and open to the public.
Please call the phone number listed with each event
to confirm dates, times, and locations,
or visit www.ccac-art.edu.

The Logan Galleries, SF are open Monday, Wednesday, Thursday,
Friday, Saturday, 11 am–5 pm, Tuesday, 11 am–9 pm; closed Sunday.

The Oliver Art Center, Oakland, is open Sunday, Tuesday, Thursday,
Friday, Saturday, 11 am–5 pm, Wednesday, 11 am–9 pm; closed Monday.

CCAC's Oakland campus
5212 Broadway
(at College Avenue)
Oakland, CA 94618
510.594.3600

CCAC's development campus
1111 Eighth Street
(at Sixteenth and Wisconsin Streets)
San Francisco, CA 94107-2247
415.703.9500

CCAC
San Francisco/Oakland
1111 Eighth Street
San Francisco, CA
94107-2247

Nonprofit organization
US Postage
PAID
San Francisco, CA
Permit No. 211

california college of arts and crafts

ccac

Designer/art director Bob Aufuldish

Photographer Bob Aufuldish

Design company Aufuldish & Warinner

Country of origin USA

Client California College of Arts and Crafts

Work description Prospectus of a college's
public programs and lectures. A child's
toy elephant was photographed to
resemble a monumental sculpture
– a deliberate play on the audience's
perceptions.

Dimensions 6 x 9 in; 153 x 229 mm

september9/october10/november11/december12

September 1–October 6
**Exhibition: Mecanoo, the
Reflective Architect**
Bruce Galleries, Montgomery Campus (SF)
Info: 415.703.9562

Mecanoo, The Reflective Architect is an exhibition
of photographs by well-known German archi-
tectural photographer Christian Richters that
chronicles nine recent projects completed by the
Netherlands-based architecture firm
Mecanoo, which is committed to innovative
engineering and environmental technology. A
lecture by Mecanoo architect Henk Döll will be
held in conjunction with the exhibition.

September 5–16
Exhibition: Add/Drop/Add
Oliver Art Center, Oakland campus
Opening receptions: September 5 and 12, 6–8 pm
Info: 510.594.3712

Add/Drop/Add consists of two self-curated,
weeklong exhibitions of work by artists who will
be teaching in CCAC's fine arts, core, and gradu-
ate programs during the 2000–01 academic
year. A series of artist talks/performances will
be held in conjunction with the exhibitions.

September 5–October 14
CCAC Institute presents
Exhibition: Rooms for Listening
Logan Galleries, Montgomery campus (SF) and
September 27–October 28
Opening reception, San Francisco exhibition:
Friday, September 8, 7–9 pm
Opening reception, Oakland exhibition:
Wednesday, September 27, 7–9 pm
Info: 415.551.9210

Rooms for Listening features a spectrum of
experimental electronic sound and music on
CCAC's two campuses. Participating artists
include Toshio Iwai, Matthew Herbert (a.k.a.
RadioBoy), Atom Heart, and Toshiya Tsunoda. A
series of artist talks, performances, and film pro-
grams accompanies the exhibition. Selections
from *Rooms for Listening* will be webcast live at
www.betalounge.com.

September 13
Graduate Information Night
Montgomery campus (SF), 7–9 pm
Info: 415.703.9523

An opportunity for prospective students to
learn more about CCAC's programs, have their
portfolios reviewed, and (for applicants) com-
plete their admission interview.

September 22 and September 23
CCAC Institute presents
Symposium: The Deleuzian Age
Logan Galleries, Montgomery campus (SF)
Friday, 6–10 pm; Saturday, 10 am–5:30 pm
Info: 415.703.9562

This two-day event will explore the impact of
the work of French philosopher Gilles Deleuze
on the practice and theory of architecture, art,
and design. Presentations by artists and read-
ings by philosophers will mix with performanc-
es, film screenings, and conversation. Guest
speakers include painter Linda Besemer, writer
Manuel De Landa, philosopher Elizabeth Grosz,
and philosopher David Lapoujade. *Seating is lim-
ited.*

September 27
Textile Lecture Series
"CCAC/China Exchange: Fiber Arts
in the Yunnan Province"
7 pm, CCAC Textile Arts Department, Room L3,
5301 Broadway (above The Art Store), Oakland
Info: 510.587.3703

Carole Beadle, professor and chair of CCAC's
Textile Arts Department, will share her unique
experiences meeting the minority peoples of
China's Yunnan Province and researching their
textiles. CCAC has received funding to create an
exchange program with the art department at
the National Minorities Institute in Kunming,
China.

September 29
Small Press Traffic at CCAC
Literary Readings Series:
Rae Armantrout and Carol M...
7:30 pm, Timken Lecture Hall,
Montgomery campus (SF)
Info: 415.703.9500 or 415.437.3454
Cost: $5 (free to CCAC students)

Rae Armantrout has published
poetry, including *Made to Seem*,
plot about sets, and a prose po...
collection, *The Pretext*. Is
Armantrout is the 2000–01 poet...
CCAC. Carol Mirakove is the au...
and is an editor with Subpress.

October 2
Architecture Lecture Series:
Theory and Practice
Henk Döll, Mecanoo Archite...
"The Reflective Architect"
7 pm, Timken Lecture Hall, Montgom...
Info: 415.703.9562

Henk Döll, a partner in Mecan...
Delft, will present the recent w...
ting-edge Dutch firm.

October 13
Small Press Traffic at CCAC
Literary Readings Series:
David Baratier and Chris Kra...
7:30 pm, Timken Lecture Hall,
Montgomery campus (SF)
Info: 415.703.9500 or 415.437.3454
Cost: $5 (free to CCAC students)

David Baratier's poems are al...
American Poetry: The Next G...
Clockpunchers: Poetry for the...
Workplace. His collections inc...
Letters and *The Fall of Becon...*
the author of *Aliens & Anorexia*...
She is the founding editor of...
Native Agents new fiction seri...
regular column for *Art/Text* mag...

WHO CAN SING A SONG TO UNFRIGHTEN ME?

FORCED**ENTERTAINMENT**

COMPANY THE GUARDIAN

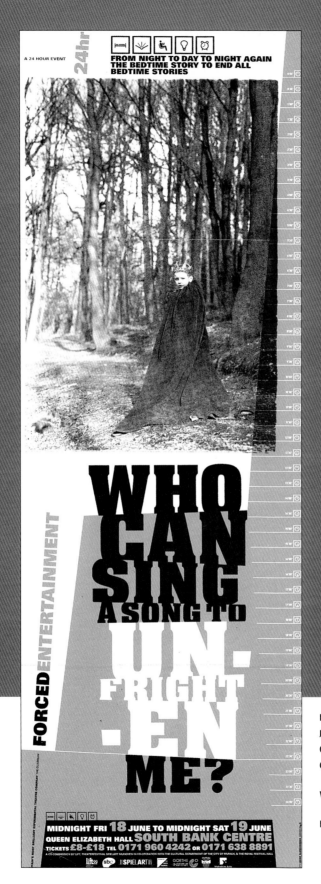

Designer Dom Raban

Design company Eg.G

Country of origin UK

Client Forced Entertainment
Theatre Company

Work description Poster (left) and detail of
flyer (far left) for theatre performance.

Dimensions Poster: 11 3/4 x 33 in;
297 x 840 mm
Flyer: 4 x 11 3/4 in;
105 x 297 mm

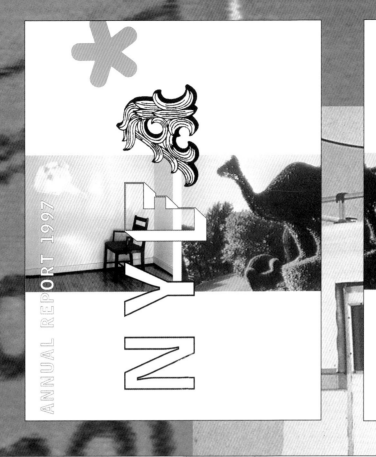

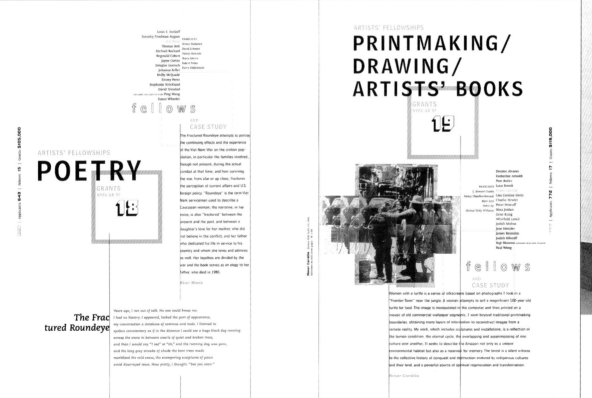

ANNUAL REPORT 1997

NYFA

ARTISTS' FELLOWSHIPS
POETRY

GRANTS
NYFA AR 97
18

Louis S. Asekoff
Dorothy Friedman August
Thomas Bolt
Michael Burkard
Reginald Cabico
Jayne Cortez
Douglas Goetsch
Johanna Keller
Molly McQuade
Emmy Perez
Stephanie Strickland
David Trinidad
Ping Wang
Susan Wheeler

PANELISTS:
Denise Duhamel
David Lehman
Nancy Stuteside
Tracie Morris
Robert Polito
Barry Wallenstein

fellows

AND
CASE STUDY

The Fractured Roundeye attempts to portray the continuing effects and the experience of the Viet Nam War on the civilian population, in particular the families involved, though not present, during the actual combat at that time; and how surviving the war, from afar or up close, fractures the perception of current affairs and U.S. foreign policy. "Roundeye" is the term Viet Nam servicemen used to describe a Caucasian woman; the narrative, in her voice, is also "fractured" between the present and the past, and between a daughter's love for her mother, who did not believe in the conflict, and her father who dedicated his life in service to his country and whom she loves and admires as well. Her loyalties are divided by the war and the book serves as an elegy to her father, who died in 1985.

The Frac
tured Roundeye

Years ago, I ran out of talk. No one could know me.
I had no history. I appeared, looked the part of appearance,
my conversation a database of commas and nods. I listened to
spoken commentary as if in the distance I could see a huge black dog running
across the snow in between snarls of quiet and broken trees,
and then I would say "I see" or "oh," and the running dog was gone,
and the long gray streaks of shade the bent trees made
marbilzed the cold snow, the scampering sculptures of paws
amid disarrayed rows. How pretty, I thought. "See you soon."

ARTISTS' FELLOWSHIPS
PRINTMAKING/
DRAWING/
ARTISTS' BOOKS

GRANTS
NYFA AR 97
19

Desiree Alvarez
Katherine Arnoldi
Pam Butler
Luca Buvoli
Lisa Corinne Davis
Charlie Hewitt
Peter Hristoff
Nina Jordan
Gene Kraig
Whitfield Lovell
Judith Mohns
Jose Morales
James Reynolds
Judith Ribicoff
Koji Shimimi
Paul Wong

PANELISTS:
L. Stewart Crosley
Nancy Chunker-Jessups
Bayn Leys
Helen Oji
Michael Kelly Williams

fellows

AND
CASE STUDY

Women with a turtle is a series of silkscreens based on photographs I took in a "Frontier Town" near the jungle. A woman attempts to sell a magnificent 100-year-old turtle for food. The image is manipulated in the computer and then printed on a mosaic of old commercial wallpaper segments. I went beyond traditional printmaking boundaries, obtaining many layers of information to reconstruct images from a remote reality. My work, which includes sculptures and installations, is a reflection of the human condition, the eternal cycle, the overlapping and superimposing of one culture over another. It seeks to describe the Amazon not only as a unique environmental habitat but also as a reservoir for memory. The forest is a silent witness to the collective history of conquest and destruction endured by indigenous cultures and their land, and a powerful source of spiritual regeneration and transformation.

Rimer Cordillo

NYFA's Services strive

NEW YORK FOUNDATION FOR THE ARTS
ANNUAL REPORT 1997

ARTISTS' FELLOWSHIPS

NONFICTION
LITERATURE

GRANTS
NYFA AR 97

16

Dorothy Barthouse
Louise Bernikow
Rachel Cohen
Martha Frankel
Andrew King
Sindiwe Magona
Thomas McDonough
Achim Nowak
William Patrick
Julie Phillips
Susan Sherman
Michael A. Bezma

PANELISTS
Eli Gottieb
Jason Kaye
Maurice Kenny
Susan Mulcahey

f e l l o w s
AND
CASE STUDY I have been writing about
Latino art and cultural politics for the past decade. Most recently,
I have been concentrating on such issues as the relationship
between ethnic marginalization and artistic interventions in
public space, and the influence of Catholicism on specific uses
of the body in Latino performance. I am also looking at how
certain paradigms that are frequently used to interpret Latin
American art preclude or inhibit examination of gender issues.

Coco Fusco

"Americans often ask me why
Cubans, exiled or at home, are so passionate about Cuba, why our
discussions are so polarized, and why our emotions are so raw
after thirty-three years. My answer is that we are always fighting with the people we love
the most. Our intensity is the result of the tremendous repression and forced
separation that affects all people who are ethnically Cuban, wherever they reside.
Official policies on both sides collude to make exchange practically impossible. Public
debate is extremely limited in the United States and on the island. Only extreme
positions get attention; any other stance is recast as what Cubans call 'ideological
diversionism,' a pejorative way of characterizing those who stray from the official
view of things. Travel is severely restricted by the United States and Cuban
governments, making contact difficult and allowing exaggerated rumors to pass for
truth. Communication, when it does happen, is often strained."*

ARTISTS' FELLOWSHIPS

PERFORMA
MULTIDISC
WORK

Tanya Barfield
Judith Barry
Maureen Fleming
Raymond Ghirardo and Megan Roberts
Antony Hegarty
Anne Iobst and Lucy Sexton
Grisha MacGregor
Henrietta Mantooth
Carlos Ortoz-Stanton
Carmen Pelaez
Jenny Romaine
George Emilio Sanchez

Igor Vamos

PANELISTS
Luz Maria Garcida
Hattie Gassan
Lorna Hill
Jenny Meyers
Jennifer Miller

f e l l o
AND
CASE STUL

Designer/art director Weston Bingham
Design company Deluxe
Country of origin USA
Client New York Foundation for the Arts
Work description Annual report and grant
 description handbook for a New York
 arts organization.
Dimensions 9 x 11 ½ in; 229 x 292 mm

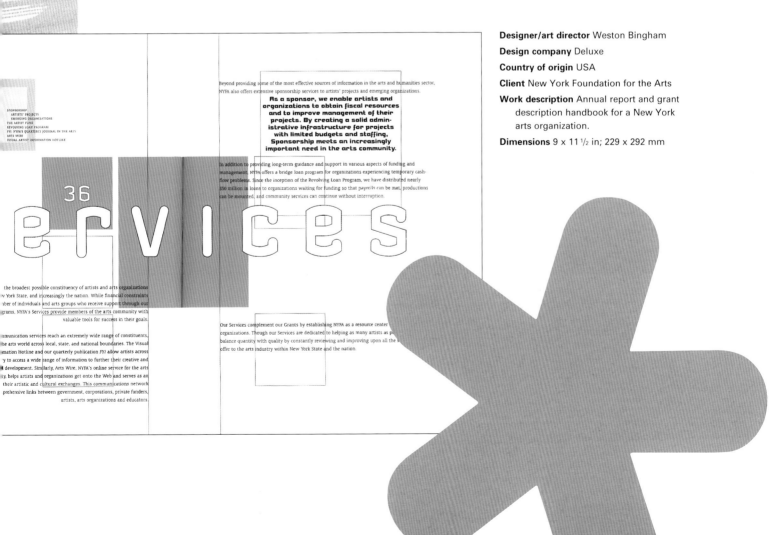

SPONSORSHIP
 ARTISTS' PROJECTS
 EMERGING ORGANIZATIONS
 THE ARTIST FUND
 REVOLVING LOAN PROGRAM
 FYI: NYFA'S QUARTERLY JOURNAL IN THE ARTS
 ARTS WIRE
 VISUAL ARTIST INFORMATION HOTLINE

36

ervices

Beyond providing some of the most effective sources of information in the arts and humanities sector,
NYFA also offers extensive sponsorship services to artists' projects and emerging organizations.

**As a sponsor, we enable artists and
organizations to obtain fiscal resources
and to improve management of their
projects. By creating a solid admin-
istrative infrastructure for projects
with limited budgets and staffing,
Sponsorship meets an increasingly
important need in the arts community.**

In addition to providing long-term guidance and support in various aspects of funding and
management, NYFA offers a bridge loan program for organizations experiencing temporary cash-
flow problems. Since the inception of the Revolving Loan Program, we have distributed nearly
$50 million in loans to organizations waiting for funding so that payrolls can be met, productions
can be mounted, and community services can continue without interruption.

the broadest possible constituency of artists and arts organizations
w York State, and increasingly the nation. While financial constraints
ber of individuals and arts groups who receive support through our
grams, NYFA's Services provide members of the arts community with
valuable tools for success in their goals.

mmunication services reach an extremely wide range of constituents,
he arts world across local, state, and national boundaries. The Visual
mation Hotline and our quarterly publication FYI allow artists across
y to access a wide range of information to further their creative and
development. Similarly, Arts Wire, NYFA's online service for the arts
y, helps artists and organizations get onto the Web and serves as an
their artistic and cultural exchanges. This communications network
prehensive links between government, corporations, private funders,
artists, arts organizations and educators.

Our Services complement our Grants by establishing NYFA as a resource center
organizations. Though our Services are dedicated to helping as many artists as p
balance quantity with quality by constantly reviewing and improving upon all the
offer to the arts industry within New York State and the nation.

HERRON SCHOOL OF ART, IUPUI
1701 NORTH PENNSYLVANIA STREET
INDIANAPOLIS, IN 46202

www.herron.iupui.edu
herrart@iupui.edu

HERRON SCHOOL
BUILDING ARTISTIC VISION SINCE 1902

ALL VISITING ARTIST LECTURES ARE FREE AND OPEN TO THE PUBLIC,
AND TAKE PLACE IN THE MUSEUM BUILDING AUDITORIUM, 1701 NORTH PENNSYLVANIA STREET
LECTURES SPONSORED IN PART BY ACTIVE STUDENT ARTISTS [ASA]

DATES AND TIMES ARE SUBJECT TO CHANGE
CALL 317.920.2413 OR 317.920.2455 FOR FURTHER INFORMATION

00/01 LECTURES

SEPTEMBER

9.7.00
/ TH / 10:00 am
1. **RICHARD FORD JR.**
Woodworker
sponsored by IUPUI, Grant in Aid for Research

9.19.00
/ T / 12:30 pm
2. **JAMES NAKAGAWA**
Photographer

9.28.00
/ TH / 10:00 am
3. **ANDY BUCK**
Woodworker

OCTOBER

10.10.00
/ T / 12:30 pm
4. **KAREN THOMPSON**
Photographer

10.18.00
/ W / 4:00 pm
5. **MICHAEL KRUEGER**
Printmaker

JANUARY

1.18.01
/ TH / 10:00 am
8. **GAIL FREDELL**
Woodworker

NOVEMBER

11.8.00
/ W / 7:00 pm
6. **VICTOR SPINSKI**
Ceramicist

11.13.00
/ M / 7:00 pm
7. **RICHARD REZAC**
Multi-Media Sculptor

MARCH

3.19.01
/ M / 12:30 pm
9. **JIM LUTES**
Painter
sponsored by Dr. Gary Rosenburg

3.22.01
/ TH / 7:00 pr
NANETTE SA
Art Historian

FALL SEMESTER SPRING SEMESTER

1. 2. 3. 4. 5. 6. 7. 8.

SCHEDULE

HERRON GALLERY IS LOCATED IN THE MUSEUM BUILDING, 1701 NORTH PENNSYLVANIA STREET
EVENTS ARE FREE OF CHARGE, OPEN TO THE PUBLIC AND WHEELCHAIR ACCESSIBLE

GALLERY HOURS M / T / W / F / S 10 AM–5 PM, TH / 10 AM–7 PM
CALL 317.920.2420 FOR FURTHER INFORMATION

00/01 EXHIBITIONS

JANUARY/FEBRUARY

1.10.01 – 2.3.01 [OPENING / WEDNESDAY

CLAYFEST 2001

This year's installment of the Woodsmall Foundation's C
at Herron's Sculpture and Ceramics building. In additior
contemporary ceramics, the work of several prominent
Steven Carter, this year's guest juror, will give a brief slide

NON PROFIT ORG
US POSTAGE PAID
INDIANAPOLIS, IN
PERMIT #4245

OF ART | IUPUI

3.29.01
/ TH / 10:00 am
ON 10. ANDREW BLAUVELT
Graphic Designer

9. 10.

HERRON SCHOOL OF ART | IUPUI
BUILDING ARTISTIC VISION SINCE 1902

ALL VISITING ARTIST LECTURES ARE FREE AND OPEN TO THE PUBLIC,
AND TAKE PLACE IN THE MUSEUM BUILDING AUDITORIUM, 1701 NORTH PENNSYLVANIA STREET
LECTURES SPONSORED IN PART BY ACTIVE STUDENT ARTISTS [ASA]
DATES AND TIMES ARE SUBJECT TO CHANGE
CALL 317.920.2413 OR 317.920.2420 FOR FURTHER INFORMATION

9.7.00
/ TH / 10:00 am
1. RICHARD FORD JR.
Woodworker

9.19.00
/ T / 12:30 pm
2. JAMES NAKAGAWA
Photographer

9.28.00
/ TH / 10:00 am
3. ANDY BUCK
Woodworker

10.10.00
/ T / 12:30 pm
4. KAREN THOMPSON
Photographer

10.18.00
/ W / 4:00 pm
5. MICHAEL KRUEGER
Printmaker

1.18.01
/ TH / 10:00 am
6. GAIL FREDELL
Woodworker

11.8.00
/ W / 7:00 pm
7. VICTOR SPINSKI
Ceramicist

11.13.00
/ M / 7:00 pm
7. RICHARD REZAC
Multi-Media Sculptor

3.19.01
/ M / 12:30 pm
8. JIM LUTES
Painter

3.22.01
/ TH / 7:00 pm
NANETTE SALOMON
Art Historian

3.29.01
/ TH / 10:00 am
10. ANDREW BLAUVELT
Graphic Designer

HERRON GALLERY IS LOCATED IN THE MUSEUM BUILDING, 1701 NORTH PENNSYLVANIA STREET
EVENTS ARE FREE OF CHARGE, OPEN TO THE PUBLIC AND WHEELCHAIR ACCESSIBLE
GALLERY HOURS M / T / W / F / S 10AM–5PM, TH / 10AM–7PM
CALL 317.920.2420 FOR FURTHER INFORMATION

1.10.01 – 2.3.01 [OPENING / WEDNESDAY / 1.10.01 / 5–7PM]
CLAYFEST 2001
This year's installment of the Woodsmall Foundation's Clayfest will be presented in tandem with the new gallery at Herron's Sculpture and Ceramics building. In addition to the event's juried competition and display of statewide contemporary ceramics, the work of several prominent ceramicists from around the country will be on display. Steven Cortie, this year's guest juror, will give a brief slide lecture and present awards during the opening celebration.

8.30.00 – 9.23.00 [OPENING / WEDNESDAY / 8.30.00 / 5–7 PM]
INDICOLLECTS
IndiCollects will feature works of art from many of the best private collections in the city. This exhibit will reflect the high caliber of artwork collected locally, and the broad interests of Indianapolis' independent art collectors. This edition has been curated to reflect the aesthetically eclectic times in which we live, and demonstrates how contemporary collections are affected by this climate.

10.4.00 – 11.4.00 [OPENING / WEDNESDAY / 10.4.00 / 5–7 PM]
H X W X D X 6
Curated as a complimentary/companion experience to the Indianapolis Museum of Art's Crossroads of America exhibit, and it's 20th Century Sculpture Symposium, this exhibit will present the work of six contemporary American sculptors: Amy Brier, Patti Davis, Christopher Furman, Alison Helm, David Nelson, and Diane Simpson.

11.15.00 – 12.16.00 [OPENING / WEDNESDAY / 11.15.00 / 5–8 PM]
HERRON SCHOOL OF ART STUDENT EXHIBITION 2000
Herron's annual juried exhibition of student work. The Student Exhibition is open to all Herron students, and features work from the ceramics, furniture design, painting, photography, printmaking, sculpture, and visual communication programs. Awards will be presented by this year's guest juror during opening night.

2.14.01 – 3.10.01 [OPENING / WEDNESDAY / 2.14.01 / 5–7 PM]
HERRON FACULTY EXHIBIT: 3/4
This is the third in a cycle of four exhibits featuring the recent professional work of Herron faculty. Each exhibit features approximately ten instructors, one or two from each of Herron's departments, providing Herron students the opportunity to see the work their teachers create.

3.21.01 – 4.14.01 [OPENING / WEDNESDAY / 3.21.01 / 5–7 PM]
CHRISTINA RAMBERG DRAWINGS:
Christina Ramberg (1946–1995) was well-known for her intricate paintings of cropped fetishized female torsos. This exhibit, originally curated for Gallery 400 at the University of Illinois at Chicago, examines the artist's drawings. Christina Ramberg Drawings will utilize the rich holdings of sketches, drawings, and visual reference materials from the Ramberg estate, which have not been displayed, chronicled, or catalogued until now. Catalog available.

4.25.01 – 5.14.01 [OPENING / WEDNESDAY / 4.25.01 / 5–8 PM]
2001 HERRON SENIOR SHOW
Herron's annual Senior Show provides graduating students the opportunity to publicly display their artwork. Works included are selected by the graduates themselves, to represent the level of technical prowess, and conceptual refinement each has attained as an artist.

EVENTS MADE POSSIBLE THROUGH THE SUPPORT OF FRIENDS OF HERRON, INDIANA ARTS COMMISSION,
AND CENTRAL INDIANA COMMUNITY FOUNDATION

Designers Elisabeth Charman and Brad Frost
Photographer Kurt Hettle
Design company Herron School of Art
Country of origin USA
Work description Poster announcing schedule of artists and exhibitions visiting the Herron School of Art. Printed on light green translucent stock in black and white inks, the poster is designed to be placed in a window where it can be back-lit.
Dimensions 18 x 24 in; 457 x 610 mm

10.01 / 5–7PM]
st will be presented in tandem with the new gallery
e event's juried competition and display of statewide
nicists from around the country will be on display.
are and present awards during the opening celebration.

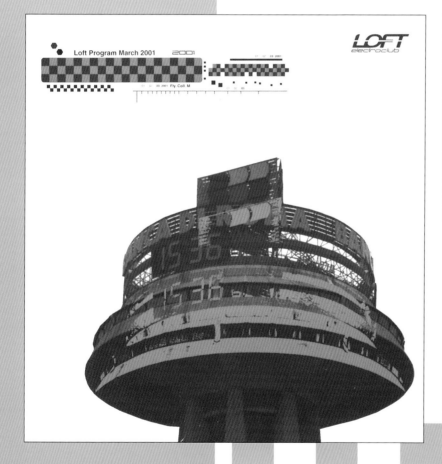

Designers Walter Stähli, Ibrahim Zbat,
and Marco Simonetti

Design company Walhalla Artforce

Country of origin Switzerland

Client Loft Electroclub

Work description Sleeve containing eight
flyers for the Loft Electroclub, one of
the best-known clubs in Switzerland.

Dimensions 5 1/2 x 5 1/2 in; 140 x 140 mm

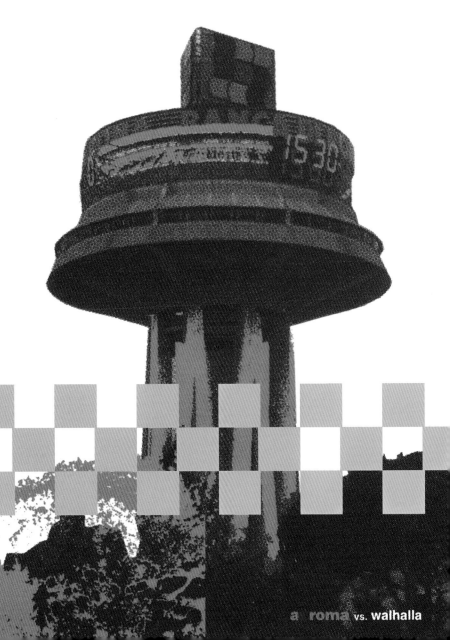

93

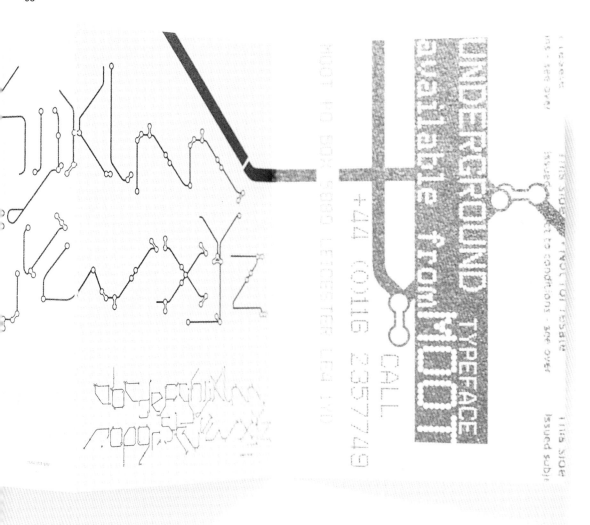

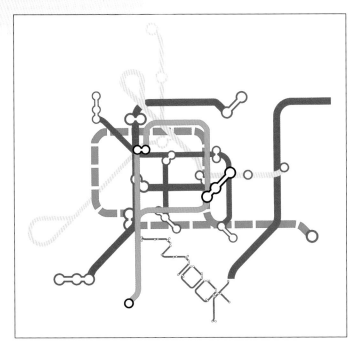

Designer Nitesh Mody

Design company Moot

Country of origin UK

Work description Gatefold leaflet to promote a
new font. The leaflet was mailed out within
a plastic wallet accompanied by a narration
on dictation tape. Inset graphics show uses
of the font.

Dimensions Leaflet: 4 x 14 in; 104 x 358 mm

A man, his watch and his time

Story by Lidio Neto, layout Lilly Tomec, photos Samuel Hattenschweiler, Lilly Tomec

Designer/art director Lilly Tomec

Photographers/illustrators Lilly Tomec and Samuel Hattenschweiler

Design company Lilly Tomec

Country of origin Germany

Client Shift!

Work description Booklet produced for Berlin design magazine Shift!

Dimensions 4 x 5 3/4 in; 105 x 148 mm

There are men ...
emptiness, a lack ...
incarnation of th...
on only one obje...
of their faces w...
fierce and untam...
believes in hims...
adoration, a god...
a vanguardist Kr...
hurting, killing, ...
single commandn...
Things." This god ...
aspirations and h...
sumptuous Victor...
shrine or temple, ...

This man is know...
Boss, the Father, c...
many names he h...
But his heart was ...
young man with a...
by an unexpected ...
opera world were ...
new bitter being ...

8 ... **9**

know that in the course of that day all his "logical" theories about love would prove wrong.

Once on the street, Antonioni moved with his usual fast pace, passing familiar faces on his way without even noticing them. His mind was busy and so was his time. He walked to the bus stop and on missing his bus, he decided to take the tube, his favourite transport.

He arrived at Slone Square a little over eight o'clock, climbed down into the station and noticing that the gates were unattended, he went through without buying a ticket - he wouldn't spend his money if he could manage no to. As an android he went automatically to the platform and waited for the train. A few minutes went by and his train did not come. He looked at his watch and started to get impatient. Suddenly a message was delievered through the loud speakers anoucing another five minutes delay; the apologies were given and the inconvinience was caused. He waited and waited and the train never came, he was about to loose his mind and take some drastic measure, though no one knows what he could have done about it. He tought of leaving and taking a cab, but a cab was such an extravagance and was definetly out of the question - he

10

place to stand tiptoeing on everybody's feet while trying to reach the handles hanging over his head, but of course they were to far up for his little self.

Outside there was still all the crowd who were pushing to get in though it was obvious that not a single other soul could fit in. The Italian asked himself "Why Do I Do It To Myself?" But as he would not dare to answer his own question, he formulated

14

another "Why The Hell Don't They Close The Bloody Doors?" And as he was thus reflecting a voice was heard announcing the departure of the train. "Mind The Doors", they said to the relief of everyone who was already in and to the despair of those who weren't. Antonioni wondered for a second whether he had developed some kind of telepathic power, but immediately dropped the idea for a fat woman stepping right on his toes forced him out of his dreams and back to reality and check his priorities and at that moment the most important one was to vouchsafe his security while in this hell of a train.

But alas! The train was moving and now all that he had to do was to hold himself still the best he could for the next twenty minutes and it would all be over. The trip to the next station, as it is usually said, seemed to take an eternity. The train went chuck, cheeck, chewing slowly with its heavy cargo, while

shuck, sheeck shaking side to side, throwing the passengers here and there when there was place to be thrown to. Being who he was, Antonino Antonioni suffered considerably more than anybody else and had he been a believer, he would have gone down on his knees and prayed for the end of this torment, had he also managed the problem with space, of course. He looked at his

15

watch ... have done too much
in such a little time. Suddenly the train came to an abrupt halt, not at any station, rather between them. Everybody took a deep breath ... as if they all knew what was about to come. But they didn't. Five, ten, fifteen minutes elapsed and it did not move, neither was any message given to explain such a delay. The atmosphere in the carriage was heavy and low, the smell of bodies mixed with perfume increased with the increase of temperature, and the hot and humid air made breathing a hard task. Some people began to feel dizzy and the fat woman who had formerly stepped on Antonioni's toes gave clear signs of loosing conscience, prespiring a cold sweat, while loosing all the colour to her face, so much that she reminded him of an over made-up Geisha. Antonioni who entertained a special hate for fat people, realized that the woman was going

to faint and felt the ...
escape the blow tha...
constitution. But ...
anything, she was ...
heroically he held ...
than would have be...
pushed her over to ...
school boy wh...
woman's belly ...
ciousness ...
followed by an unh...
only be described a...

And this way the tr...
collapsed into total ...
it would seem like ...
film, something tha...
were people shout...
was at its most. Sc...
himself down and v...
so far had not bee...
started shaking and...
lizing that she ha ...
appealling to the m...

16

e inspires in us a certain
n open space to all and every
hollow created by the fixation
being only. Through the eyes
ess. It is the stare of a god who
who deserves all worship and
iveness, a streetwise Buddha,
hrist 2001, a god capable of
d of cheating; breaking every
er one: "To Love God Above All
eonic stare, lunatic face, divine
lives now among us in an old,
a dark and menacing place, his
ress.

o Antonioni, or the Italian, the
aster, Il Signore; many titles and
the same man, the same heart.
o corrupted, and he was once a
ice and a promising future, but
, his chances to make it in the
ith the bitter disappointment, a
ever to depart as long as the

physical being existed. Antonioni music for money, Rome for London and love for cash a sweet ugly lady who had more money than face could withstand, but a caring capable of accepting what the man gave her (almost nothing) in exchange for what he took from her (almost though not just for the title of a married woman, for she was somehow too emancipated for that; she was a woman who read a lot and even had some gift of understanding what she read. But she hoped for a family; man, children and dog, which her looks rendered impossible whilst her account created an endless number of possibilities, and also, she believed that there was some hope for the man who proposed to her with such cruel and true words, saying "You, Signora, have got something that I covet, and I believe I have something that you need - we should join our lives."

The children came, two of them, a boy and a girl, who grew up to become a Greenpeace terrorist and a nymphomaniac, respectively. The years went by, and with them dwindled the hopes of this good lady of ever seeing any changes in her husband, as dwindled her hopes of having a happy, normal family. But the man changed and changed a lot growing richer, more distant, enclosed, uncaring and unloving, acquiring more

and more strange habits and paranoia, turning into a strange being, estranged from all and everything.

And here is a little piece of a day in the life of this man, a few hours among so many. That day, he left his house and headed to work like he always did. He had been rude to his wife, as more than once he'd noticed that a few words unexpectedly thrown in had passed for being witty, and at every opportunity he proved his theory. He left his disconcerted and went down for breakfast, finding Lucrecia, the family maid, arrayed in a full panoply of female armour, an Amazon prepared for war; they had a row, and he hit her, left her unconscious on the floor, and to work he went.

But alas! Who would have guessed that even for him there would still be a chance of love? Sometimes he, in his incoherent duality, had felt that one part of himself would be utterly crushed if driven to divest from the idea of love, the romance of his life, the clear water in which his contaminated thoughts were to be washed until they become purer. But what if love were to be banished from the number of delights that were offered to him, he asked himself; but then giving in to what he calls his "logical self", he classified the subject as trivial and forced his mind to defer from wandering so. But little did he

would not give his money to no cab drive, no, not him; he would rather wait. Looking behind himself searching for a seat he found the only one available on his platform, right there were he was, but he also noticed an older lady who seemed to be heading for the same seat. Without loosing one second, he ran for it managing to take it just before the old lady with her slow steps could get there herself, and making himself confortable he opened the newspaper and began to read. Surprised and disgusted, the other passangers watched him unable to believe what they saw, they stared at him with reproach in their eyes but it did not mean a thing to Antonioni who was used to this kind of reaction from people to whom he hardly spared a single thought.

Seing that he was not going to stir from where he was, a gentleman stood up and offered the dowager her seat, who accepting it, sat herself without a single word of gratitude, as if he had done nothing but his obligation. The man looked disappointed and disconcerted whilst Antonioni, enjoying the scene revealed a satisfied smile.
Another five minutes passed by and no sign of the train.
Next Antonioni noticed that the electronic notice board was not defective as he had tought and that it finally anounced the arrival of the next train. It was a Circle Line train, his train,

his favourite train. He stood up and went to the end of the platform and prepared himself for travelling.

In a few seconds the train could be heard entering the station. Antonioni adjusted himself to where he had calculated one of the carriages door would stop and waited to be the first one in. With stricking precision, the second door of the last wagon stopped wide open right there where he stood, revealing a packed train. Some passagens got off but the great majority of the crowd remained and there were still all those who intended to get in.
Antonioni could not make up his mind whether to take this train or to wait for the next one. But here he looked at his watch and that finished with his doubts. He stepped into the carriage and prepared himself for the second part of his morning ordeal.

Directly through the doors he was enveloped by a foul smell of sweat bodies and cheap perfume, he was the owner of a sensitive nose and that was more than he could take. He covered his mouth and nose with his hand and tried to step further in, but there was no place to be found and he only managed to keep himself up and straight because falling was not possible. He carried on with this exercise of looking for a

bing something fast in order to
uld have meant on his smallish
could have man to do
ping all herself over
ving more vigour and stre
on him and with all his migh
son who in the case was a little
turn, pinched the unconcious
ncil forcing her right into con-
f pain the sound of which could
of a mermaid in heat.

e precisely Antonioni's carriage
nyone entering that wagon now
t straight into some catastroph
alled as Terror in the Tube: there
nting everywhere and hysteria
ed to light a cigarette to calm
y attacked while a tranny, whom
on seeing the burning match
to loose her self control, but rea-
eep herself in low profile and
managed to take hold of herself

the inside room seemed to be getting smaller and the panic was beyond description. While in the other carriage, the other passengers who were going through the same situation, looked in amazed wonder through the windows at the bizarre carry on of those who travelled with the Italian.

And the Italian longed to be out of that mad house, and for one moment, he also felt like loosing hold of himself. But here the train started moving, and though Antonioni immediately noticed the change, it took a few seconds before the crowd realized that their time had not come yet, not yet. They all stopped for a moment, motionless, right exactly where they were: the fat woman with her mouth wide open, the little boy armed with a now broken pencil pointing it at a child molester looking fellow, an older man, who looked just like his geography teacher and who at that moment had his eyes devided into the little boy and the tranny's breast while this one had her hands on the man's wallet. They stood just like that for a second or two, then as if suddenly coming to life they started jumping and hugging each other and laughing a united laughter, a laughter of hope and satisfaction.
Next the train came to another halt, but this time it was

a normal stop on a station and when the door sprang open everybody got off, everybody but two people, the Italian and the lady transvestite; it looked as if it were the last stop rather than one from the many that were still yet to come. The carriage was completely empty, except for the two of them, and consequently they had the whole place for themselves. Antonioni heaved a deep sigh and dumped his little person on the first vacant seat while Miss Tranny counted the money found on the dirty old mans wallet.

The signal was given and the doors were closed leaving the two of them locked inside staring at each other but being neither able to break the silence, though to break the silence was now their one and only thought.

The train was in motion while they were thus frozen, looking in silence at each other like people who have told and listened to a secret. Antonioni meant to say something but was prevented by pride and prejudice though he would have sworn it was sense and sensibility. But here he stood up, walked towards the doors at the end of the carriage and crossed to the other wagon, while being constantly followed by the ever so present stare of the object of his passion, who was wondering to herself why had he gone like this without even saying a world.

Had he realized that I am not what I am? But nobody could answer that question, not even Antonioni himself knew what he was doing or why. Before taking one of the seats he looked back at his former wagon and gave one last look at the strange lady and then struggling with himself he sat down and against his own desires never did he turn his head towards the other carriage where she was, as he could feel, still looking at him.

He just stayed there motionless, untill the train came to his station when he stood up and went to the door. Here, just as he was leaving the train he looked through the window to that part where he had last seen her, but to his surprise she was no longer to be seen, though he could swear she was there just a second before. He looked at his watch and assuming an erect, vertical posture but with a hole in his heart he left the train and the station.

section 2

type as **image**

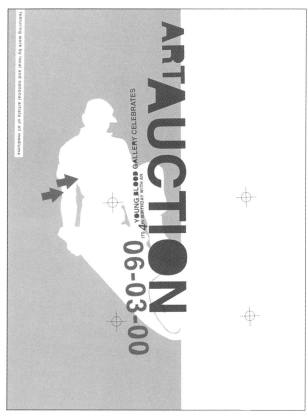

Design company
Graphic Havoc avisualagency

Illustrator Kelly Teasley

Country of origin USA

Work description Invitations to 'Young
Blood' gallery show (left). Mailer to
announce relocation of studio (above).

Dimensions Various

Design company
Graphic Havoc avisualagency

Illustrator Kelly Teasley

Country of origin USA

Work description Mailer to announce
relocation of studio (above).
Opposite from top: sticker announcing
release of Wamdue Project album;
Lush party invitation; invitation to
'Young Blood' gallery show; self-
promotional stickers (background).

Dimensions Various

WAMDUE
PROJECT
PROGRAMYOURSELF

Manufactured and distributed by Strictly Rhythm Records, Inc.
920 Broadway, New York, N.Y. 10010 www.strictly.com
℗©1998 Strictly Rhythm Records, Inc.

wamduepro@mindspring.com

SR330cd5

L US H
saturday
yin- yang
09/12/9 8
2 am
$7

design by
graphic havoc
4 523 8313

to >

opening for the artist > saturday oct 02 7-11pm

oct 02 > nov 01

629 GLENWOOD AVENUE
WEEKDAYS:404.755.4599 WEEKEND:404.627.0393

YOUNG BLOOD GALLERY
hours :: sat & sun 12 - 5

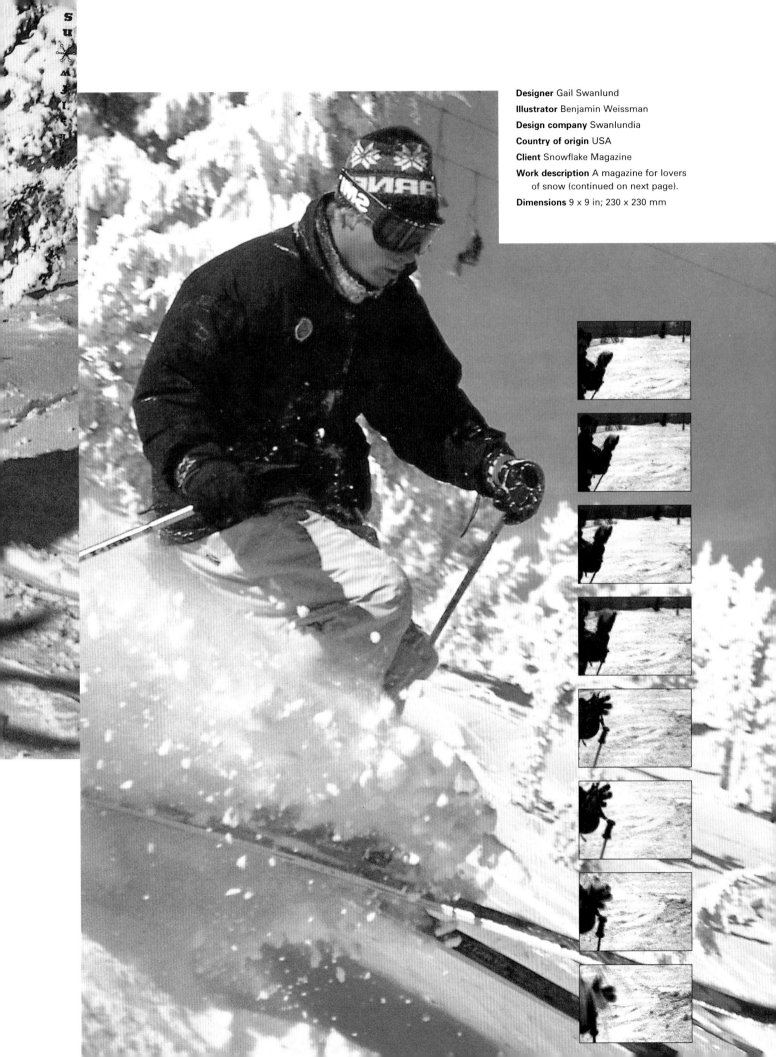

Designer Gail Swanlund

Illustrator Benjamin Weissman

Design company Swanlundia

Country of origin USA

Client Snowflake Magazine

Work description A magazine for lovers
of snow (continued on next page).

Dimensions 9 x 9 in; 230 x 230 mm

Mom & Dad eyeball

MURRAY WEISSMAN

❊❊❊

A LIFE ON SKIS

FIRST TIME, AGE 19 IN '45, was pure craziness. Paradise Inn near Mt. Rainier. Down a narrow icy path wearing Navy bell bottoms. It was the precipitous "Devil's Dip" run, wide as the driver's side of a sports car. My Navy buddy Harry Lyness, the experienced local who fantasized about returning to the sport during long months at sea, was our sadistic leader. The other innocent was Dick Wiegand, a sweet Idaho ranch kid. Just three try-anything high school grads on a weekend liberty. We had bonded as radio operators on a troop transport to survive WWII against the real enemy: bigoted asshole shipmates from Iowa.

"Just point those tips downhill," was Harry's "it's a piece-of-cake" advice, and gravity will do the rest. I got banged up bad and went to sickbay. At the end of the run, well before extreme became popular, Dick did an unplanned 180 degree flip landing firmly on his head. No helmet. He was down for the full count. Concussion.

After that, while GI-Billing it at USC, I bought war surplus skis with best friend Marty Frank. They were nine feet long, stiff as telephone poles, with turn of the century boots and bindings that strapped to the skis, jerryrigged together like the haphazard luggage of immigrants. Of course, no safety release and unconditionally guaranteed to break bones somewhere down the line. Somehow we survived all this, including hiking strenuously up Waterman when rope tows weren't working and from the top of Chair One at Mammoth to higher heights. Ah, youth.

When Marty and I first hit Mammoth, it had just one (yes, one) chair lift, one rope tow, and one T-Bar. An all day ticket cost $5.00. Marty and I opened the Mammoth Mountain Inn and haunted it, trip after trip. Then we added June, Yosemite, Heavenly, and

Badger. After getting married and having children, two for me, three for Marty, we took the kids on the hill, starting them at 5 with the best equipment and stylish German ski clothes. My wife Gracia took one accommodating Mammoth ski lesson, fainted from the altitude and, thereafter, just came dutifully on trips, watching the action from sun decks with hot chocolate. Ben and Julie, our kids, were apeshit for the sport. Fortunately, they both married skiers. Soon, Julie's three pre-schoolers will follow the madness.

One of the joys of my present life, I must admit, is to ride Mammoth lifts with Ben on a cold, clear winter day, the beautiful Minarets to my right. I keep Ben uphill in case I crash, which is seldom, since I describe my current ski style as "jaunty, jolly." Ben says he owes me such service from years of schlepping him and his equipment to the mountains and patiently hand facing his boots and snapping him into his skis. My new wife (married last May), the eternal babe Kay, doesn't ski because of replaced hips from dancing Flamenco across the world with Jose Greco. Now she watches from sundecks. But she drinks tea.

Have I loved the whole experience? Would I rather be a golfer? The answer can be found in Ben's pledge to spread my ashes over a particular Eastern Sierra Peak once pop-off time comes. But don't start crying for me yet, because that's not expected for at least another 100 years. Until then, look for me at mid-chalet, and I'll tell you more about the way it was.

❊

TODDY TALK

parchment of his chest. Because of our wounds, we each have grown permeable and have for example consoled one another at twilight. He babbles incurably gentle, ambiguous words that seal our complicity and this is

true love,

to which nothing else can compare.

Ruffled curtains of snow floating in the sky at dawn diagnose all glare. Laughter and screams from the kitchen. We wish in five, draw the weight of the weather to our breasts, interpolate the valley with our knowledge, never be alone.

Besides me in the bathroom, brother seems to say that we must reason with them, try to talk. I am shocked; I violently disagree. We begin to struggle, grunting and slapping, brushing one another on the floor. Snow crusts drop from the window. FATHER hears, approaching with his hesitant curiosity. Then, the astoundingly loud footsteps of MOTHER.

That winter we learned that the snow annexed our games and the desire to freeze away our mother's sickness and we grew angry.

There in the bathroom, we invented all sorts of people who adore the sun.

JAMES WELLING

FRANCE
Adam DesLauriers

So

I have this really weird thing happening with my feet. Whenever they're wet for a long time, they end up looking like a couple sponges on the bottoms. I can't quite figure it out and for some reason I'm avoiding the doctor like the plague. There is some unwritten stoner law that states "thou shalt not do anything un-fun until it is absolutely, absolutely necessary." As of right now, my feet don't hurt or anything so I'm blowing it off. It's just that when I take a long shower or have wet boots on for too many hours, my feet end up super pruned. They formed these crevices all over the bottom, kind of like the surface of a sponge but harder. At first I was a little concerned because they were beginning to stink and they looked really weird. But then I got kind of used to it and they pretty much went back to normal after they dried out. Anyhow, I thought it was some fungus or something unique to France (that's where it started) and maybe it would go away after I left.

Well, it didn't.

To this day, it haunts my post-shower moments like leftover macaroni and cheese. This is the story of my feet.

FRANCE

The mountains are almost as pompous as the people and, frankly, they both scare me to death. I went over there with the crew of the "Extreme Team Advanced Ski Clinics," which, lo and behold, also happens to be the case of the new Straight up Films ski movie. Coincidence? I don't think so, since they both are run by my brothers, Rob and Eric, and Ski Flick maker extraordinaire, Scott Gaffney. It's amaz-

ing how far you can get in the ski industry just by being related to some people! I was over there to ski in the flick and shoot video for the clinics. Suffice to say, I was traveling and skiing the shit for free (of course, realizing that I landed this gig mostly because of my last name). I felt somewhat obligated to rip as hard as I could for the flick, which, sadly enough for my big brothers, I did. Anyway, back to my feet...

When we first got there, we had a week before the clinic started. This basically meant that we had to pay for lift tickets. Unlike in the U.S., where just the mention of a ski movie gets you not only lift tickets for the entire crew, but also a quickie in the back room, we got absolutely nothing from the French bastards.

So we hit the backcountry. I threw all my gear together and we paid for a one way tram to the top of the Grands Montets (pronounced nasally: Grawn Mone Tay). From there, we traversed for a couple of miles and then skinned across this glacier that looked like it wasn't so big, but ended up being freaking huge. Then we hiked for a little bit to get to the Argentiere Refuge.

Now, before I continue, it's important to note that we arrived in France at the beginning of March during a low snow year and the weather was really warm. This means that the sun was out and the snow was melting. If you happen to have ski boots that don't keep your feet dry, this combination of factors is bad news when you're camping and have nothing else to wear on your feet.

We arrived at the hut in the late afternoon and set up shop. I basically spent the rest of the night walking around in soggy boot liners drinking red wine and farting a lot (they have some crazy cheese in that country). I didn't think this was a problem at the time, but I got a bit suspicious when I took my liners

Designer Gail Swanlund

Photographer Sean Dungan

Design company Swanlundia

Country of origin USA

Client Self-promotion

Work description Promotional postcard
 (above) and business card (right).

Dimensions
 Postcard: 4 1/4 x 6 inches; 152 x 108 mm
 Business card 2 x 3 1/2 inches; 5 x 9 mm

Designer Holger Lippmann and Harald Weist

Art director Holger Lippmann

Design company Monocrom

Country of origin Germany

Work description A randomly composed,
 abstract artwork for projection in
 nightclubs. Authored in Director
 and supplied on CD Rom.

Dimensions Electronic format

Designer/art director Holger Lippmann

Design company Monocrom

Country of origin Germany

Work description Website for Big Fish, a Berlin-based video production and advertising company.

Dimensions Electronic format

Designer/art director Holger Lippmann

Design company Monocrom

Country of origin Germany

Work description Websites for Ariston Pictures, a video company (above); NBI, an electronic music record label and club (below); and Monocrom itself (right).

Dimensions Electronic format

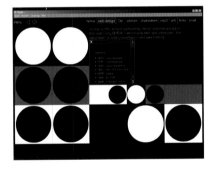
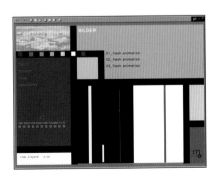

Designer/art director Agnes Bruegger
Design company Aluwerk
Country of origin Switzerland
Work description Flyers
Dimensions 3 1/2 x 7 in; 90 mm x 180 mm

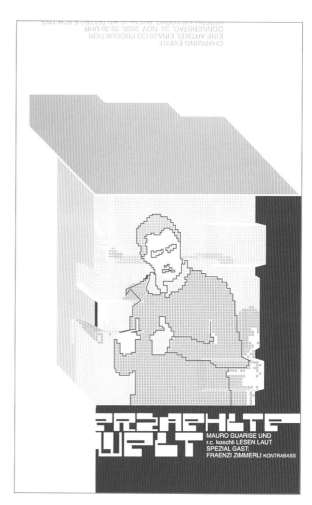

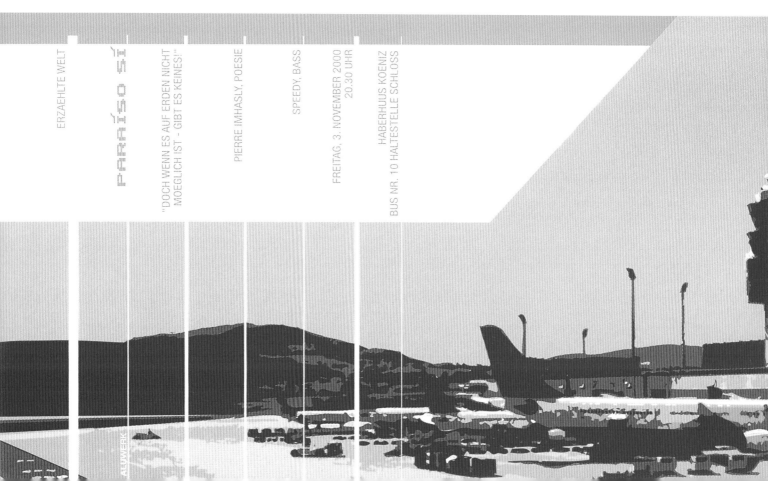

WELT

Da WELT

E R Z A E H L T E W E L T
K A T H A R I N A Z I M M E R M A N N
"KEIN ZURUECK FUER SOPHIE W."
FREITAG 14. APRIL 2000 20.30 UHR
H A B E R H U U S K O E N I Z
BUS NR. 10, HALTESTELLE SCHLOSS

64/65

INSTALLATION

PAGE/S 8-13
DATE 1989
PLACE NEW YORK
TITLE LIGHT DRAWING
MEDIA INSTALLATION
DIMENSIONS VARIABLE

PAGE/S 16-19
DATE 1990
PLACE NAGOYA, JAPAN
TITLE MOTORCORNER
MEDIA INSTALLATION
DIMENSIONS VARIABLE

PAGE/S 22-25
DATE 1993
PLACE FELDKIRCH, AUSTRIA
TITLE MILL TELECINETICS
MEDIA AUDIO INSTALLATION
DIMENSIONS VARIABLE
COLLABORATION JOE VICTORY, PETER LEW

PAGE/S 26-27
DATE 1994
PLACE NEW YORK
TITLE ENTROPY FPU 13
MEDIA MULTIMEDIA INSTALLATION
DIMENSIONS VARIABLE
COLLABORATION JOE VICTORY, PETER LEW

06/07

MOTOR CORNER

12/13

INSTALLATION ART AND SOURCES OF THE NATURAL AS INSTALLATION

INSTALLATIONSKUNST UND QUELLEN DES NATÜRLICHEN ALS INSTALLATION

10/11

04/05

MARC HUNGER BÜHLER

MOTOR

08/09

DRAWINGS

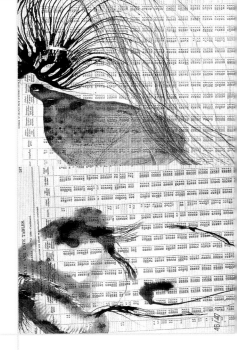

Designer Antonia Henschel

Photographer
Marc Hungerbühler

Country of origin USA

Client Marc Hungerbühler

Work description
Double page spreads
from book of work by
photographer and artist
Marc Hungerbühler (this
spread and previous).

Dimensions 9 1/2 x 12 1/2 in;
240 x 315 mm

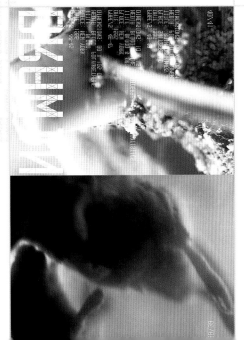

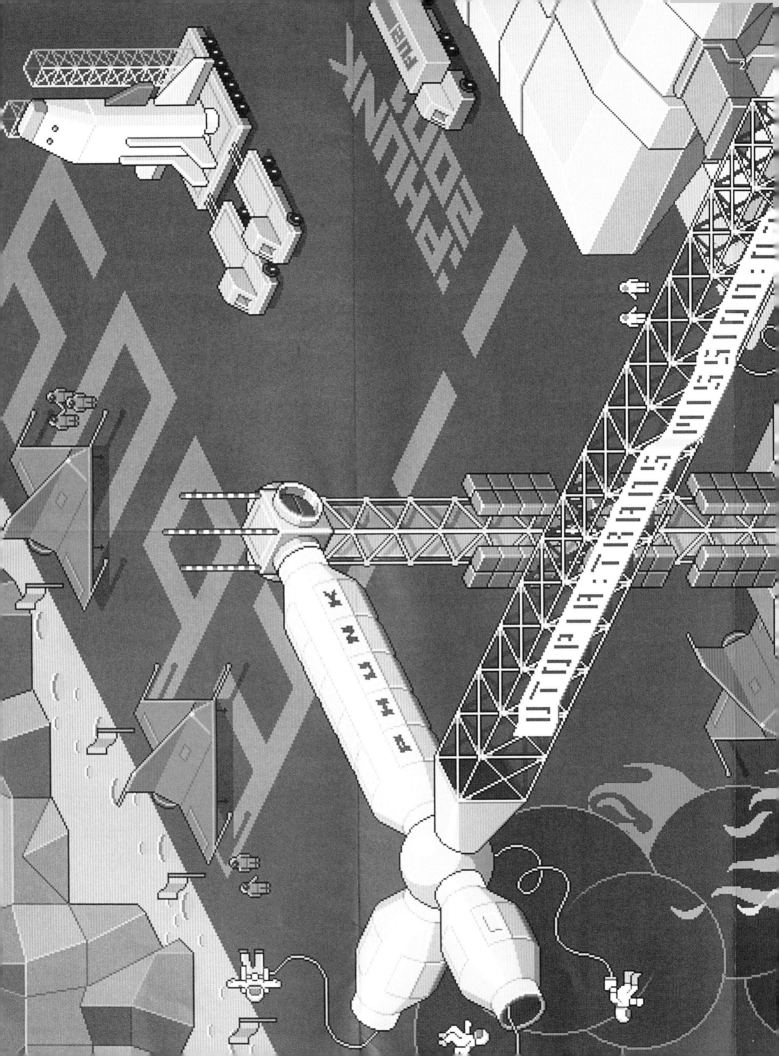

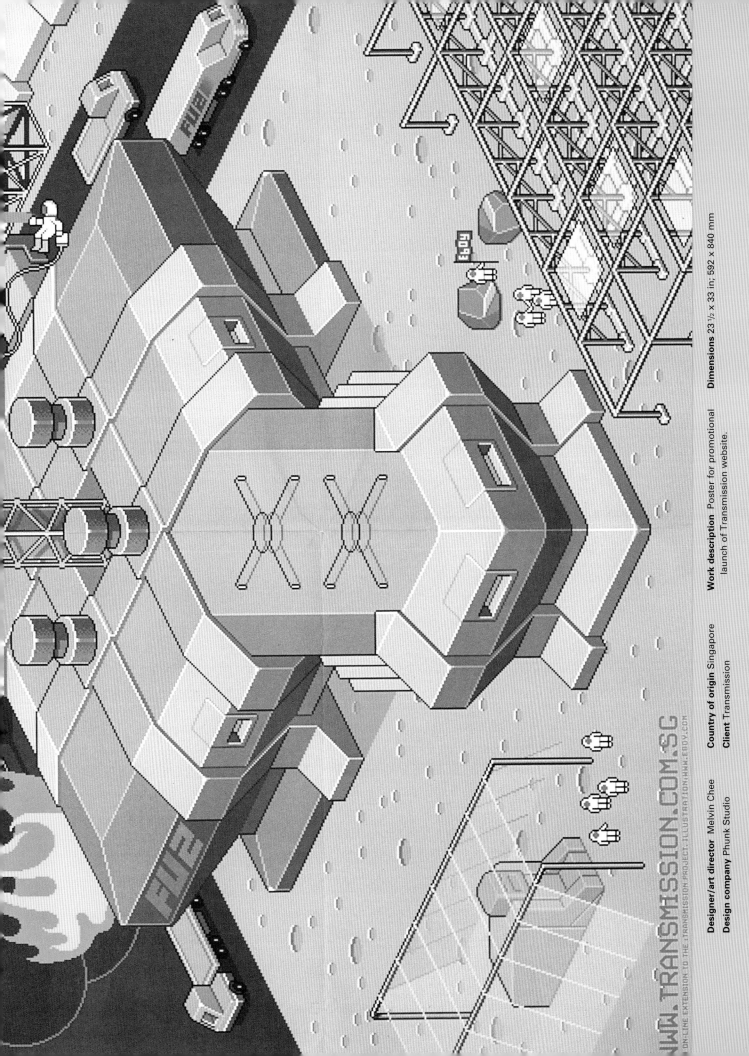

WWW.TRANSMISSION.COM.SG
ON-LINE EXTENSION TO THE TRANSMISSION PROJECT.ILLUSTRATION:WWW.EBOY.COM

Designer/art director Melvin Chee

Design company Phunk Studio

Country of origin Singapore

Client Transmission

Work description Poster for promotional launch of Transmission website.

Dimensions 23 ½ x 33 in; 592 x 840 mm

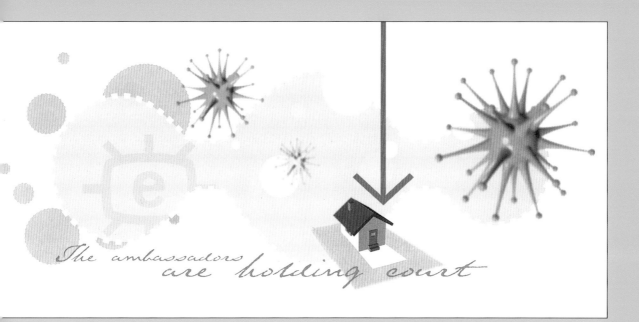

The ambassadors are holding court

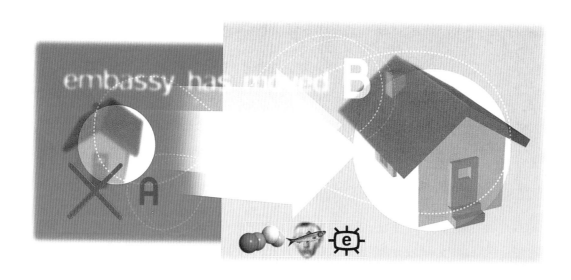

embassy has moved

A

B

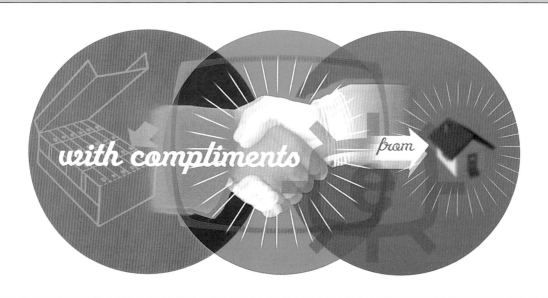

with compliments from

Designer/illustrator Dirk Uhlenbrock

Design company Signalgrau Designbureau

Country of origin Germany

Client Embassy

Work description Complete stationery set and promotional items for Embassy, one of Germany's foremost film production companies. Includes letterheads, business cards, compliments slips, trading cards, moving card, invitations, labels, Christmas card, and stamps.

Dimensions Various

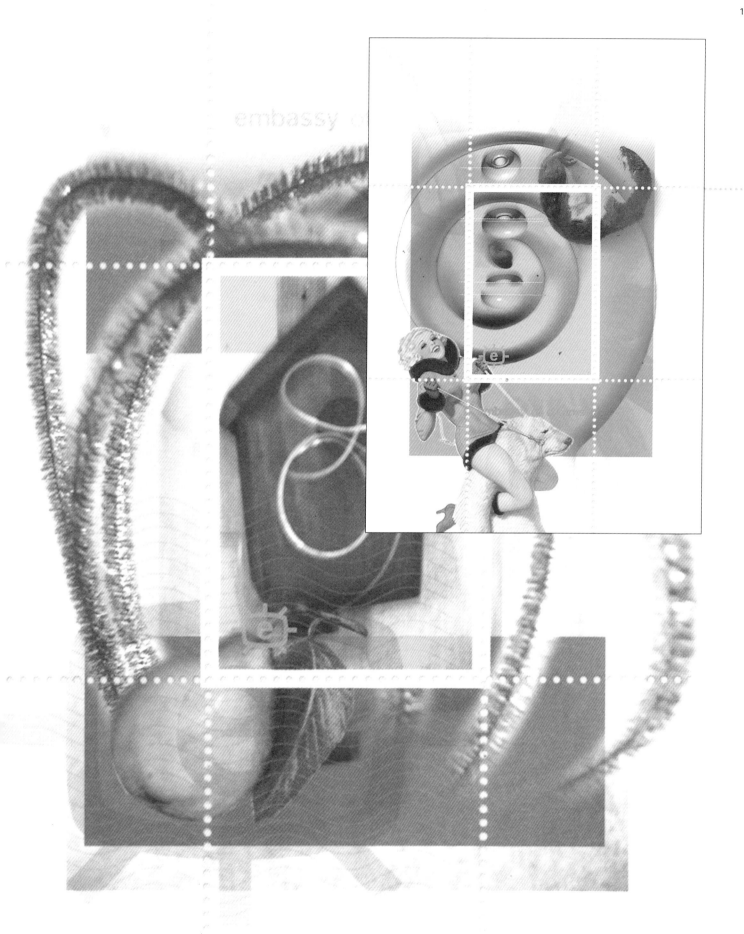

120

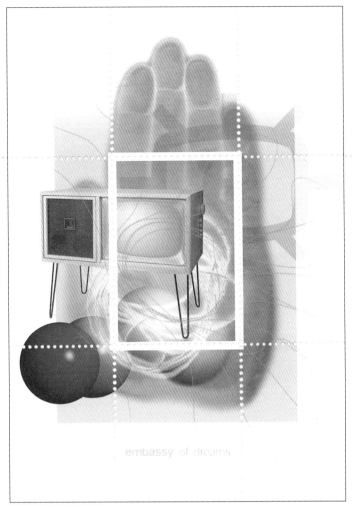

Designer/illustrator Dirk Uhlenbrock

Design company Signalgrau Designbureau

Country of origin Germany

Client Embassy

Work description Complete stationery set and promotional items for Embassy, one of Germany's foremost film production companies. Includes letterheads, business cards, compliments slips, trading cards, moving card, invitations, labels, Christmas card, and stamps.

Dimensions Various

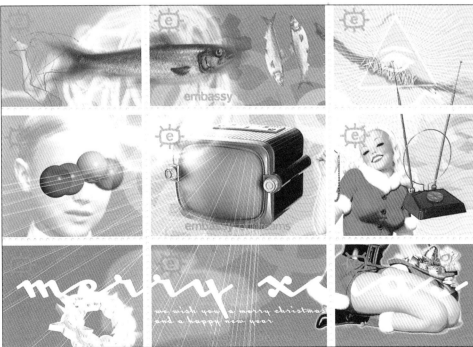

Designer David Hand

Design collective Beaufonts

Country of origin UK

Work description Poster for Dead Metal typeface. Found metal objects were scanned and converted into abstract digital pieces to create the font.

Dimensions 16 ¹/₂ x 22 ³/₄ in; 420 x 580 mm

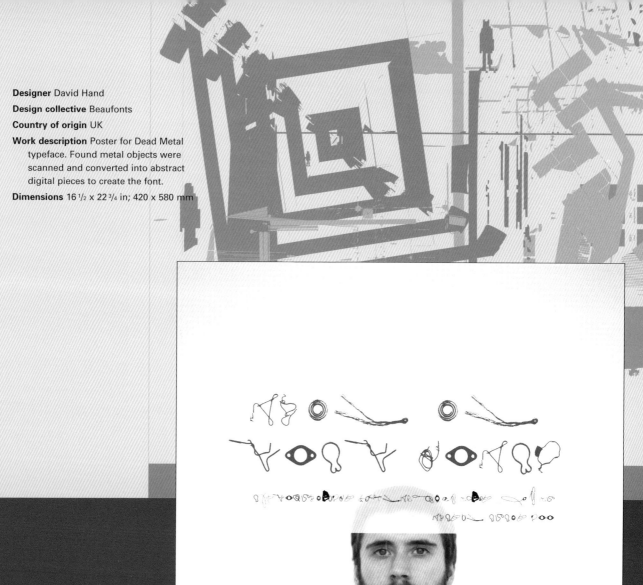

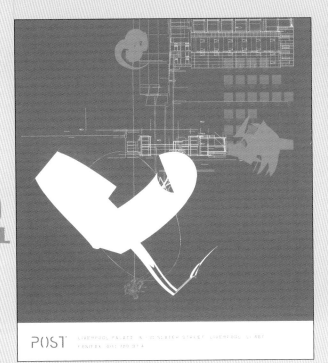

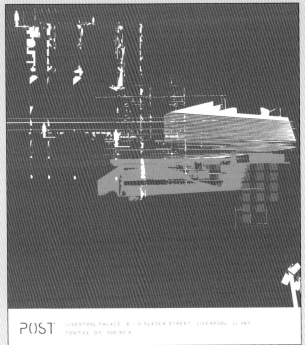

Designer David Hand

Design collective Beaufonts

Country of origin UK

Work description Promotional cards
for POST Clothing company (above)
and two-sided silk-screened poster
introducing 'mr & mrs woo', a set
of letterforms & illustrations (below).

Dimensions Cards
5 3/4 x 6 1/2 in; 148 x 165 mm
Poster 33 x 33 in; 840 x 840 mm

Designers Tnop,
Carlos Segura, and
Henrik Muler

Art director Carlos Segura
and Henrik Muler

Illustrator Tnop

Programmer Dave Weik

Design company Segura Inc

Country of origin USA

Client The (T26) Digital
Type Foundry

Work description
Promotional poster
for type foundry (right)
and website.

Dimensions
Poster: 24 x 36 in;
610 x 914 mm
Web pages:
Electronic format

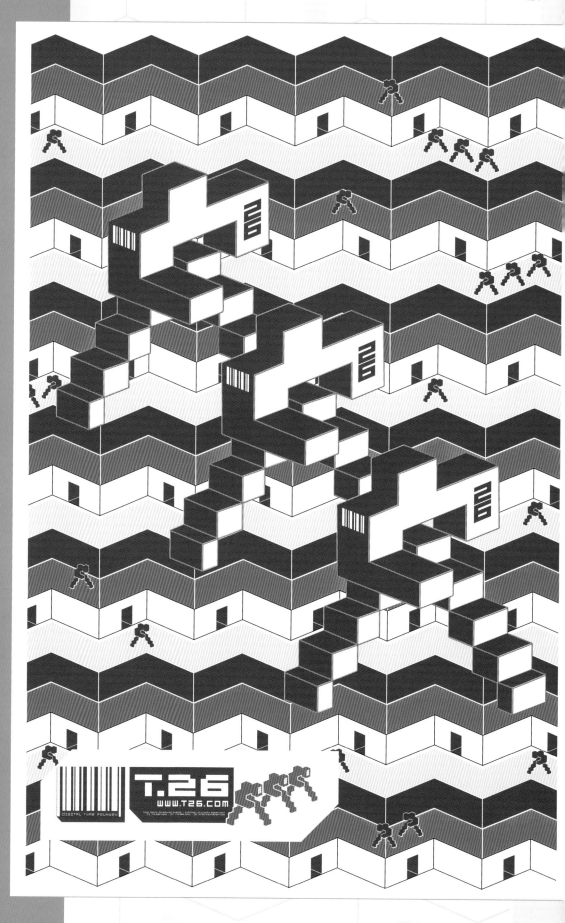

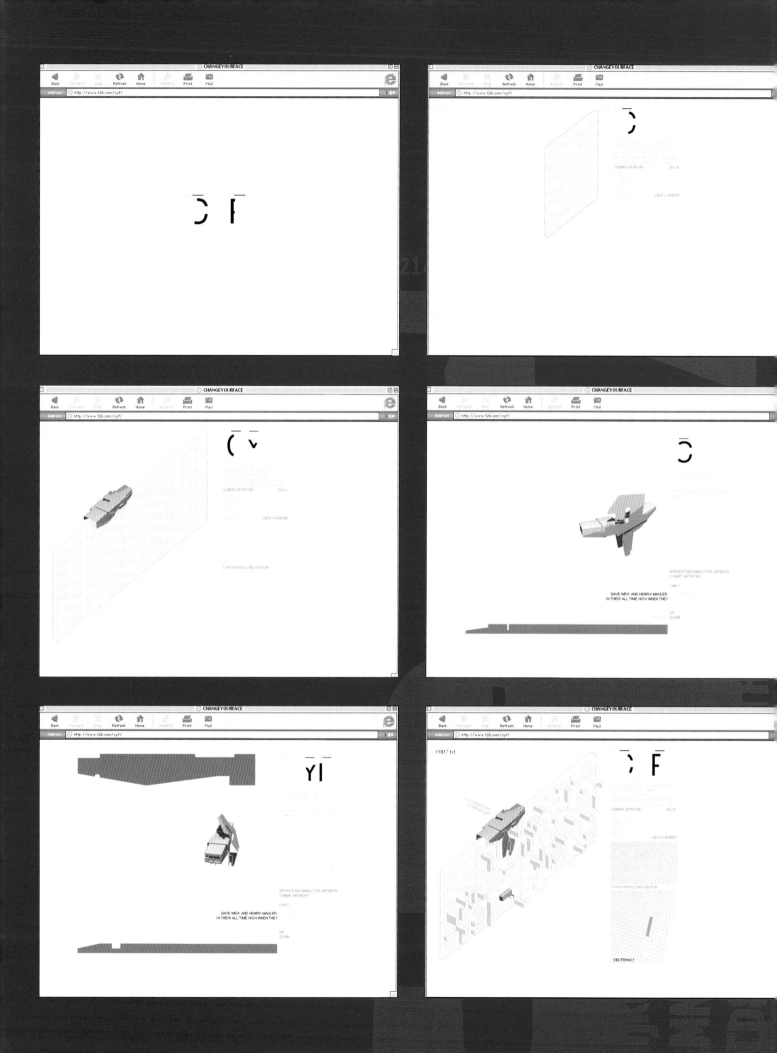

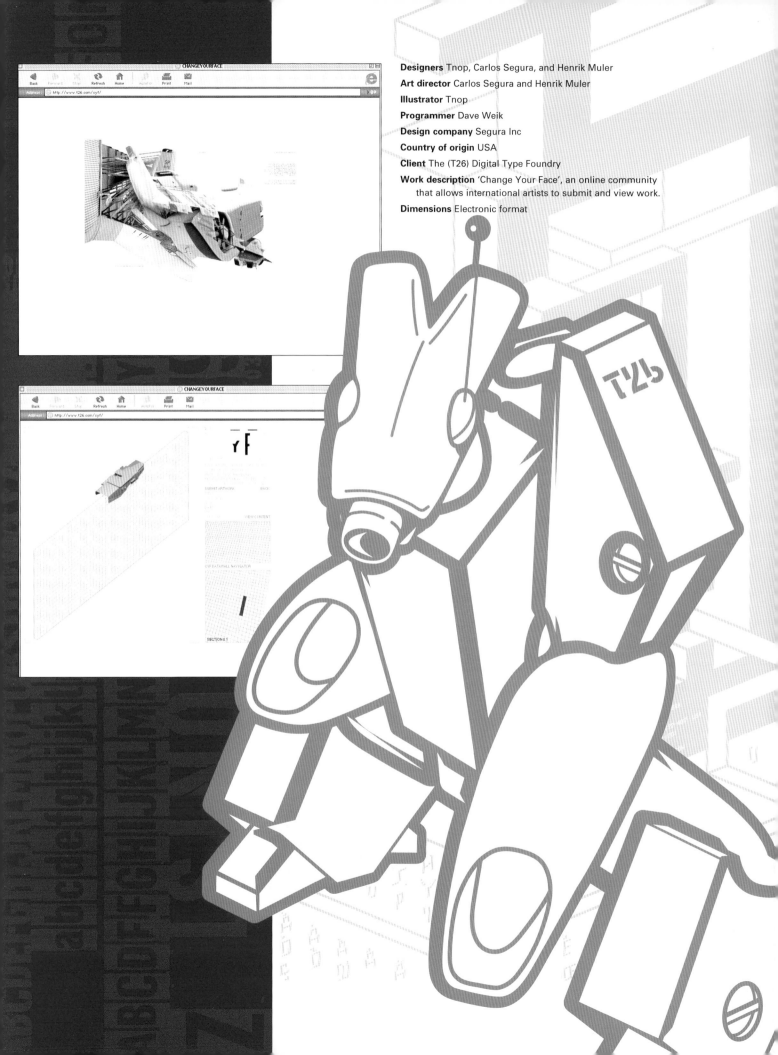

Designers Tnop, Carlos Segura, and Henrik Muler

Art director Carlos Segura and Henrik Muler

Illustrator Tnop

Programmer Dave Weik

Design company Segura Inc

Country of origin USA

Client The (T26) Digital Type Foundry

Work description 'Change Your Face', an online community
that allows international artists to submit and view work.

Dimensions Electronic format

BossaNova! presents
LIVING STEREO | HOLIDAY SELECTOR

B!

LIVING STEREO | HOLIDAY SELECTOR
compiled & mixed by **Jason Bentley**

FOR THE SEASON, IN THE SPIRIT OF THE HOLIDAYS **BossaNova!** IS PLEASED TO PRESENT **LIVING STEREO** A COLLECTION OF ESSENTIAL SOUNDS INSPIRED BY A WORLDWIDE COMMUNITY OF LIKE-MINDED MUSICIANS, PRODUCERS, DJS, CLUB-GOERS, AND MUSIC LOVERS

BossaNova! THANKS THE FAMILY — JUN ANTAZO, ALLEN VOSKANIAN, GLEN WALSH, CARLY EISEMAN, AND, IN NO PARTICULAR ORDER, PAUL SANGSTER @ FUTURE LIGHTING, STEFAN BUCHER @ 344 DESIGN, BRUNO GUEZ, MICHAEL FRICK, SAAM GABBAY, DAVE HERNANDEZ, MARISOL SEGAL, KIM BENJAMIN, SMURF, MAURICE BERNSTEIN, VALIDA CARROLL, ADELINE PETROS, KELLY HIBBERT, FRANCIS CHEVI, SCOTT FRITZ, RENEE BARRON, BIX SIGURDSSON, SAM KIRBY, KEITH GRECO, LIZA RICHARDSON, ALL @ KCRW
WARM THANKS TO ALL THE GUEST DJS WHO MADE THIS A STELLAR YEAR
CONTACT KAVI OHRI OR JENNIFER STONE @ 310.281.7950
OR BOSSANOVA! @ WWW.BOSSANOVACLUB.COM
DESIGN BY WWW.344DESIGN.COM
FOR PROMOTION ONLY. NOT FOR SALE.

BossaNova!
presents the deep and soulful house sound
of london's roadblocked sunday night party

djs ben watt of everything but the girl
and jay hannan

with bossanova resident djs **jason bentley** and **jun** at sugar

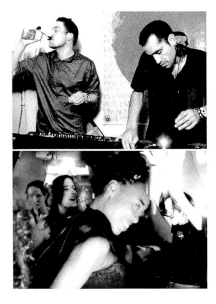

lazy dog
11:18:00

Designer/art director Stefan G Bucher

Design company 344 Design

Country of origin USA

Client Bossanova! A Los Angeles-based
DJ collective

Work description Left: CD sleeve for
'Living Stereo'. The type was created
using a programmable LED device that
is twirled in the air to display messages.
Above: Flyer for a special event
staged by Bossanova!

Dimensions CD sleeve 5 x 5 in;
130 mm x 130 mm
Flyer 6 x 4 in; 150 mm x 100 mm

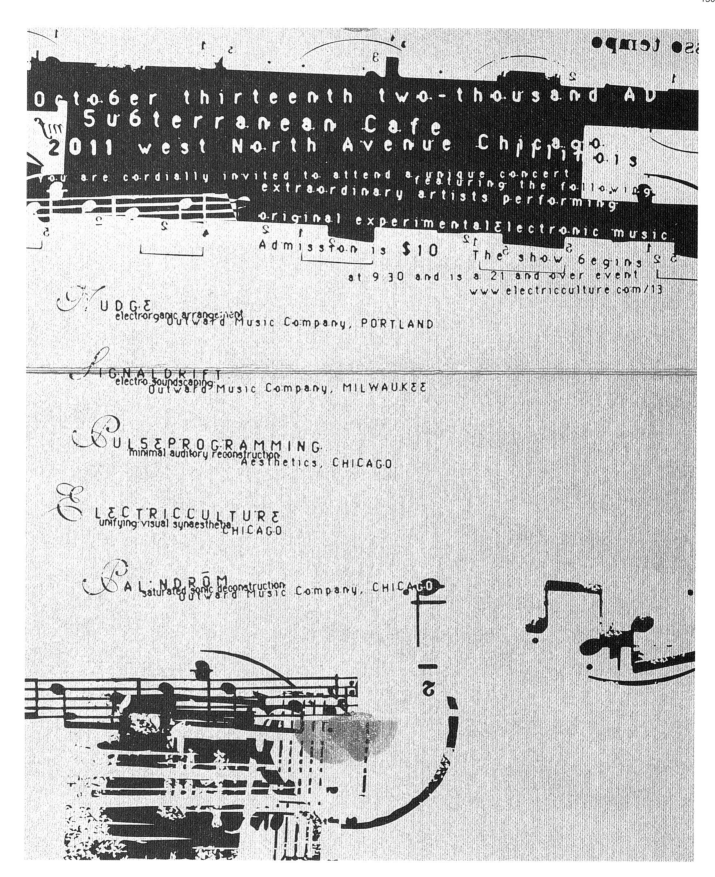

October thirteenth two-thousand AD
Subterranean Cafe
2011 west North Avenue Chicago Illinois

you are cordially invited to attend a unique concert featuring the following
extraordinary artists performing

original experimental Electronic music.

Admission is $10 The show begins
at 9:30 and is a 21 and over event
www.electricculture.com/13

NUDGE
electrorganic arrangement
Outward Music Company, PORTLAND

SIGNALDRIFT
electro soundscaping
Outward Music Company, MILWAUKEE

PULSEPROGRAMMING
minimal auditory reconstruction
Aesthetics, CHICAGO

ELECTRICCULTURE
unifying visual synaesthesia CHICAGO

PALINDROM
saturated sonic deconstruction
Outward Music Company, CHICAGO

Designer/art director Bob Davies

Country of origin USA

Work descripton Invitation to a one-night
 showcase of experimental electronic art
 and music, called the 13th Show. The
 flyer, which folds to postcard size, was
 created using distressed musical notation
 and distorted fonts. It was printed on
 uncoated black stock in silver ink.

Dimensions 6 x 7 1/4 in; 152 x 184 mm

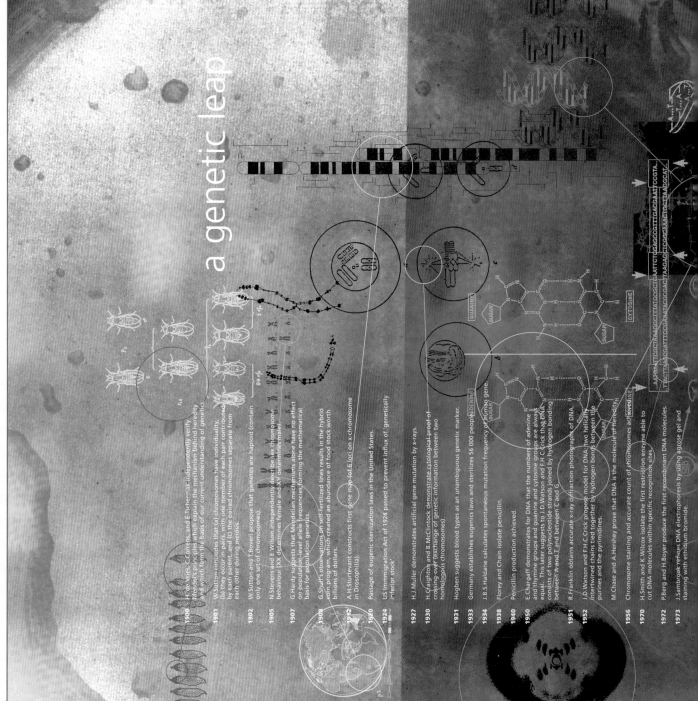

a genetic leap

H.de Vries, C.Correns, and E.Tschermak independently verify Mendel's principles which explain the mechanism behind heredity and which form the basis of our current understanding of genetics.

1900

1901 W.Sutton concludes that: (a) chromosomes have individuality; (b) they occur in pairs, with one member of each pair contributed by each parent, and (c) the paired chromosomes separate from each other during meiosis.

1902 W.Sutton and T.Boveri propose that gametes are haploid (contain only one set of chromosomes)

1905 N.Stevens and E.Wilson independently describe the sex chromosome behaviour (XX determines female and XY determines male)

1907 G.Hardy suggests that Mendelian mechanisms alone have no effect on population-level allele frequencies, forming the mathematical basis for population genetics.

1908 G.Shull's observations on self-fertilized lines results in the hybrid corn program, which created an abundance of food stock worth billions of dollars

1912 A.H.Sturtevant constructs first gene map for 6 loci on x-chromosome in Drosophila).

1920

1924 Passage of eugenic sterilization laws in the United States.

US Immmigration Act of 1924 passed to prevent influx of 'genetically inferior stock'

1927 H.J.Muller demonstrates artificial gene mutation by x-rays.

1930 H.Craighton and B.McClintock demonstrate cytological proof of crossing-over (exchange of genetic information between two homologous chromosomes).

1931 Hogben suggests blood types as an unambiguous genetic marker.

1933 Germany establishes eugenics laws and sterilizes 56 000 people

1934 J.B.S.Haldane calculates spontaneous mutation frequency of human gene.

1938 Florey and Chain isolate penicillin.

1940 Penicillin production achieved.

1950 E.Chargaff demonstrates for DNA that the number of adenine and thymine groups and guanine and cytosine groups are always equal. This later suggests to J.D.Watson and F.H.C.Crick that DNA consists of two polynucleotide strands joined by hydrogen bonding between A and T, and between C and G

1951 R.Franklin obtains accurate x-ray diffraction photographs of DNA.

1952 J.D.Watson and F.H.C.Crick propose model for DNA; two helically intertwined chains tied together by hydrogen bonds between the purines and the pyrimidines.

M.Chase and A.Hershey prove that DNA is the molecule of Heredity.

1956 Chromosome staining and accurate count of chromosomes achieved.

1970 H.Smith and K.Wilcox isolate the first restriction enzyme able to cut DNA molecules within specific recognition sites.

1972 P.Berg and H.Boyer produce the first recombinant DNA molecules.

1973 J.Sambrook refines DNA electrophoresis by using agrose gel and staining with ethidium bromide.

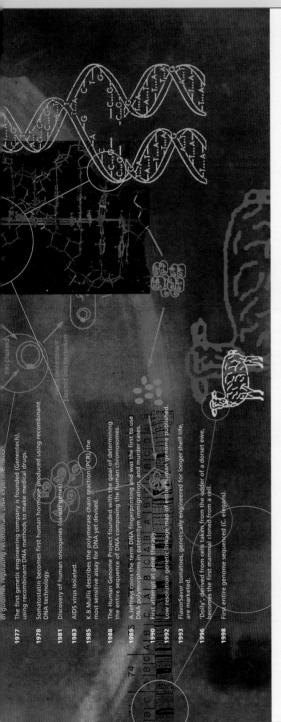

of genomes regulating recombinant DNA experimentation.

1977 The first genetic engineering company is founded (Genentech), using recombinant DNA methods to make medical drugs.

1978 Somatostatin becomes first human hormone produced using recombinant DNA technology.

1981 Discovery of human oncogenes (cancer genes).

1983 AIDS virus isolated.

1985 K.B.Mullis describes the polymerase chain reaction (PCR) the most sensitive assay for DNA yet devised.

1988 The Human Genome Project founded with the goal of determining the entire sequence of DNA composing the human chromosomes.

1989 A.Jeffreys coins the term DNA fingerprinting and was the first to use DNA polymorphims in paternity/m immigration, and murder cases.

1990 First attempt at gene therapy.

1992 Low resolution genetic linkage map of entire human genome published.

1993 FlavorSavor tomatoes, genetically engineered for longer shelf life, are marketed

1996 'Dolly', derived from cells taken from the udder of a dorset ewe, becomes the first mammal cloned from a cell.

1998 First entire genome sequenced (C. elegans).

Designer Diane Ngai

Art director Louise Holloway

Design college Parsons School of Design, Paris

Country of origin France/Canada

Work description Main image: Poster carrying a visual interpretation of the history of genetics. Border: Experiments with photograms of a typface.

Dimensions Poster: 16 1/2 x 23 1/2 in; 420 x 594 mm Photogram panels: 11 3/4 x 16 1/2 in; 297 x 420 mm

Designer/illustrator Julian Morey

Design company Julian Morey Studio

Country of origin UK

Client *The Independent*/The London
Cardguide

Work description Design featured in the
Eye Magazine of *The Independent*
newspaper (this page). Postcard design
for The London Cardguide (opposite).

Dimensions
Eye design: 8 ³/₄ x 11 ¹/₄ in; 219 x 288 mm
Postcards 4 x 6 in; 105 x 148 mm

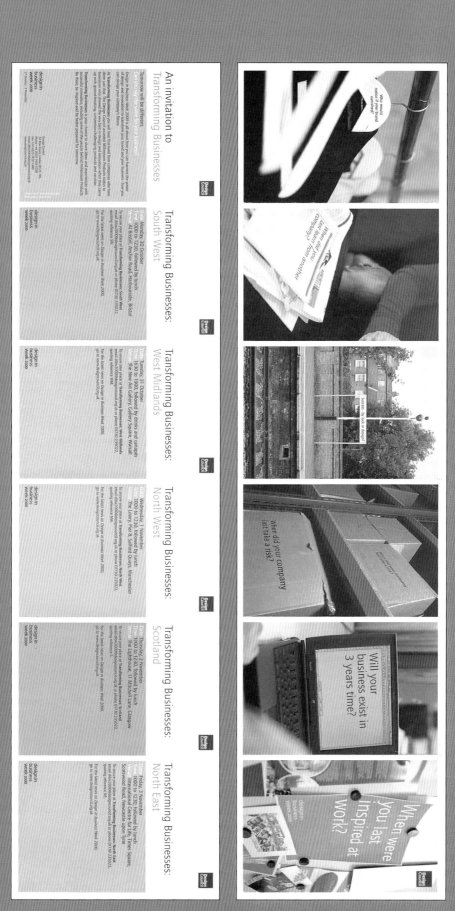

Designer Paula Benson
Art directors Paula Benson and Paul West
Photographer Spiros Politis
Design company Form
Country of origin UK
Client The Design Council
Work description Gatefold invitation to 'Design in Business Week', an event that explored how design can transform business.
Dimensions 5 ³/₄ x 23 ¹/₄ in; 148 x 592 mm

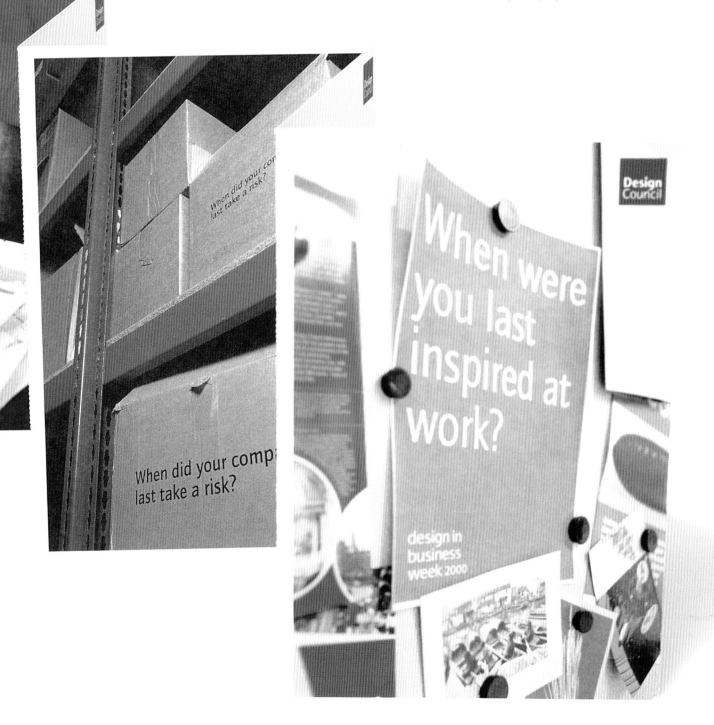

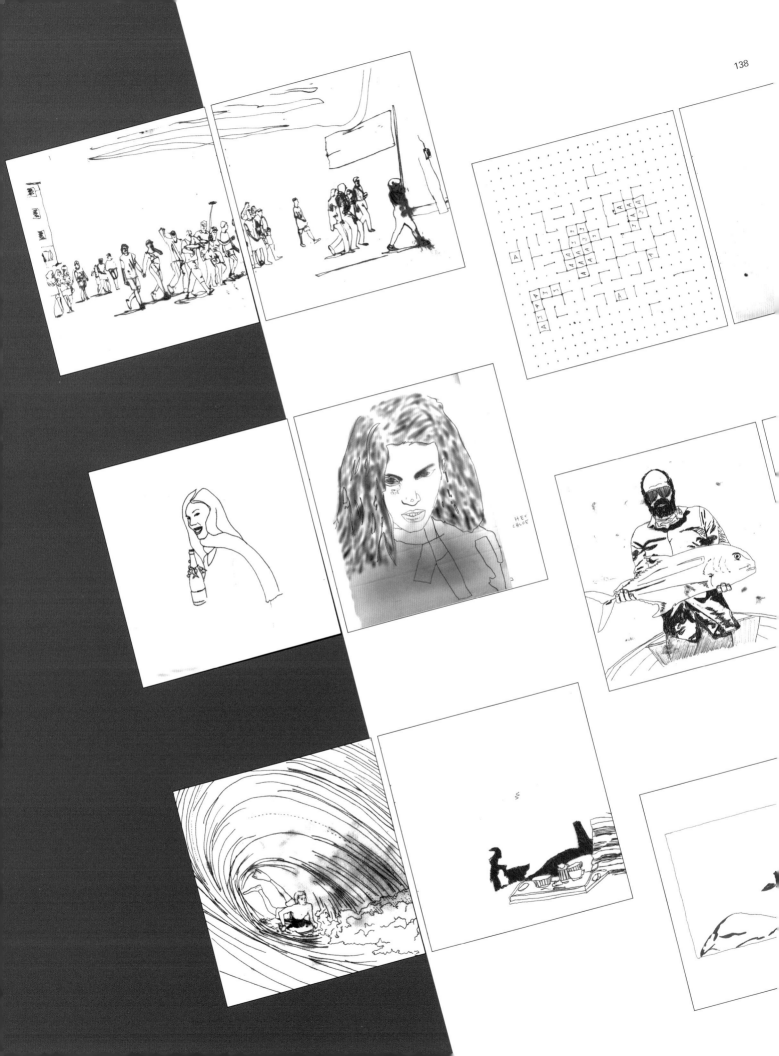

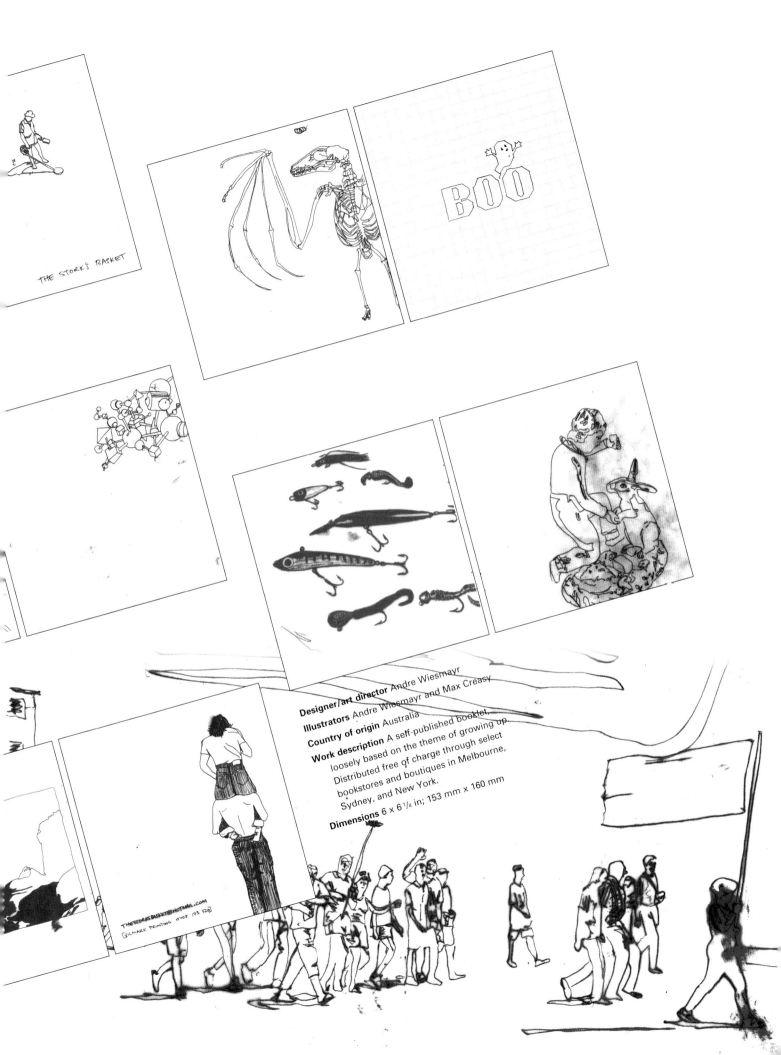

THE STORK'S BASKET

BOO

Designer/art director Andre Wiesmayr
Illustrators Andre Wiesmayr and Max Creasy
Country of origin Australia
Work description A self-published booklet,
loosely based on the theme of growing up.
Distributed free of charge through select
bookstores and boutiques in Melbourne,
Sydney, and New York.
Dimensions 6 x 6¼ in; 153 mm x 160 mm

THESTORKSBASKET@HOTMAIL.COM
VICMARK PRINTING 0408 173 528

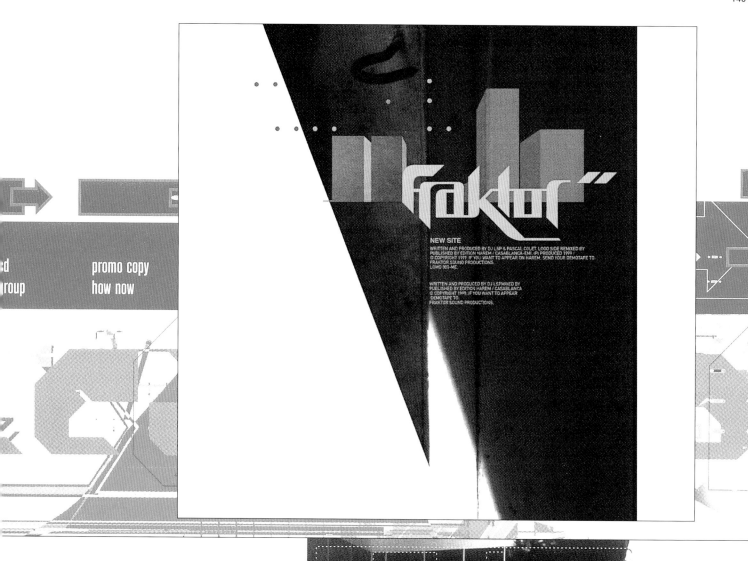

promo copy
how now

NEW SITE

WRITTEN AND PRODUCED BY DJ LSP & PASCAL COLET. LOGO SIDE REMIXED BY
PUBLISHED BY EDITION HAREM / CASABLANCA-EMI. (P) PRODUCED 1999 /
Ⓒ COPYRIGHT 1999. IF YOU WANT TO APPEAR ON HAREM, SEND YOUR DEMOTAPE TO:
FRAKTOR SOUND PRODUCTIONS.
LOMO 001-ME.

WRITTEN AND PRODUCED BY DJ LSP.MIXED BY
PUBLISHED BY EDITION HAREM / CASABLANCA
Ⓒ COPYRIGHT 1999. IF YOU WANT TO APPEAR
DEMOTAPE TO:
FRAKTOR SOUND PRODUCTIONS.

FR, 23.

07.00pm — TÜRÖFFNUNG KOLLEKTE
08.00pm — VERNISSAGE
08.30pm — PERFORMANCE >KULTURPROJEKT 5,4

10.00pm — GUSTAV UND DAS KUMMERORCHESTER

SA, 24.

02.00pm — WORKSHOPS >THEATER, ACRYLGLASSCHMUCK, LAMPEN, YOGA, DJEMBE, TON
05.00pm — TUROFFNUNG 10.-/ab 09pm 15.-
06.00pm — EARTH FOG >INDEPENDENT ROCK
08.00pm — PLAYSKOOL >BIG BEATS, VIDEO ANIMATION
10.00pm — EL BAROCO VOUS CONVIE A UN DINNER DANS LES CARPATES >HAIRDESIGN EXHIBITION

11.00pm — DJ MINUS 8 >DRUM'N'BASS

SO, 25.

10.00am — TÜRÖFFNUNG KOLLEKTE
10.30am — SUSI FUX-LOPFE >PUPPENTHEATER
01.00pm — TALENTOSCOP >VERONIQUE MÜLLER PRÄSENTIERT JUNGE TALENTE IM BLICKFEL

02.00pm — ABAKUSTIKER >A CAPELLA QUARTETT

BOLLWERK (FREIBURG) PLATTFORM KULTUR AUSSTELLUNG>PARTY
APART AS A SYNONYME FOR VERY SPECIAL EVENTS IN THE WIDEST INTERPRETATION OF CULTURE COULD BE A REGISTERED TRADEMARK IN THE NEAR FUTURE AND YOU MIGHT BE PART OF IT!

DESIGN: 5.

esign stähli 5,4, bern this is a promo-cd only and therefore not for sale

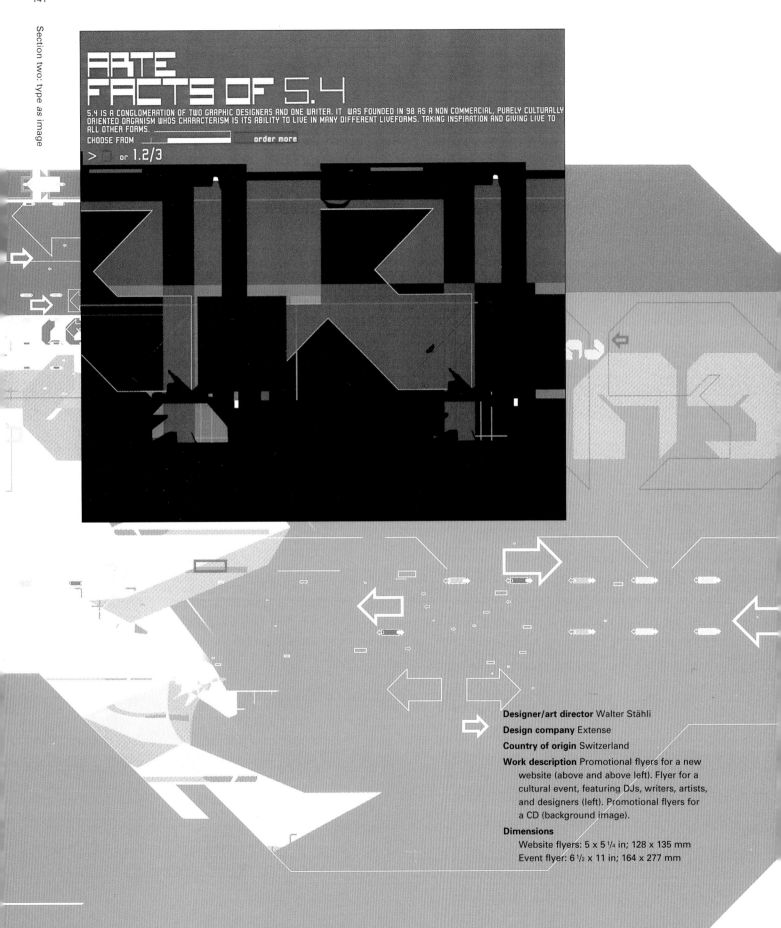

ARTE
FACTS OF 5.4

5.4 IS A CONGLOMERATION OF TWO GRAPHIC DESIGNERS AND ONE WRITER. IT WAS FOUNDED IN 98 AS A NON COMMERCIAL, PURELY CULTURALLY ORIENTED ORGANISM WHOS CHARACTERISM IS ITS ABILITY TO LIVE IN MANY DIFFERENT LIVEFORMS. TAKING INSPIRATION AND GIVING LIVE TO ALL OTHER FORMS. _____

CHOOSE FROM _____ order more

> ☐ or 1.2/3

Designer/art director Walter Stähli

Design company Extense

Country of origin Switzerland

Work description Promotional flyers for a new website (above and above left). Flyer for a cultural event, featuring DJs, writers, artists, and designers (left). Promotional flyers for a CD (background image).

Dimensions
Website flyers: 5 x 5 ¼ in; 128 x 135 mm
Event flyer: 6 ½ x 11 in; 164 x 277 mm

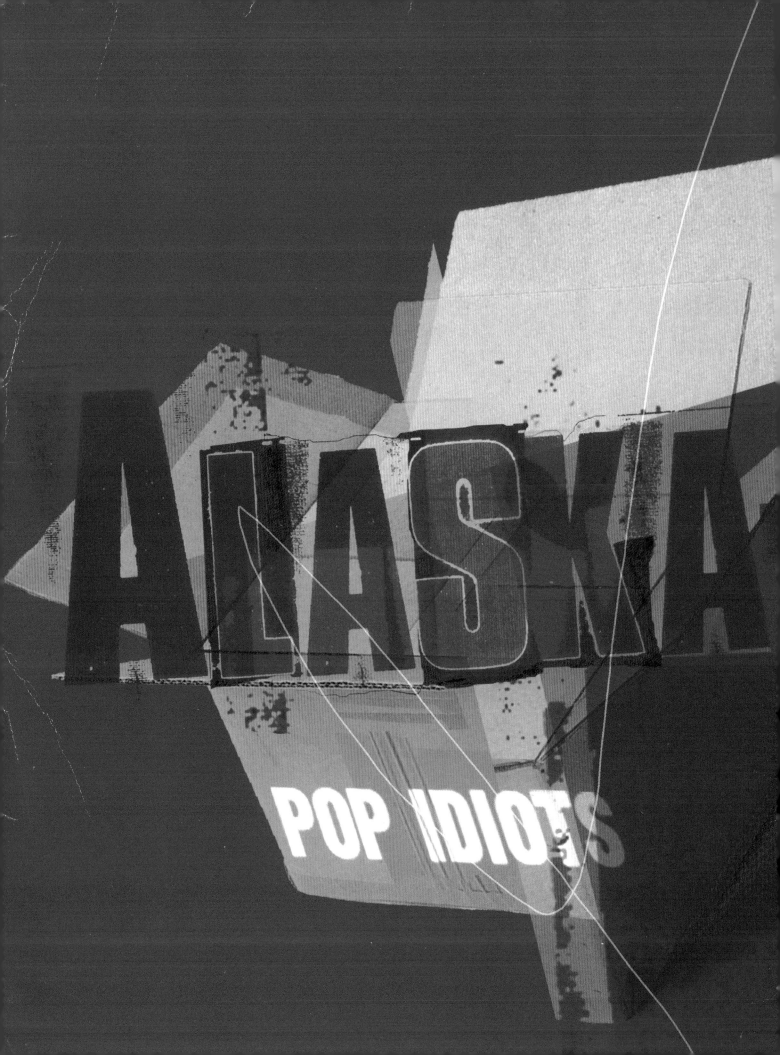

Designer/art director Nitesh Mody

Design company Moot

Country of origin UK

Client London Records

Work description Cover of vinyl and CD single
by Alaska-J. The principal typographic
elements were created using Letraset.

Dimensions
Vinyl cover: 12 $\frac{1}{2}$ x 12 $\frac{1}{4}$ in; 315 x 311 mm
CD cover: 4 $\frac{1}{2}$ x 5 $\frac{1}{2}$ in; 115 x 137 mm

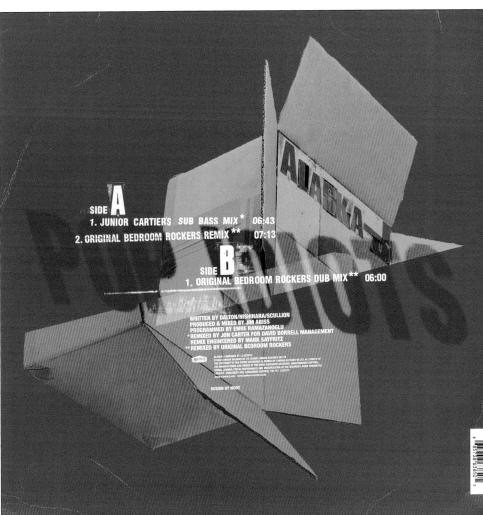

WHAT'S IT FOR IF IT AIN'T...

4★pop'n

THE OFFICIAL 4TH OF JULY SNAPPER
★ ☆ ★ ☆ BROUGHT TO YOU BY SLATOFF+COHENPARTNERS
FORGING NEW FRONTIERS IN IGNITION FREE EXPLOSIVES©

☆ ☆ ☆ ☆ ☆ ☆ ☆

Designer Elsie Woolcock

Art directors Tamar Cohen and David Slatoff

Design company Slatoff+ Cohen Partners Inc

Country of origin USA

Work description
Self-promotional box containing 'snappers', mailed out to celebrate July 4th.

Dimensions Matchbox size

SNAPPER'S HEAD

SNAPPER'S TAIL

DIRECTIONS: GRAB THE SNAPPER BY ITS TAIL
AND THROW IT ON A HARD SURFACE. BY DOING
THIS, THE SNAPPER'S HEAD WILL EXPLODE!!

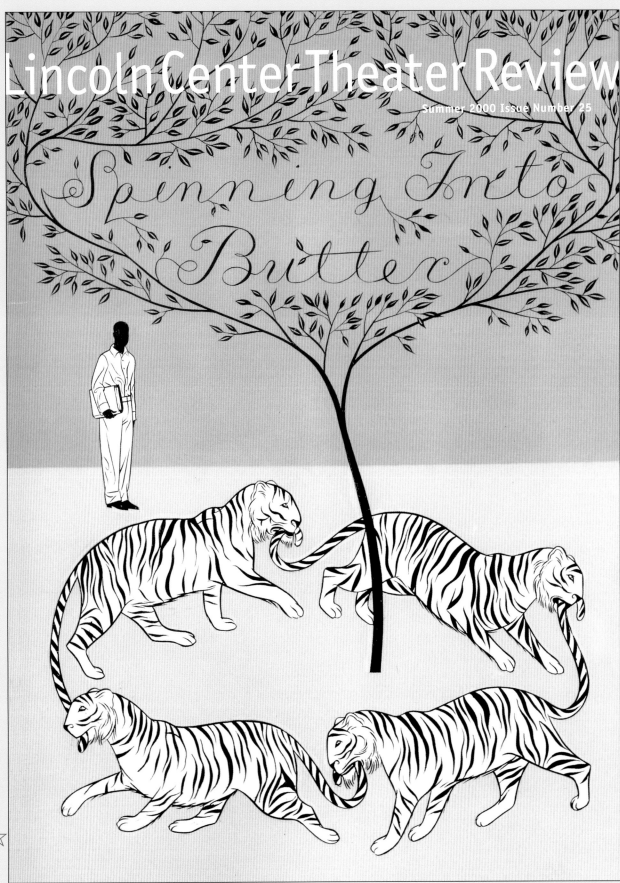

Designers David Slatoff, Tamar Cohen, and David Jacobson

Art direction David Slatoff and Tamar Cohen

Design company Slatoff+Cohen Partners Inc

Illustration Nick Dewar

Country of origin USA

Client Lincoln Center Theater

Work description Review magazine produced by Lincoln Center

Dimensions 8 1/2 x 11 3/4 in; 215 x 297 mm

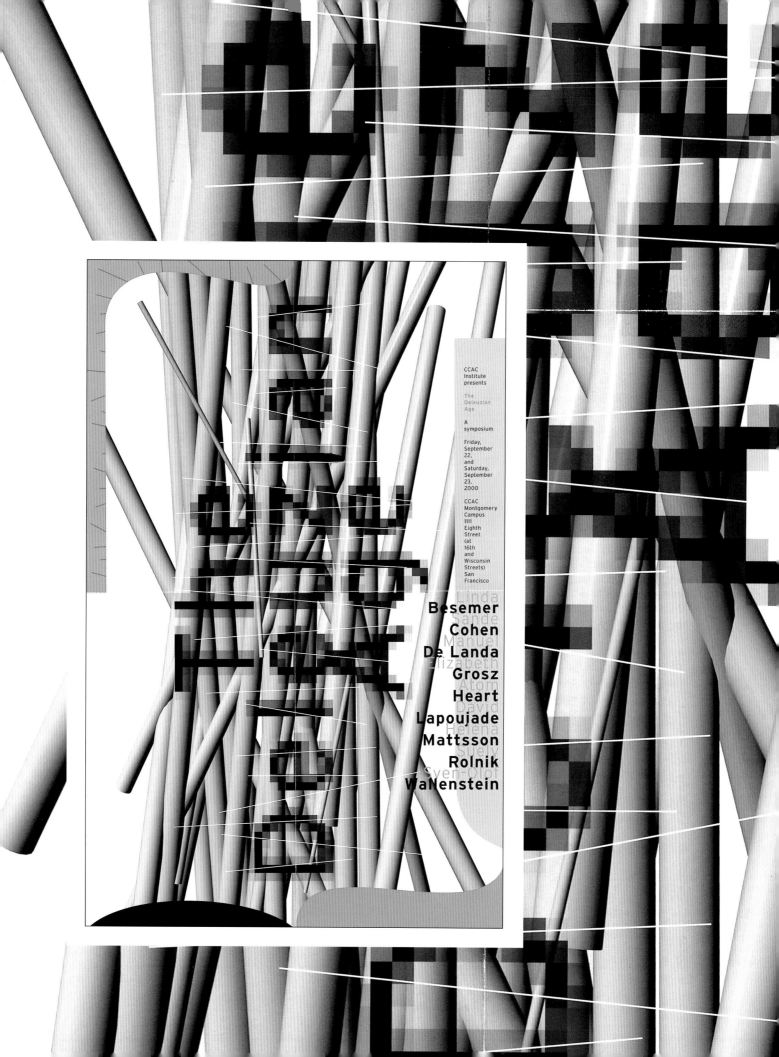

CCAC
Institute
presents

The
Deleuzian
Age

A
symposium

Friday,
September
22,
and
Saturday,
September
23,
2000

CCAC
Montgomery
Campus
1111
Eighth
Street
(at
16th
and
Wisconsin
Streets)
San
Francisco

Linda
Besemer
Sande
Cohen
Manuel
De Landa
Elizabeth
Grosz
Atom
Heart
David
Lapoujade
Helena
Mattsson
Suely
Rolnik
Sven-Olof
Wallenstein

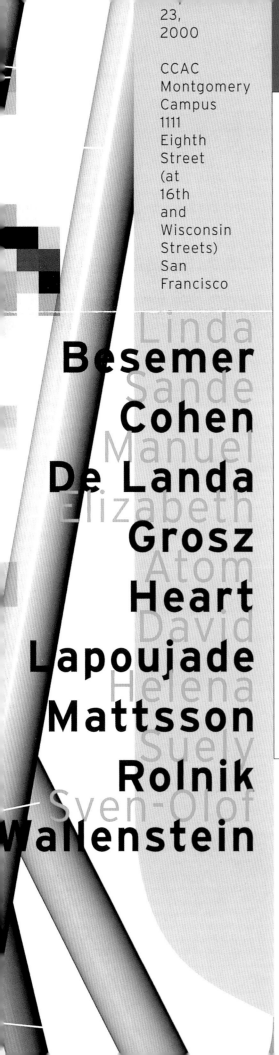

23,
2000

CCAC
Montgomery
Campus
1111
Eighth
Street
(at
16th
and
Wisconsin
Streets)
San
Francisco

Linda
Besemer
Sande
Cohen
Manuel
De Landa
Elizabeth
Grosz
Atom
Heart
David
Lapoujade
Helena
Mattsson
Suely
Rolnik
Sven-Olof
Wallenstein

ccac institute presents_an exhibition in san francisco & oakland

rooms_for_listening

san francisco exhibition dates	: september 5 through october 14, 2000
	opening reception: friday, september 8, 8 to 11 pm_kent and vicki logan galleries
	ccac montgomery campus_1111 eighth street (at 16th and wisconsin streets)_san francisco
san francisco installations	thom faulders/beige design: *mute room_involving systems/meso: mutable muzzy musics_*
	toshio iwai: *composition on the table_*leo villareal: *sound box*
performances	joshua kit clayton_atom heart_matthew herbert/radioboy_brandon labelle_
	loren chasse/eleanor harwood_blectum from blechdom
oakland exhibition dates	: september 27 through october 28, 2000
	opening reception/performances: wednesday, september 27, 7 to 10 pm_oliver art center
	ccac oakland campus_5212 broadway (at college avenue)_oakland
oakland installations	toshiya tsunoda: *monitor units for solid vibration/oliver art center_*john hudak: *facade*

Designer/art director Bob Aufuldish

Design company Aufuldish & Warinner

Country of origin USA

Work description Poster for a symposium
on the French philosopher, Gilles
Deleuze (left). Poster for an exhibition
and performance featuring a spectrum
of electronic sound and music (above).

Dimensions Both posters: 11 x 17 in;
280 x 430 mm

A Fortnight in Seaton Carew

Designers Students from the BA (Hons)
Graphic Design course at
the University of Teesside

Art directors Sandra Armstrong,
Bob Beagrie, and Adrian Moule

Design college Hetergloss & the
University of Teeside

Country of origin UK

Work description Book containing graphical
interpretations of the work of 14 writers
whose poems and prose were inspired
by a visit to the town of Seaton Carew.

Dimensions 6 3/4 x 6 3/4 in; 170 x 170 mm

Aurora Borealis

Last week they went to Crete. "We only decided on Thursday. It was great, fantastic." They hired a couple of scooters,

The Langscar Centre: The North East's Only Air Conditioned Prize Bingo.
"There's money everywhere," Jason says. "Its all picking up." At breakfast he wears a white baseball cap.

"No, no" Jason sprints upstairs. He has a wife and two infant sons in Fulham.
There are seals again at Seal Sands, since they put up the Tees Barrier. And the salmon, and the wild swans.

At Cameron's Staincliffe Hotel, somebody else is just married.
Elderly dogwalkers gaze across the forecourt at the disco lights staining the lofty windows all the colour of an arctic sky.

There's the bride, still in regalia. Exhausted at a garden table among her guests, she sits supping pints of Vaux.

In September, they're going to Tanzania.

went all over: "Didn't cost any more than we spent the first couple of days on taxis."

Three women go by in cream slingbacks, talking of cream cakes. "I went over and bought a little top, I think, just a round neck..."
"Tell them you met a steelworker who's too bright for his job." He says.
Is that what he feels?
but he works weekends at Seal Sands, because the money's better

The seals come onto the sands and bask. "There were seventeen this morning.
Everyone was pulled up on the bank to watch them."
Decorous white and blue balloons dance all over the silver peugeot. Indoor, the bars are packed with guests.

Her dress spreads wide and fluffy as the 10 o'clock plume from the stacks at Seal Sands.

to climb Mount Kilmanjaro. "But that's for charity."

Colin Greenland

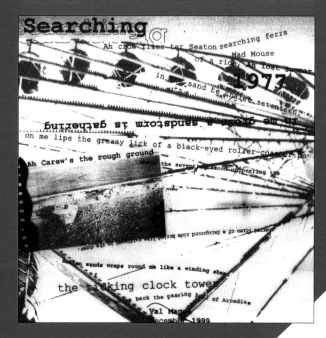

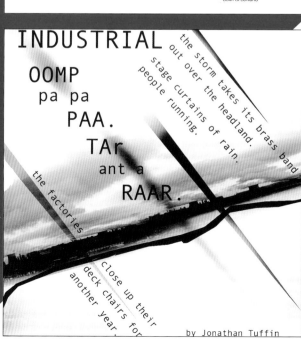

welcome to las vegas

by Pauline Plummer

The plaster palomino rides
me back to knickerbocker glories
to sticks of rock, the cold seas' purgatory
holidays at the North East, sea-side.

Like a postcard from the post war decade
I watch the kids and grans
build moats and towers with bucket and spade
by a sweep of raw sea on grainy sand.

The Cafe Royal where we'd have a treat
of tea and cakes, now streaked
with blistered paint; the NF slogan
on art deco sea-front concrete.

A wedding in the pub, men
in awkward pose grip lager; their queens
in loud voices and red trouser suits
knock back Bacardi Breezers.

Container ships stride for port,
like the bare-chested lad
freed from prison striding down the prom
next to the wall his grandad built in war-time

to keep the Germans out; a sapper
billeted and waiting for the chapter
of his life he'll not forget; the comrades
who'll storm such a beach and end up dead.

Ordered to mine this beach they marked
a secret path for folk to fetch sea coal;
with pub and shop kept out of bounds
some still courted sweethearts on the sands.

In civvy life he brought us here to view
his brickwork and remember his platoon,
battles with an enemy you knew,
the exhilaration of a soldier's life.

It's a war game to the boys who gun
the Cyber Sled, terminating aliens;
to the grandson who learnt of violence
and desertion in the marriage war zone.

Such wounds don't mend, he shadow boxes
with the foe of his beguiling impulses;
crushing too close what he's afraid to lose.
he becomes his own familiar ghost.

This Paradise. Its milky-white dunes at Blue Lagoon, tufted with wire old grass, & casts of frances & cranes rooted on the Claxheaton horizon, cracks at Hartlepool. & why not?

Village is separated from town by the railway bridge that spans a l o n g between lost children & white poplar fades winding down. Maureen Almond

I don't think I'm here at all. Well,
I'm here, of course I am. But not
'here' where the map says.
There's a golf course where the
front is, and the road runs on
'here' instead of petering out in
sand like it does here in front of
my eyes. Can't be fussed to work
it out. Must be right and I'm
looking at it wrong. It's not reas-
suring after all, this map. It makes
me anxious. Anxiety makes me
h u n g r y .

Designer/art director Walter Stähli
Design company Extense
Country of origin Switzerland
Work description Promotional flyer for
 a new website (left) and a book of
 short stories (main image).
Dimensions
 Website flyer: 5 x 5 ¼ in; 128 x 135 mm
 Stories flyer: 6½ x 11 in; 164 x 277 mm

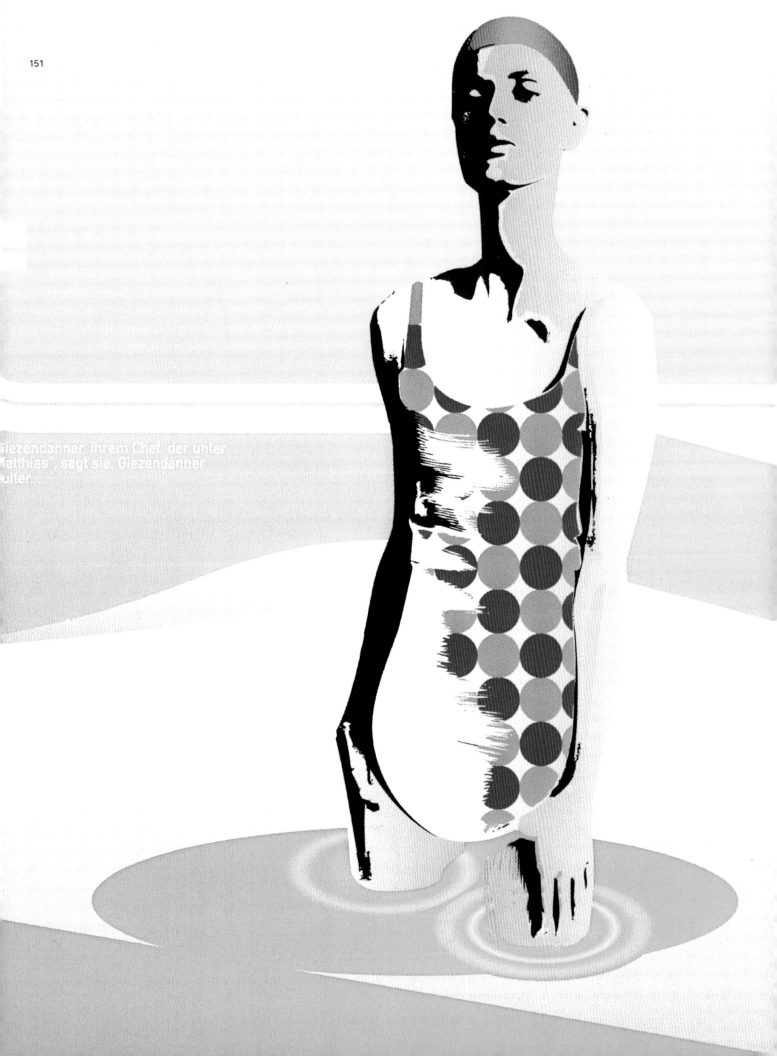

iezendanner, ihrem Chef, der unter
Matthias", sagt sie. Giezendanner
ulter..

152

Designer Deanne Cheuk

Art director Andre Wiesmayr

Design company Surfacepseudoart

Country of origin USA

Work description Poster for music event (far left) and pages from limited edition, inspirational graphics magazine, *Mu* (left).

Dimensions
Poster: 420 mm x 594 mm; 16 1/2 x 23 1/4 in
Magazine: 4 1/4 x 4 1/4 in; 110 x 110 mm

Designer Deanne Cheuk

Art director Andre Wiesmayr

Design company Surfacepseudoart

Country of origin USA

Work description Pages from limited edition, inspirational graphics magazine, *Mu.*

Dimensions 4 1/4 x 4 1/4 in; 110 x 110 mm

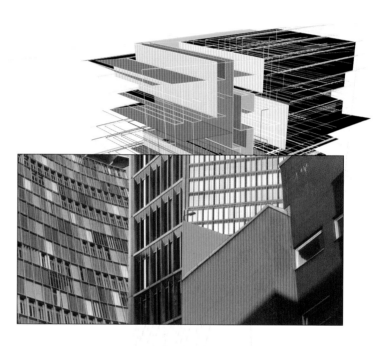

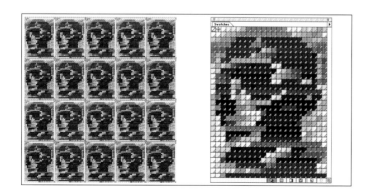

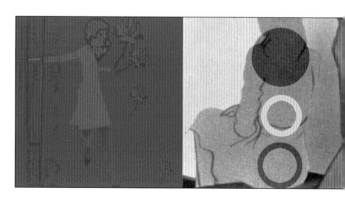

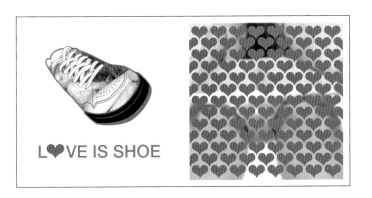

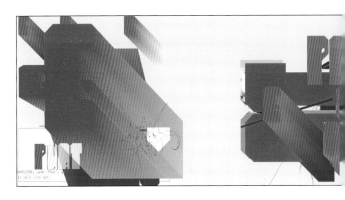

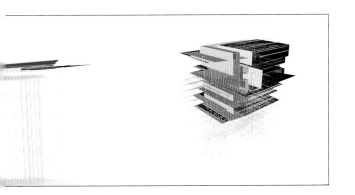

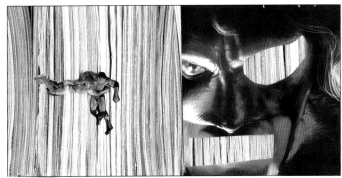

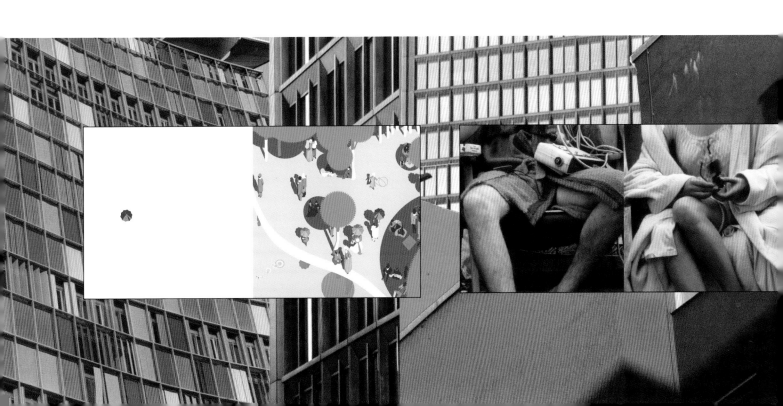

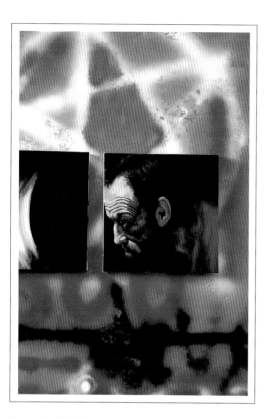

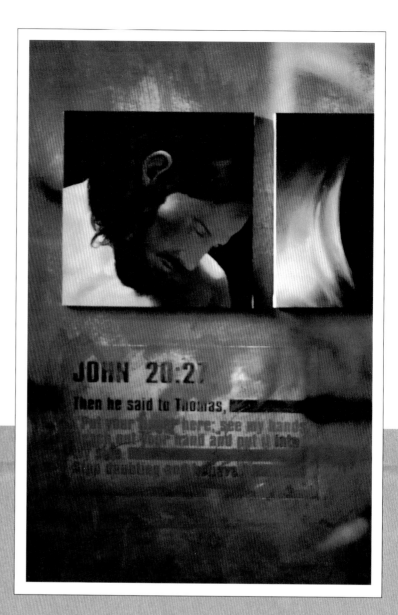

JOHN 20:27

Then he said to Thomas,

Designer/art director Alvin Tan

Photographer Alan Oei

Design company Phunk Studio/Brazen
 Communications

Country of origin Singapore

Work description Self-promotional cards.

Dimensions 5 ½ x 9 in; 140 x 225 mm

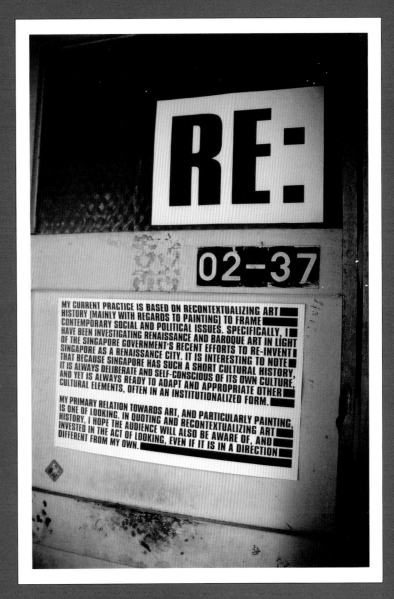

My current practice is based on recontextualizing art history [mainly with regards to painting] to frame contemporary social and political issues. Specifically, I have been investigating Renaissance and Baroque art in light of the Singapore government's recent efforts to re-invent Singapore as a Renaissance city. It is interesting to note that because Singapore has such a short cultural history, it is always deliberate and self-conscious of its own culture, and yet is always ready to adapt and appropriate other cultural elements, often in an institutionalized form.

My primary relation towards art, and particularly painting, is one of looking. In quoting and recontextualizing art history, I hope the audience will also be aware of, and invested in the act of looking, even if it is in a direction different from my own.

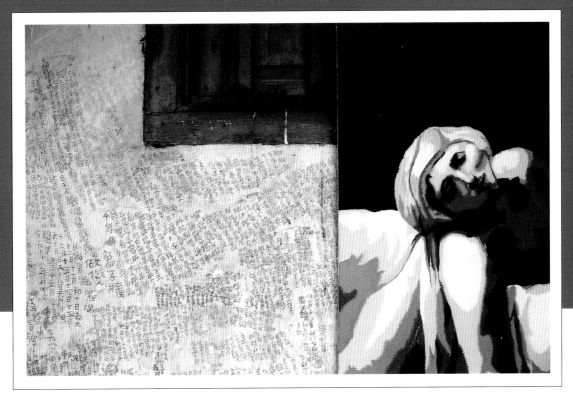

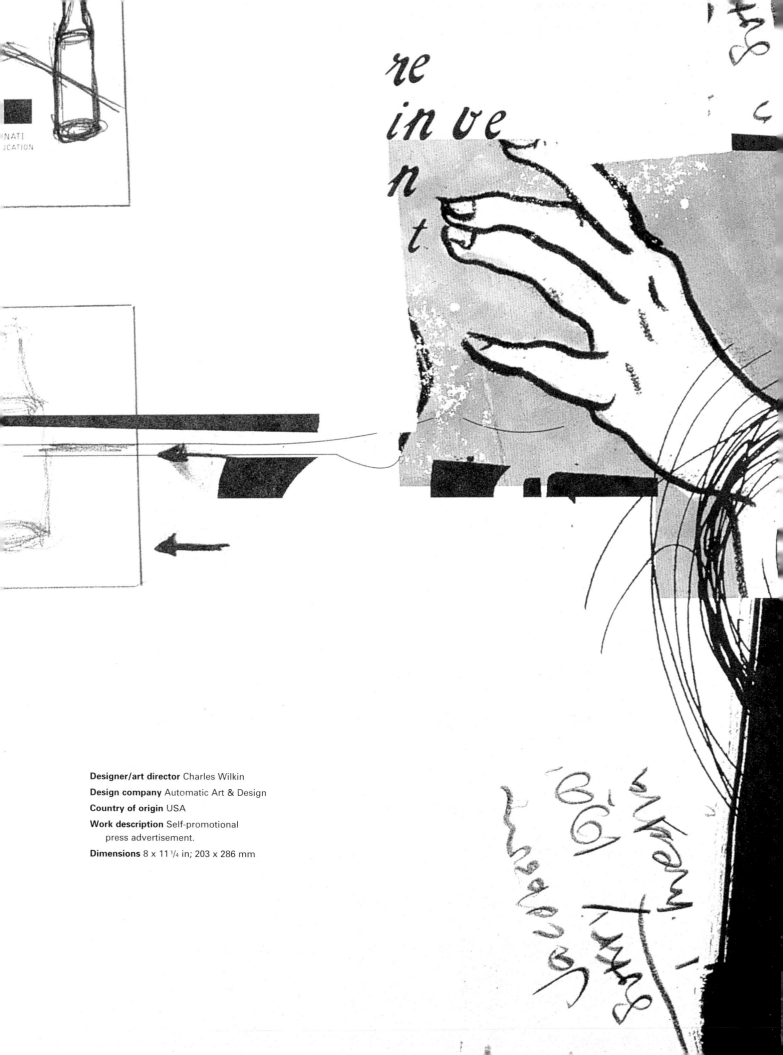

Designer/art director Charles Wilkin
Design company Automatic Art & Design
Country of origin USA
Work description Self-promotional
 press advertisement.
Dimensions 8 x 11 ¼ in; 203 x 286 mm

OF PERSONAL HISTORY AND OBJECTIVES FOR PURSUING AN ADVANCED D
RECOMMENDATION THAT SUPPORT PROFESSIONAL OR SCHOLARLY EXPERIENCE
WITH THE DIRECTOR OF ENROLLMENT SERVICES CAN BE ARRANGED BY CA
513-562-8754. AN APPLICANT'S ACCEPTANCE TO THE PROGRAM IS BASED O
PROFESSIONAL AND ARTISTIC AC
COMMITMENT TO TEACHING.

@ TRANSFER CREDIT UP TO NINE GR
TRANSFERRED TO THE MA DEGREE PR
WHERE THOSE CREDITS WERE EARNED
THE APPROPRIATE REGIONAL BODY.
MUST BE COMPATIBLE WITH THE A
AND WILL BE EVALUATED BY THE CHA
AND THE DIRECTOR OF ENROLLMENT
OF 3.0 OR BET

TUITION FOR THE FULL-TIME LOAD O
THE SUMMER OF 2000 IS $4,62
HOUR. THERE IS AN ADDITIONAL M
EACH STUDIO CLASS. TUITION AND
TIME OF REGISTRATION. THE ACA
OFFERS A LOW COST, FLEXIBLE SYSTEM

TUITION THROUGH REGULARLY
PLEASE CALL NANCY GLIER,
FOR DETAILS, (513-562-8752)

FINANCIAL AID FOR
THE DIRECTOR OF FINANCIAL
FOR COUNSELING ON FINANCIAL
AS AWARDING FINANCIAL AID
WILL ASSIST STUDENTS IN OBTAI
OF FEDERAL AND STATE LOA
LOANS AND SCHOLARSHIPS. A
FUNDS IS MADE DIRECTLY T
FINANCIAL AID. STUDENTS
FAFSA (FREE APPLICATION F
AID) TO DETERMINE ELIGIBILI
PRIOR TO APPLYING FOR THE LOANS. THE FINANCIAL AID PROGRAMS AVAILABLE AT T
THE SUBSIDIZED AND UNSUBSIDIZED STAFFORD LOAN AND THE OHIO SUPPLEMENT
SCHOLARSHIPS INCLUDE ACADEMY SCHOLARSHIPS, MARY COULTER CLARK AND BERTHA
SCHOLARSHIP MONIES. PLEASE CALL KAREN LIND, DIRECTOR OF FINANCIAL A
(513-562-8751)

appli
transfe
financia
calendar
information
aac

APRIL 1 SCHOLARSHIP APPLICATION DEADLINE
APRIL 13-24 ADVISING AND REGISTRATION
(BY APPOINTMENT)
JUNE 13 GRADUATE CLASSES BEGIN

APPLY

MA

that spark is

TRYING TO DO SOMETHING
a box spring tbl bed foun
trash summa

Designer/art director Charles Wilkin

Design company Automatic Art & Design

Country of origin USA

Client Prototype

Work description Print advertisement for type foundry.

Dimensions 5 ¹/₂ x 7 ¹/₄; 140 x 184 mm

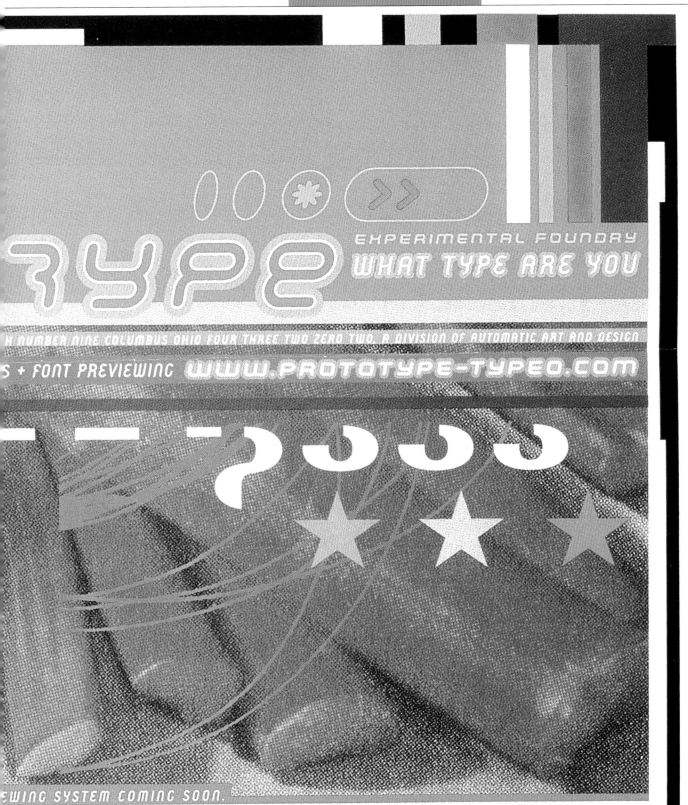

TYPE

EXPERIMENTAL FOUNDRY
WHAT TYPE ARE YOU

X NUMBER NINE COLUMBUS OHIO FOUR THREE TWO ZERO TWO, A DIVISION OF AUTOMATIC ART AND DESIGN

S + FONT PREVIEWING WWW.PROTOTYPE-TYPEO.COM

EWING SYSTEM COMING SOON.

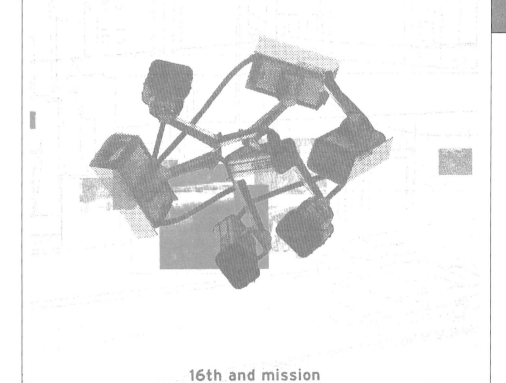

16th and mission
www.16thandmission.com
www.umwow.com

16th and mission

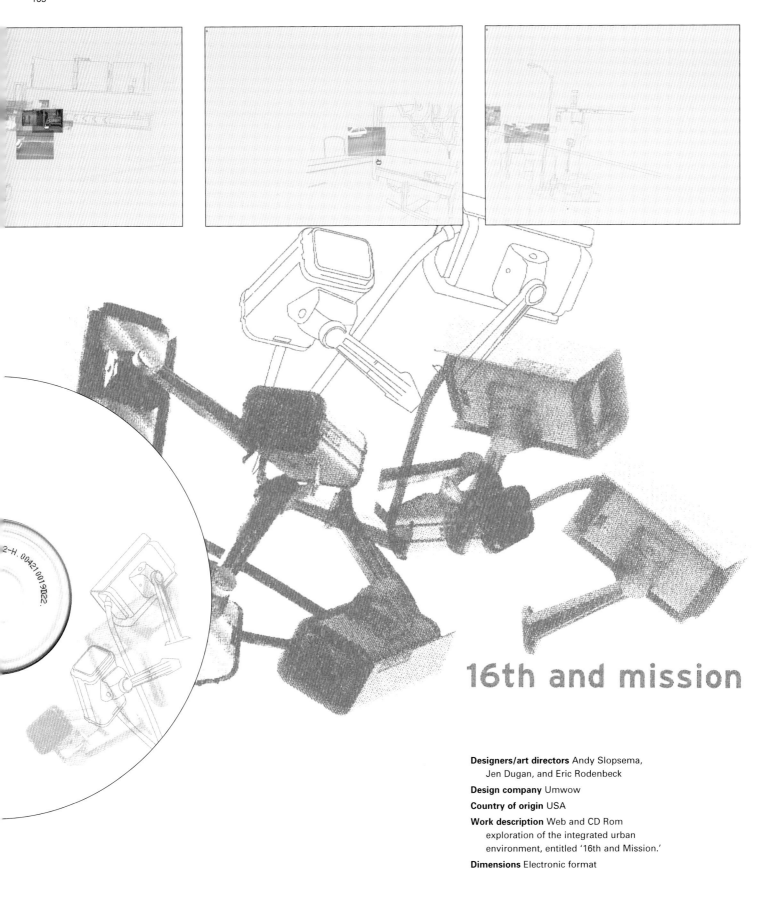

16th and mission

Designers/art directors Andy Slopsema,
 Jen Dugan, and Eric Rodenbeck
Design company Umwow
Country of origin USA
Work description Web and CD Rom
 exploration of the integrated urban
 environment, entitled '16th and Mission.'
Dimensions Electronic format

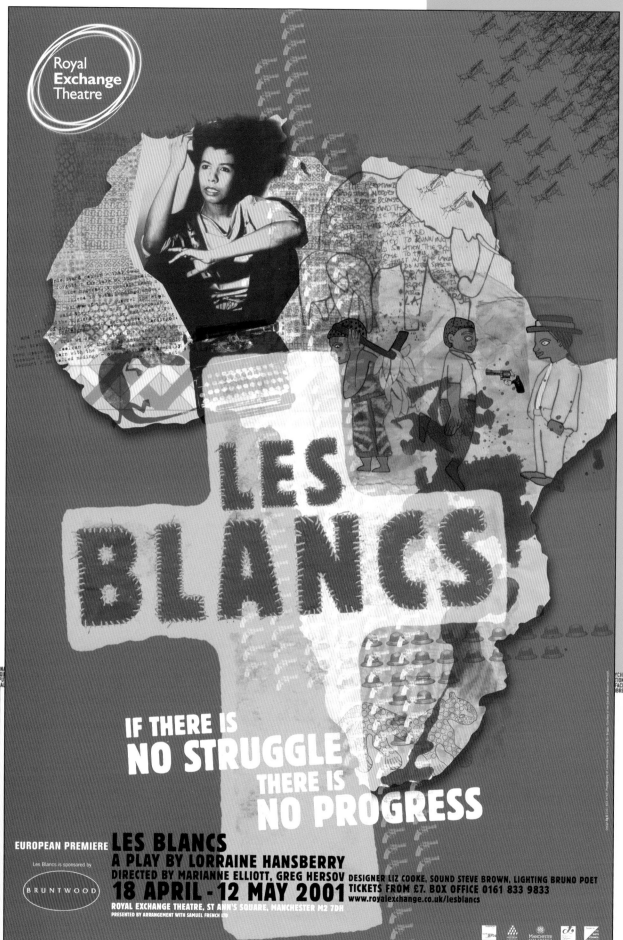

Designers Pat Walker, Dom Raban, and Jo Morritt

Design company Eg.G

Country of origin UK

Clients Manchester Royal Exchange Theatre; Leeds University; and Galaxy 105

Work description Four-sheet poster for performance of 'Les Blancs' (left); poster/broadsheet prospectus for Bretton Hall College, part of The University of Leeds (right); and wallpaper design for dance music radio station (below right).

Dimensions Theatre poster:
40 x 60 in; 1016 x 1524 mm
Bretton Hall poster:
23 ½ x 33 in; 594 x 840 mm

Above

Designers/art directors Michael Faulkner
 and Axel Stockburger
Photographer Michael Faulkner
Design company D-Fuse
Country of origin UK
Work description Video for the
 Spanish musicians, Fluid.
Dimensions Electronic format

Below

Designer/art director Michael Faulkner

Photographer Michael Faulkner

Country of origin UK

Design company D-Fuse

Work description Personal project
 footage filmed in Japan.

Dimensions Electronic format

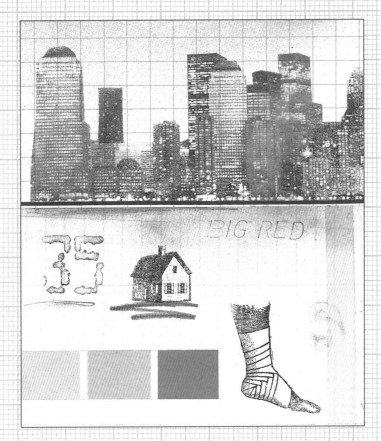

Designer/art director Craig Yamey
Design company Yam
Country of Origin UK
Description of artwork Series of one-off
 postcards exploring the use of type
 as image.
Dimensions 6 x 7 in; 150 mm x 175 mm

THE NORTHERN SALOON

delivery: ☐ fax: ☐ invoice: ☐ letter: ✓ order: ☐ purchase: ☐ quote: ☐ release: ☐ reminder: ☐

ref no:

date: 01 02 03 04 05 06 07 08 09 10 11 12 13 14 15 16 17 18 19 20 21 22 23 24 25 26 27 28 29 30 31

time: 12 ʃ2 15 am/pm / J F M A M J J A S O N D 99 00 01 02 03 04 05 06 07 08 09 10

contact name (sender): david hand

contact address: 308 Liverpool
palace. 6-10 Slater st
Liverpool L1 4BS

tel: 0151 709066 fax:77

e-mail: david@splinter.co.uk

web:

contact name (receiver): Roger / Kelly

contact address: duncan baird
Publishers

tel: fax:

e-mail:

web:

additional: there a ten copies
of everything in the envelope!

no. of pages (inc. this one):

special instructions:

thankyou..!

Designers David Hand, Alan Woods, and Seel Garside

Design company The Northern Saloon Design Collective

Country of origin UK

Work description Stationery set for The Northern Saloon
Design Collective, including a multifunctional sheet that
can be adapted for use as a delivery note, fax header,
invoices, letters, etc (far left), business cards (above
left), and reverse of continuation sheet (above).

Dimensions Letterheads: 8 1/4 x 11 3/4 in; 210 x 297 mm
Business cards: 2 1/2 x 3 1/4 in; 65 x 82 mm

Designers/art directors Jackson Tan, Alvin Tan, and Melvin Chee

Illustrator Jackson Tan

Design company Brazen Communications

Country of origin Singapore

Work description Series of self-promotional posters.

Dimensions 16 1/2 x 16 1/2 in; 420 x 420 mm

THE **HOME OFFICE** SOLUTION

WORK AT HOME **AND** HAVE A PERSONAL LIFE TOO

BEING A GOOD BOSS TO YOURSELF
BEATING STRESS
MANAGING FAMILY, FRIENDS AND CHILDREN
STAYING HEALTHY
COPING WITH ISOLATION
MOTIVATING YOURSELF

BY **ALICE BREDIN**
WITH KRISTEN LAGATREE

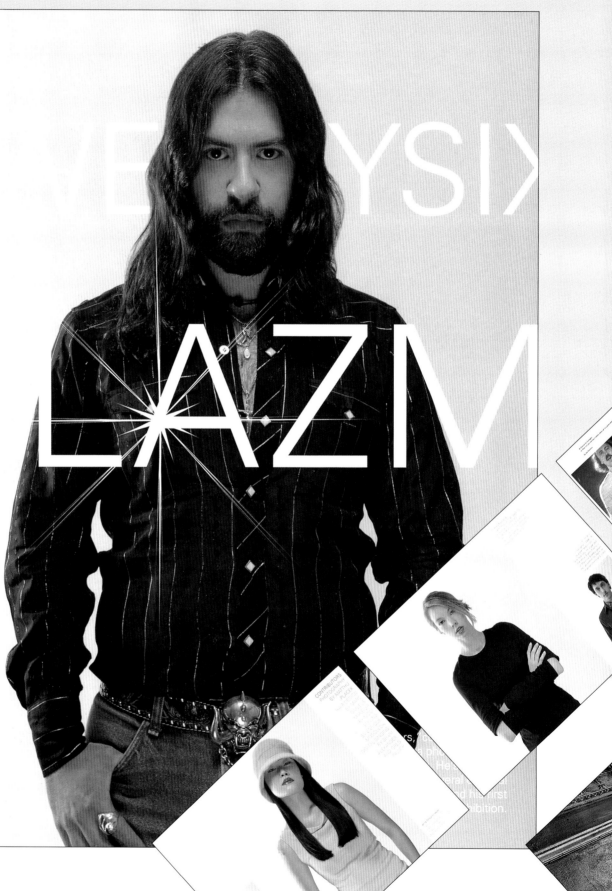

26 >

7 25274 813117

USA: $6
CDN/MEX: $7.50
PLAZM TENTH YEAR

Designers Enrique Mosqueda, Pete McCracken, Joe Peila, Jager Di Paola Kemp, and Ruby Lee
Art directors Enrique Mosqueda, Pete McCracken, Joe Peila, Jager Di Paola Kemp and Michael Jager
Creative directors Joshua Berger and Nico Courtelis
Photographers Anna Shteynshleyger, Experience Music Project, and Matthu Placek
Managing editor Jon Raymond
Design company Plazm Media
Country of origin USA
Description of work Plazm magazine.
Dimensions 9 x 12 in; 229 x 305 mm

View

"That's Nice"

Designer Phil Evans
Art director Nigel Walker
Illustrator Erica Heitman
Photographer Brian Pierce Photography
Design company That's Nice
Country of origin USA
Description of work 64-page self-promotional book.
Dimensions 6 3/4 x 8 1/4 in; 170 x 210 mm

Many people ask us why our company is called "That's Nice."

The name originates from the most common reaction people give when they see design and communication work…

"That's nice."

New York City
Economic Development Corporation

East River Bikeway & Esplanade

Brief: The East River Bikeway & Esplanade
is an urban greenway, which was created
to open up Manhattan's East River to users.
It needed a system of navigational signage
to enable safe use by cyclists, rollerbladers
and pedestrians, as well as references to
location and points of local interest.

Solution: First, we designed the system of
navigational signs that would separate the
different users along the route. We then
produced map signs and information signs,
which were placed strategically for reference.
The information signs were researched,
written and designed by us and cover
comprehensive details of historical and
geographical interest, to educate and
entertain the user.

Identity, Copywriting, Signage

Awards:
2000 Informational Diagrams, Pie – Signage
1999 Graphic Design USA Annual – Signage
1999 Signs of the Times – Signage
1999 Landscape Architecture – Signage
1998 Graphic Design USA Award – Signage

The signage system
for the ERB&E has
proven so successful,
it will be implemented
on similar projects
across the
metropolitan areas

Designers/art directors Petra Reisdorf,
Birgit Tümmess, Claudia Trauer,
and Nauka G Kirscher

Design company Atelier

Country of origin Germany

Work description Book about train travel.

Dimensions 9 x 12 ¹/₄; 225 x 310 mm

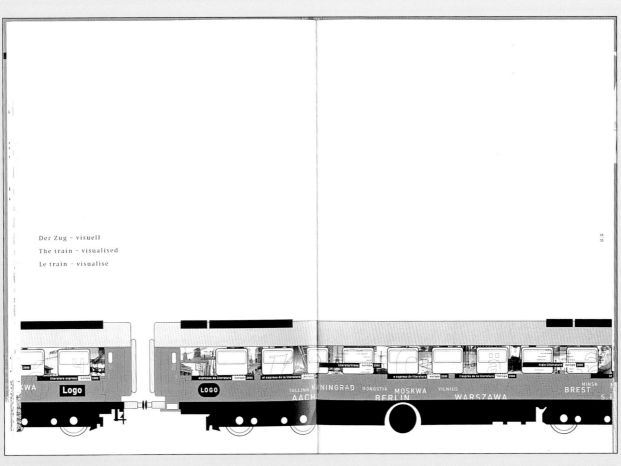

index

of designers and design companies